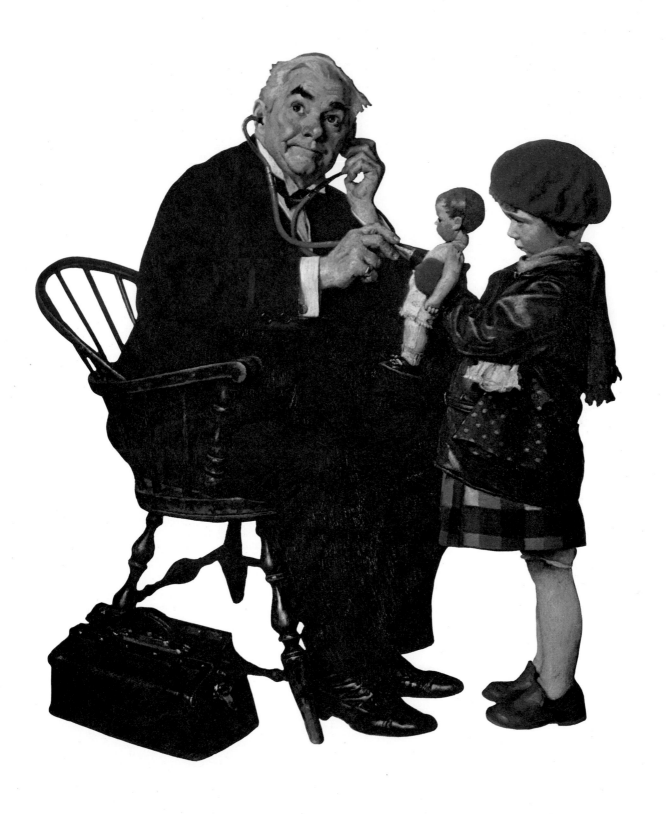

Harry N. Abrams, Inc., Publishers, New York

Reader's Digest Edition

CHRISTOPHER FINCH

Norman Rockwell's America

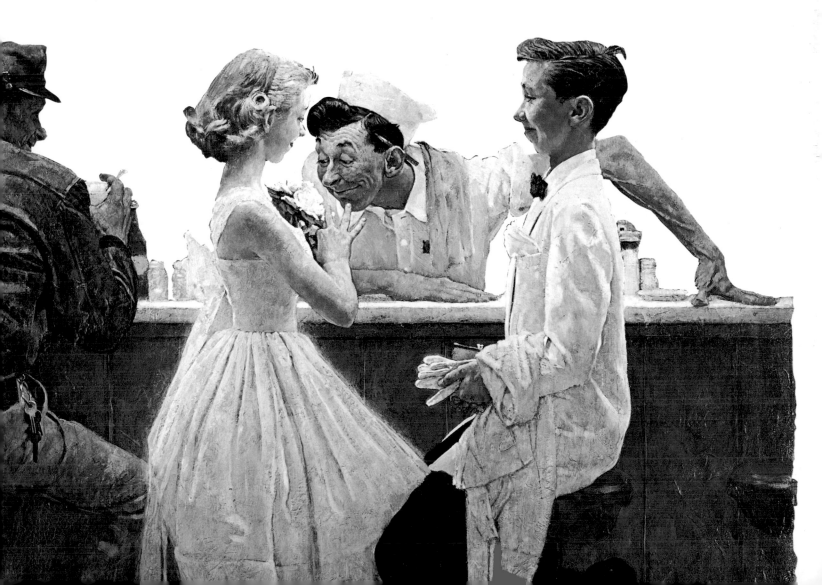

To my mother and father

TITLE PAGE ILLUSTRATIONS:

1. *Doctor and Doll.* Original oil painting for *Post* cover,
 March 9, 1929. Collection John E. Newman, San Antonio

2. *After the Prom* (detail). Original oil painting for *Post*
 cover, May 27, 1957. Collection Mr. and Mrs. Thomas Rockwell

Nai Y. Chang, *Vice-President, Design and Production*
John L. Hochmann, *Executive Editor*
Margaret L. Kaplan, *Managing Editor*
Barbara Lyons, *Director, Photo Department, Rights and Reproductions*
Joanne Greenspun, *Editor*

Library of Congress Cataloging in Publication Data

Finch, Christopher.
 Norman Rockwell's America.

 Bibliography: p.
 Includes index.
 1. Rockwell, Norman, 1894- 2. United States
in art. I. Title.
ND237.R68F56 759.13 75-15703
ISBN 0-8109-0454-3

Library of Congress Catalogue Card Number: 75-15703
Text and reproductions of works of art only
Copyright © 1975 by Harry N. Abrams B.V., The Netherlands
All rights reserved. No part of the contents of this book may be
reproduced without the written permission of the publishers.
Reader's Digest Edition ©1976
The Reader's Digest Association, Inc.
Printed in The United States of America

READER'S DIGEST

Norman Rockwell's America

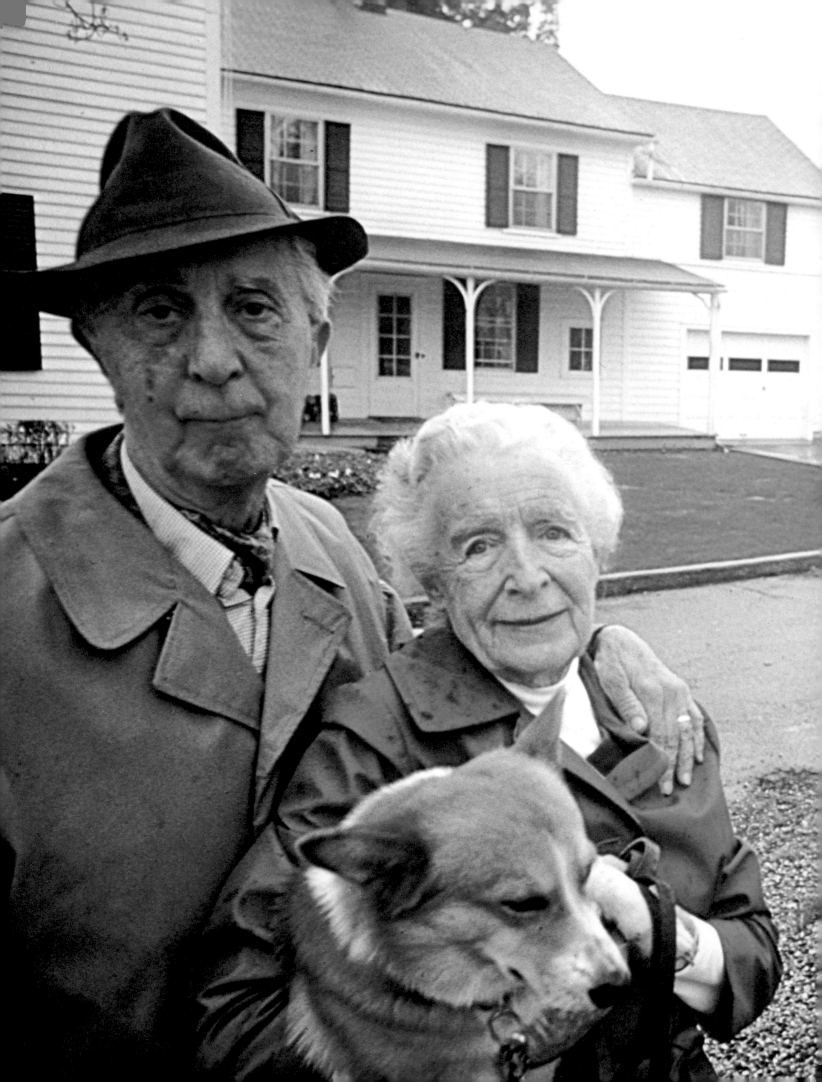

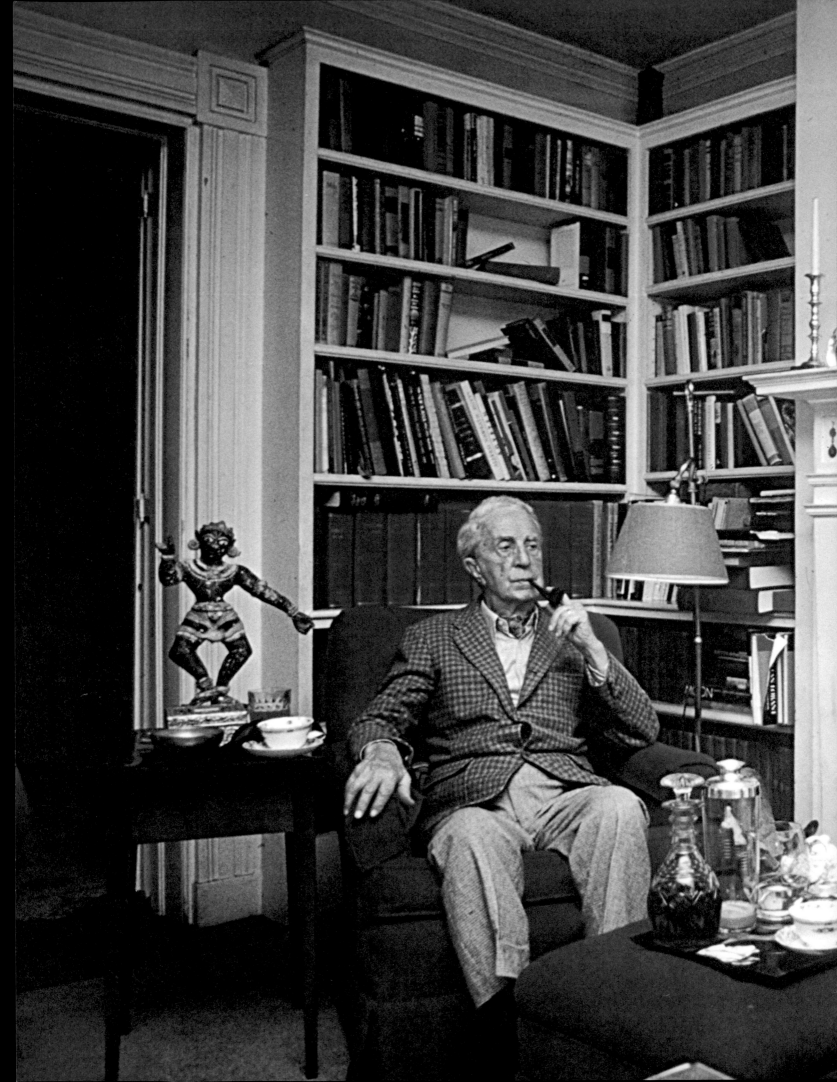

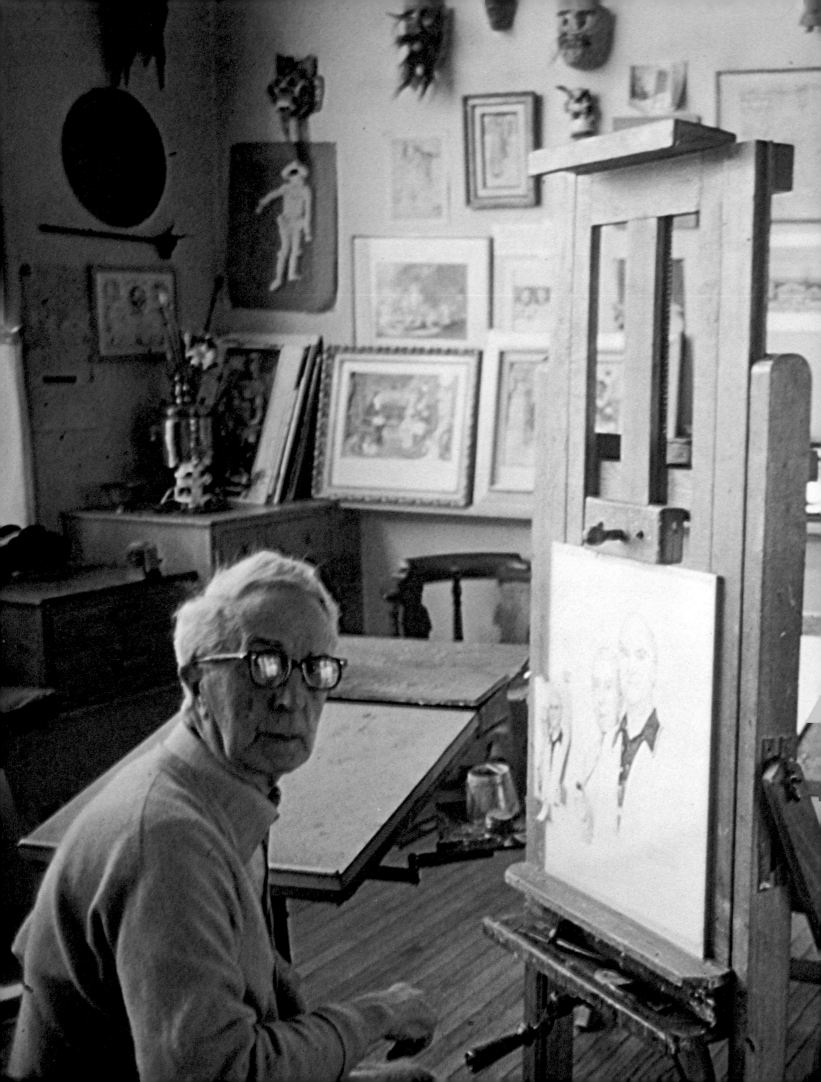

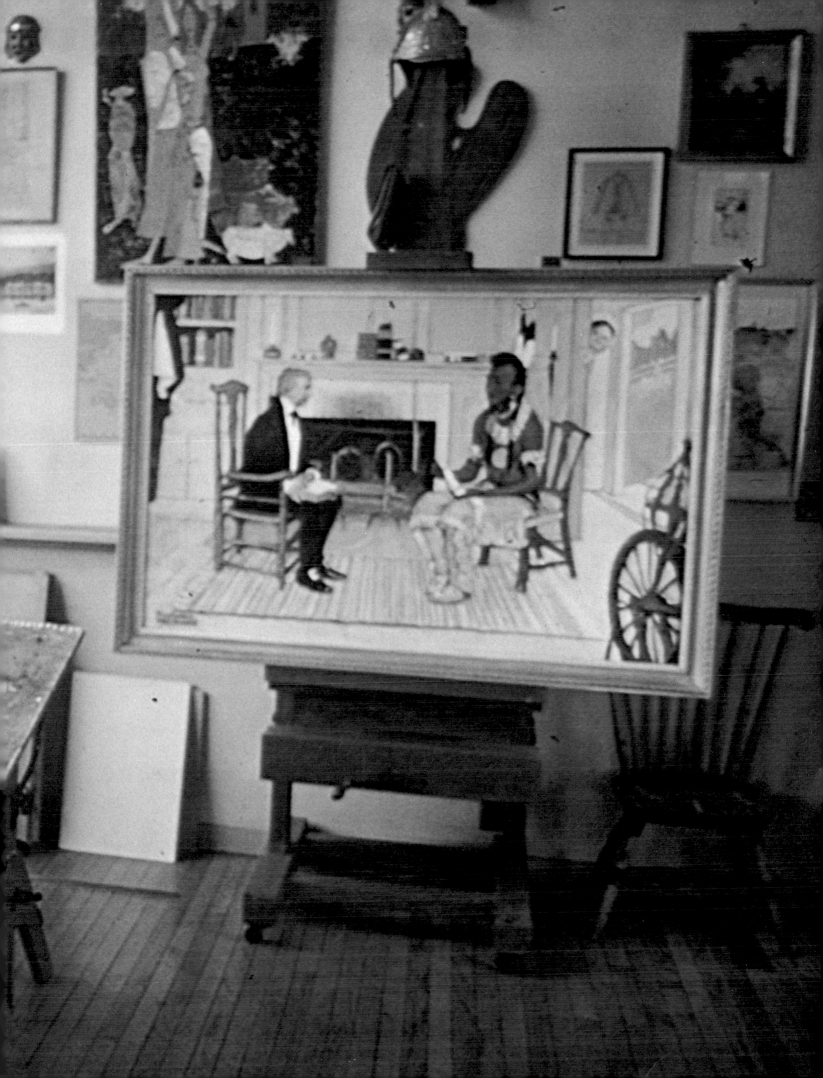

Contents

Introduction

Norman Rockwell

3. Rockwell's first *Post* cover, May 20, 1916

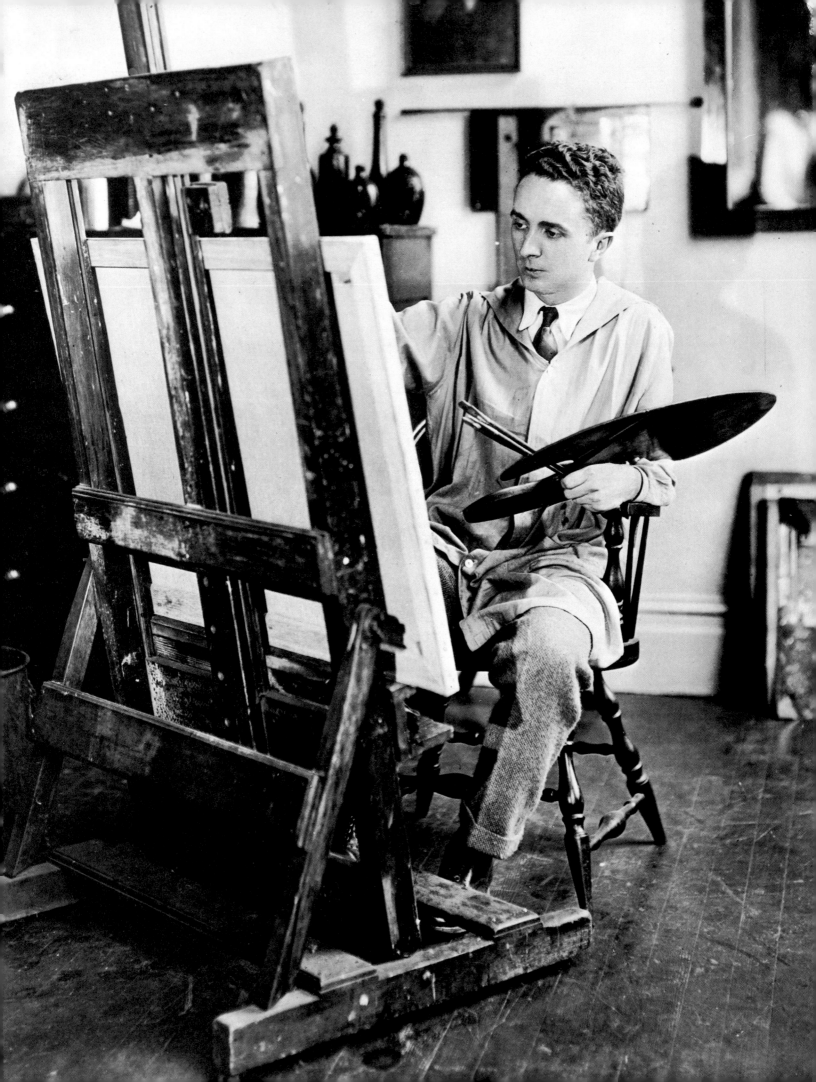

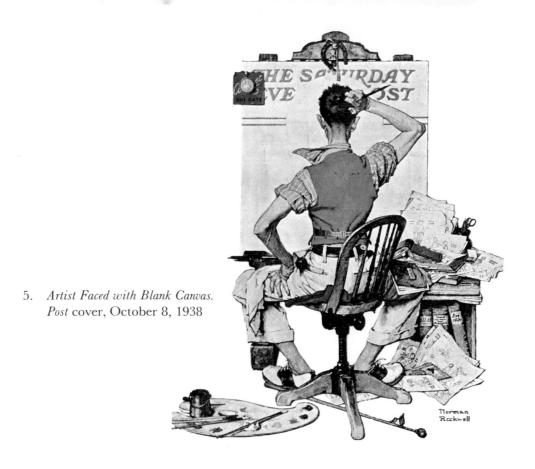

5. *Artist Faced with Blank Canvas.*
Post cover, October 8, 1938

If you ask a group of people who have been brought up on Norman Rockwell's *Saturday Evening Post* covers where they think he was born, you are likely to receive guesses that range from Missouri to Maine. It gives Rockwell considerable pleasure to inform anyone who asks that he was born in New York City—at 103rd Street and Amsterdam Avenue—and the way in which he pronounces "a hundred an' toid" would do justice to a Manhattan cabby. Of course, at the time of his birth—February 3, 1894—West 103rd Street was not quite the same kind of depressed neighborhood that it is today. Norman Percevel Rockwell's first home was a comfortable middle-class brownstone. His father—Jarvis Waring Rockwell—managed the New York office of a textile business, George Woods, Sons, and Company. Waring Rockwell seems to have been a somewhat aloof father and rather conscious of the fact that being a gentleman is not something to be taken lightly. He was given to reading Dickens aloud after dinner and to copying illustrations from the periodicals of the day. Norman's mother—Nancy Hill Rockwell—was one of twelve children sired by Thomas Hill, an English painter who emigrated to the United States shortly after the Civil War. Hill had entertained hopes of opening a portrait studio on this side of the Atlantic, but seems to have been thrown back upon the necessity of painting animals: pets, prizewinners, and the like. In Rockwell's words, Thomas Hill "painted in great detail—every hair on the dog was carefully drawn; the tiny highlights in the pig's eyes—great, watery human eyes—could be clearly seen." Nancy Hill Rockwell appears to have been a rather self-indulgent lady who chose to feel put upon, and she took great pride in her English ancestry, tracing her mother's family back to Sir Norman Percevel. As the eldest child, Norman was given the full blessing of these ancestral names. His only brother was named Jarvis.

◄ 4. Rockwell in his studio, 1934

17

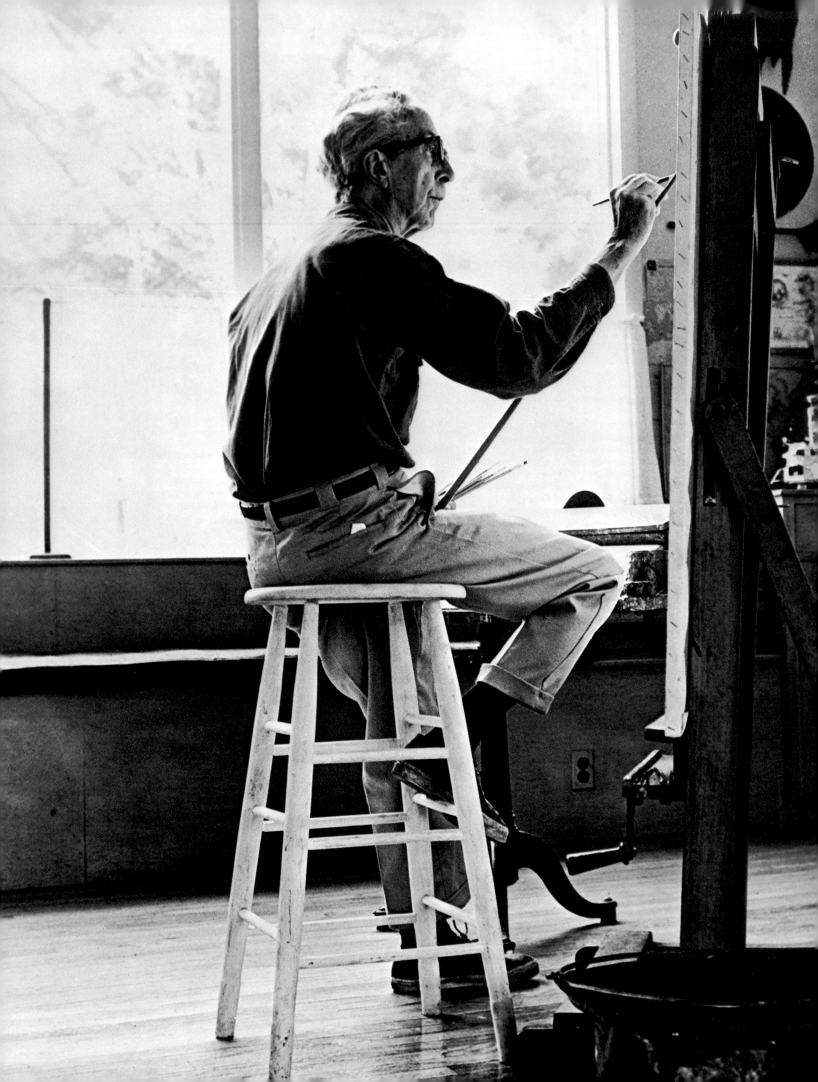

The Rockwell family was religious, in the full Victorian sense of that word. Norman became a choirboy at St. Luke's and later at the Cathedral of St. John the Divine. He also marched in the St. Luke's battalion on parade days. The neighborhood was at that time white and Anglo-Saxon, and Rockwell admits to having shared the prejudices of the period (which, he adds, amounted to little more than name-calling, learned parrot-fashion). Since Rockwell was unable to excel at sports or games—he was a physically slight child who began wearing corrective shoes at the age of ten and glasses at twelve—he entertained his contemporaries by making drawings. He confesses that he disliked the city as a boy and looked forward to summertime, which was spent in the country. It was these summer days that supplied him with the inspiration for much of his early work. When Rockwell was nine years old, the family moved just outside the city, to Mamaroneck in Westchester County. By the time he was in his early teens, Rockwell had decided that he wanted to be an artist, and at the age of fourteen he began taking lessons at the Chase School of Fine and Applied Art. During his sophomore year he dropped out of high school and enrolled as a full-time student at the National Academy School. In 1910 Rockwell transferred to the Art Students League, on 57th Street, which was then the most progressive of all New York art schools.

During this period Rockwell was still living with his parents, so his expenses were not excessive. He did, however, earn extra money at various temporary jobs. During his second year at the Art Students League he served as monitor for one class, which meant that he had no tuition to pay. One summer he bought a mail delivery route in Orienta Point, not far from the family home. Another summer he carried the paints of Ethel Barrymore, who was an enthusiastic amateur artist. During the school year he held various evening jobs. For a while he was a waiter at Child's restaurant on Columbus Circle (by coincidence, another famous *Post* contributor, F. Scott Fitzgerald, set a key scene of his short story "May Day" in that same restaurant). Later Rockwell even appeared—as an extra—on the stage of the Metropolitan Opera, where he encountered Enrico Caruso and other celebrities of the period. In 1912 Rockwell's family moved back to New York City. By that time Norman was receiving enough commissions to become a full-time illustrator. He had received his first commission (four Christmas cards) when he was sixteen and had illustrated his first book *(Tell Me Why Stories)* the following year. At the age of nineteen he became art director of *Boys' Life.*

Already he was prolific. His job with *Boys' Life* led to his producing, during 1913, one hundred illustrations for the *Boy Scouts Hike Book* and, during 1914, fifty-five more for the *Boys Camp Book* (his association with the Boy Scouts has continued down to the present day). He also made more than seventy illustrations for *Boys' Life* itself and was making frequent contributions to other youth-oriented publications such as *St. Nicholas,* the *Youth's Companion, Everyland,* and the *American Boy.* In 1912 Rockwell had rented his first studio in an attic on the Upper West Side. During the next couple of years he twice changed studios within the city; then in 1915, when his family moved to New Rochelle, he moved there too. On May 20, 1916, his first *Saturday Evening Post* cover appeared, and Norman Rockwell, then aged twenty-two, had established himself as a major-league illustrator.

◀ 6. Rockwell in his studio, 1970. Courtesy Louis Lamone, Lenox, Mass.

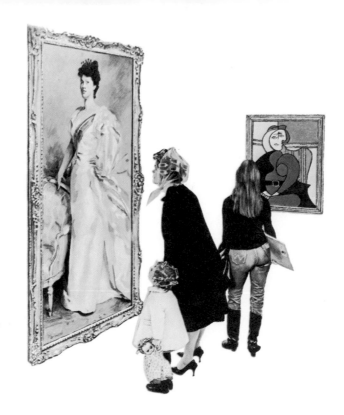

7. *Picasso vs Sargent.*
 Illustration for *Look,*
 January 11, 1966.
 © Cowles Communications, Inc.

8. Rockwell in his studio,
 1961. Courtesy Louis Lamone,
 Lenox, Mass.

9. *The Connoisseur.* ▶
 Original oil painting
 for *Post* cover,
 January 13, 1962

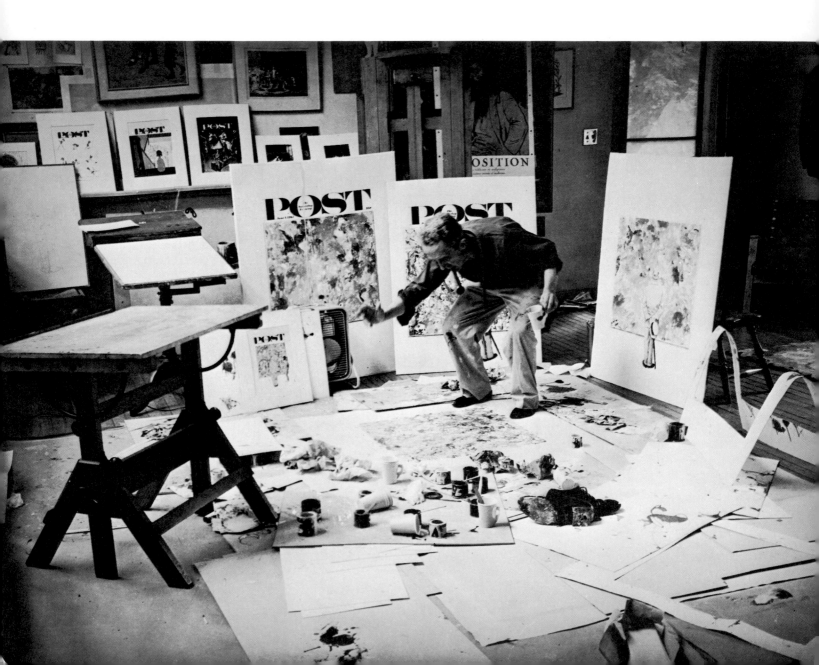

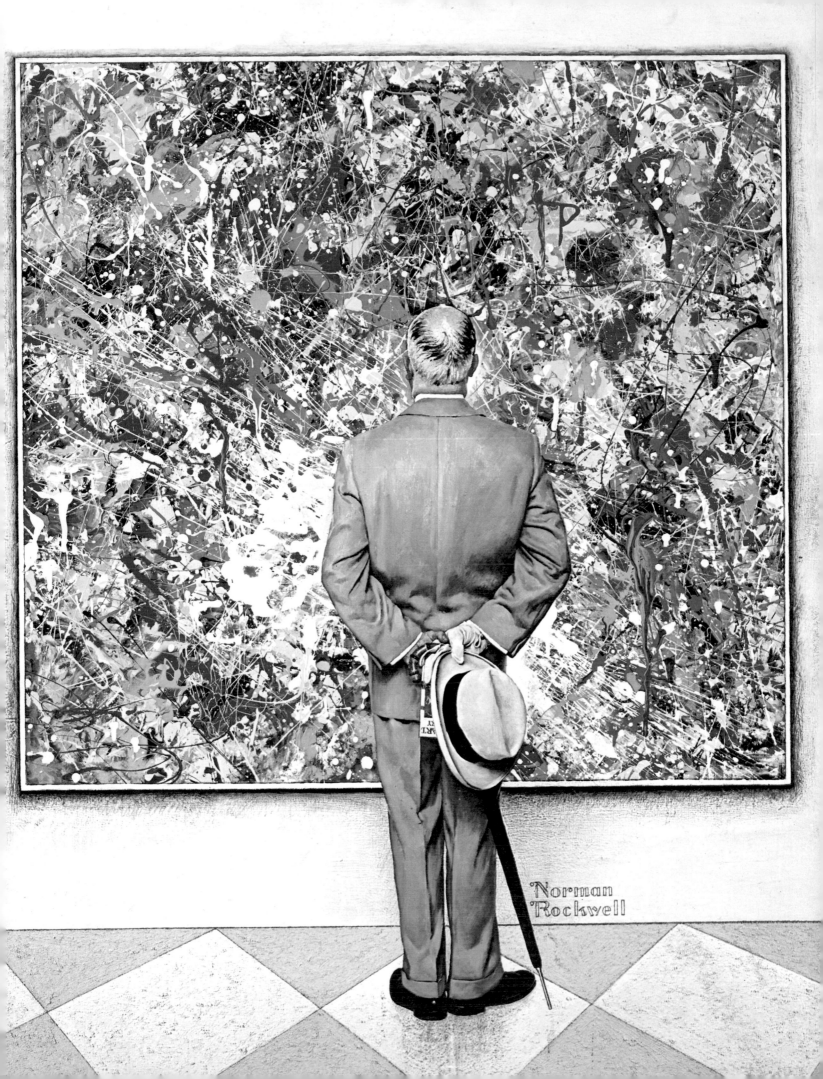

This leap to fame came at the instigation of Clyde Forsythe—a cartoonist who was sharing Rockwell's studio. He advised the young Rockwell to aim for the top if he wanted to get anywhere, and told him the type of material that the *Post* was most likely to accept. Armed with two finished proposals and a sketch, Rockwell headed for Philadelphia to hawk his wares. The then art editor of the *Post*, Walter H. Dower, took the paintings into his office, leaving Rockwell to wait nervously. When Dower reappeared, he informed the young illustrator that the magazine was buying both paintings, wanted him to finish the sketch, and that, following consultation with George Horace Latimer, the *Post*'s formidable editor, it had been decided that three more covers should be commissioned. Rockwell accepted a check and left the office in something of a daze. He sent a telegram to his friend Forsythe, then went to celebrate in Atlantic City.

Shortly after this he married Irene O'Connor.

A year after his first *Post* cover appeared, the United States declared war on Germany. Rockwell tried to join the Navy, but at his first attempt was turned down for being eight pounds underweight. He gorged himself on bananas, warm water, and doughnuts, made up the necessary poundage, and was soon shipped off to the Navy yard at Charleston, South Carolina, with the rank of third-class varnisher and painter. It was soon discovered that he was a *Post* contributor and he became something of a celebrity at the Navy yard. His attempts to have himself posted to Europe were frustrated, and throughout this period he continued to contribute to his regular clients, which, besides the *Post*, now included *Collier's, Life, Leslie's, Judge, Country Gentleman*, the *Literary Digest, People's Popular Monthly, Farm and Fireside*, and *Popular Science*. Two days a week he was working for *Afloat and Ashore* and was also painting advertisements for such products as Perfection oil heaters, Fisk bicycle tires, Overland automobiles, Jell-O, and Orange Crush.

Discharged from the Navy, Rockwell returned to New Rochelle and continued his career. Still in his mid-twenties, he was rich and famous, surrounded by other rich and famous artists of the day such as Clare Briggs, Charles Dana Gibson, Coles Phillips, and J. C. and F. X. Leyendecker. Prohibition arrived and, like any spirited young man of the day, Rockwell found himself a bootlegger and continued to party into the new decade. Many events mark this period. The artist built himself a $23,000 studio in early American style; he was invited to help select Miss America; he made the voyages to Europe that the Navy had denied him; he visited South America and North Africa; his wife divorced him.

While in Paris in 1923, Rockwell fell under the spell of modern art and even tried some ideas for *Post* covers which were heavily influenced by modern idioms. The *Post*'s editorial staff were horrified, and he soon returned to his own style. He has, however, retained a healthy respect for contemporary art—he greatly admires Picasso, for example—and, in fact, his *Post* covers of the twenties and thirties do reflect a concern with structural simplicity which, if not exactly modernistic, does at least relate to the spirit of the times. As the twenties progressed, Rockwell began to work for fewer magazines and to concentrate his efforts on his commissions for the *Post* and certain long-term advertising contracts, such as those he made with the Encylopaedia Britannica and with Edison

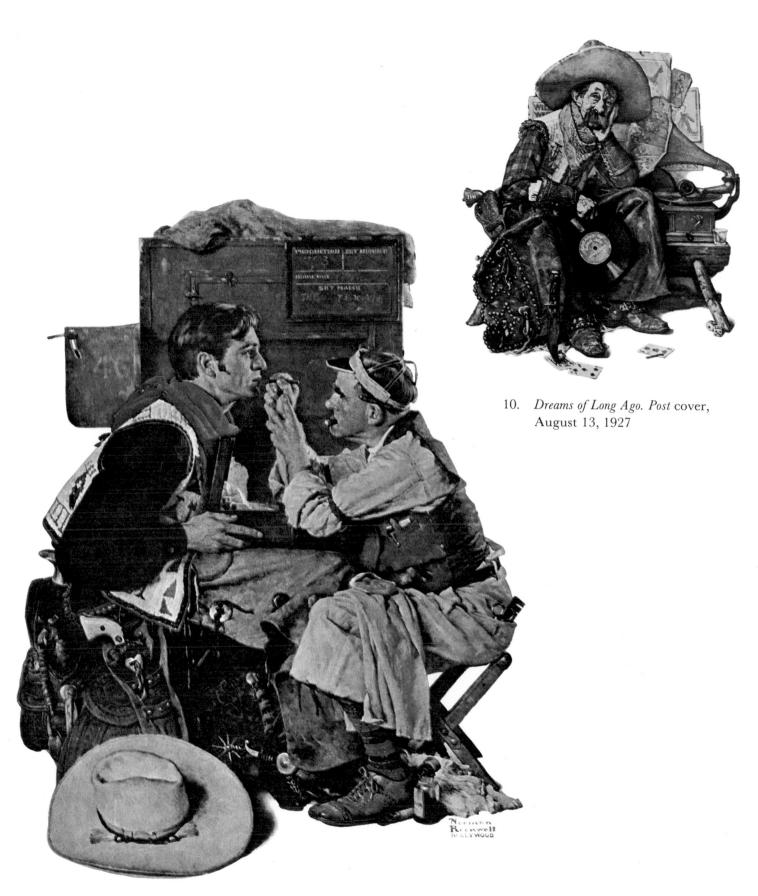

10. *Dreams of Long Ago. Post* cover,
August 13, 1927

11. *Gary Cooper as the Texan. Post* cover, May 24, 1930

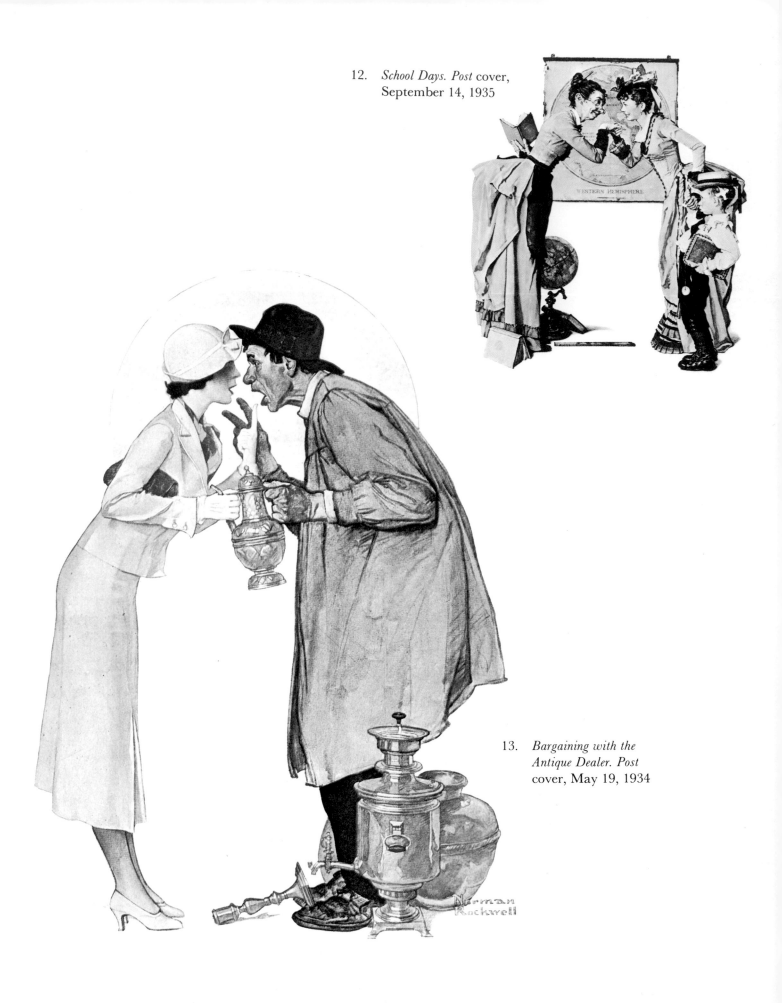

12. *School Days. Post* cover,
September 14, 1935

13. *Bargaining with the
Antique Dealer. Post*
cover, May 19, 1934

Mazda. This reduction of outlets was not by any means the result of his losing popularity. On the contrary, there had been a number of serious bids for his services, but Rockwell preferred to maintain his tried and trusted allegiances.

During Rockwell's earliest period with the *Post,* he had specialized in portraying young boys in various engaging situations. As the twenties progressed, he began to expand his range of subject matter—though boys and, to a lesser extent, girls were his bread-and-butter subjects. Sympathetic old folks began to occur with considerable frequency, and Rockwell's audience was treated to occasional glimpses of young love and family life. Generally, especially in the *Post* covers, Rockwell would isolate one or two figures—seldom more than three—against a schematic setting. The old cover format of the *Post* provided him with a strong abstract background to set his subject against while eliminating the necessity of showing deep space. It is almost as if the incidents that he illustrated at that time took place in shallow boxes. This same basic approach persisted well into the thirties, but not without both Rockwell the artist and Rockwell the man undergoing crises of some consequence.

As we have mentioned, Rockwell's first wife divorced him, and he spent a rather miserable period living in the Hotel des Artistes off Central Park West. In 1930 a difference of opinion with the art editor of *Good Housekeeping,* who was trying to persuade him to illustrate the life of Christ, led Rockwell to seek temporary refuge in Los Angeles. He was visiting his old friend Clyde Forsythe, but found time to produce a fair amount of work and—most importantly—met a young lady named Mary Barstow. Within three weeks he had married her. The marriage was to last until her death in 1959.

This satisfactory resolution of his personal situation did not, however, immediately spill over into his art, and the early thirties were sometimes a relatively lean period, creatively speaking. Having difficulties with his work back in New Rochelle, Rockwell—along with his new bride—made another trip to Paris. The year was 1932 and his output was sparse. The fallow period persisted until 1935, when he made his celebrated illustrations for *Tom Sawyer* and *Huckleberry Finn.*

Rockwell was by now a father. His first son, Jerry, was born in 1932 and his second, Tommy, in 1933. Peter followed in 1936. His *Post* covers began to reflect a new kind of firsthand interest in family life. During the second half of the thirties, his work began to become a little less studied and rather more naturalistic. This may be due partly to the fact that for the first time he was making use of the camera as an aid. Previously he had always worked from live models (and he still continued to use them in suitable circumstances), but photographic studies enabled him to show people in poses that they would not be able to hold for any length of time. This method of working enabled him to introduce a new and casual note to his illustrations. The earlier figures—those painted exclusively from the live model—had tended to be very solid, almost sculptural, and he had exploited this fact to the full, often making an arm or a leg seem to jump forward from the picture plane. The figures painted from photographs were perhaps less solid-looking, but they were also less posed, more natural.

Toward the end of the decade Rockwell moved his base of operations to Arlington, Vermont—which was also the home of two other *Post* cover artists, John Atherton and

Mead Schaeffer. The family established itself comfortably in Bennington County. Then in 1943 disaster struck: Rockwell's studio was destroyed by fire. The artist did not allow this tragedy to break his creative stride (he even illustrated it for the *Post*), but its significance should not be underplayed. Rockwell lost not only many of his paintings and records but also all of the props that he had gathered around him throughout the course of his career. It may be a strange observation to make, but it is just possible that—despite the enormous loss—the fire may have had some beneficial effect on Rockwell's work. The fact that he had lost so many of his props meant that he could not fall back so easily upon many of his old themes—especially the period pieces which had been a staple item during the previous decades. This may have helped to deflect Rockwell's attention toward the everyday environment which has dominated the latter part of his career. Of course, there were many other factors involved in this change of emphasis. We have already mentioned the impact of photography upon his work. Another factor was the changed cover format which the *Post* adopted in the early forties—a format that encouraged a more naturalistic approach and placed a priority upon establishing a

14. *Cousin Reginald
Under the Mistletoe.
Country Gentleman* cover,
December 22, 1917

15. *The Flirts.*
Original oil painting
for *Post* cover,
July 26, 1941.
The Harry N. Abrams Family
Collection, New York

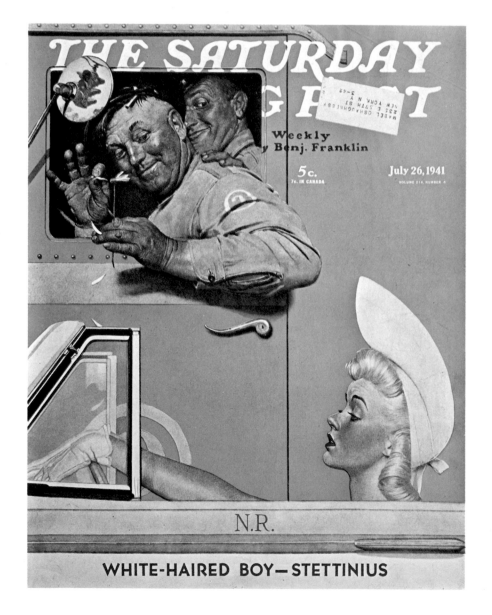

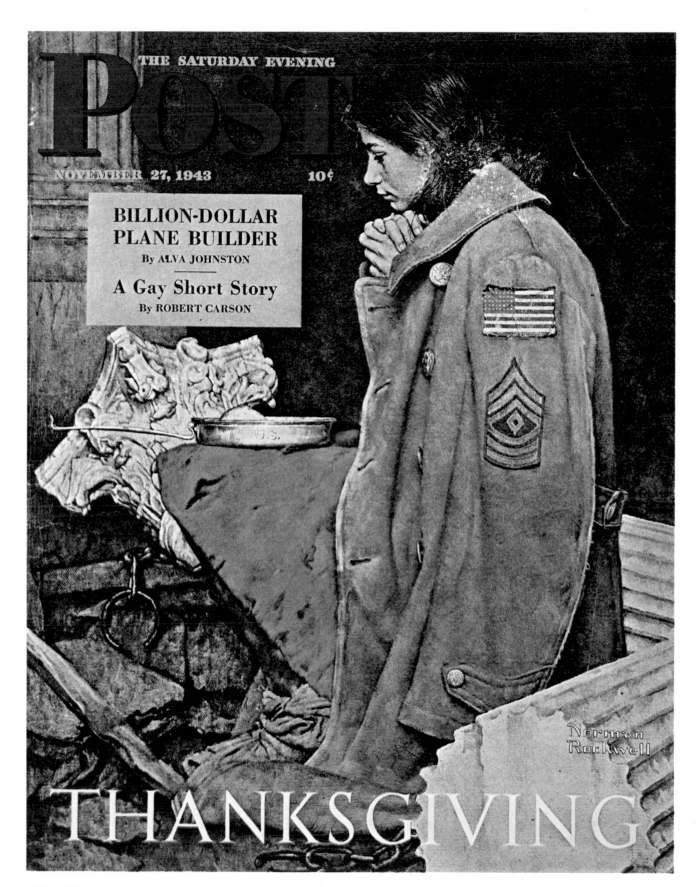

16. *Thanksgiving. Post* cover, November 27, 1943

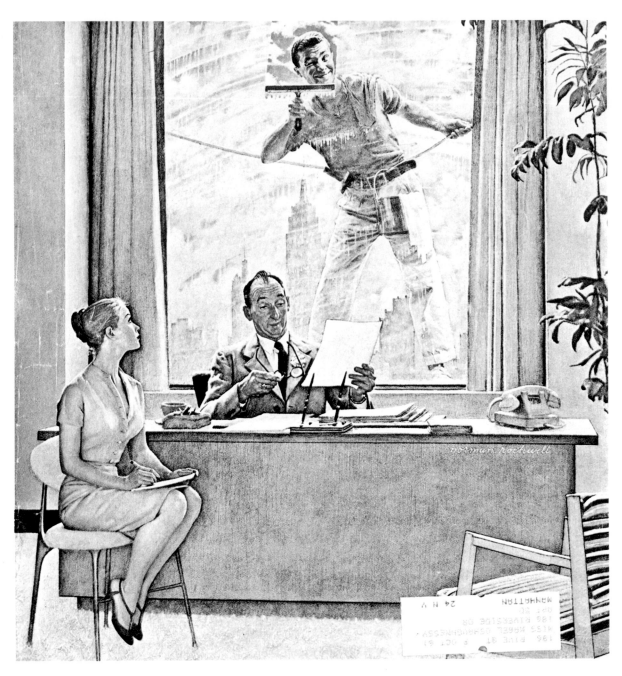

17. *The Window Washer. Post* cover, September 17, 1960

18. *Triple Self-Portrait.* Original oil painting ▶
for *Post* cover, February 13, 1960.
Collection Norman Rockwell

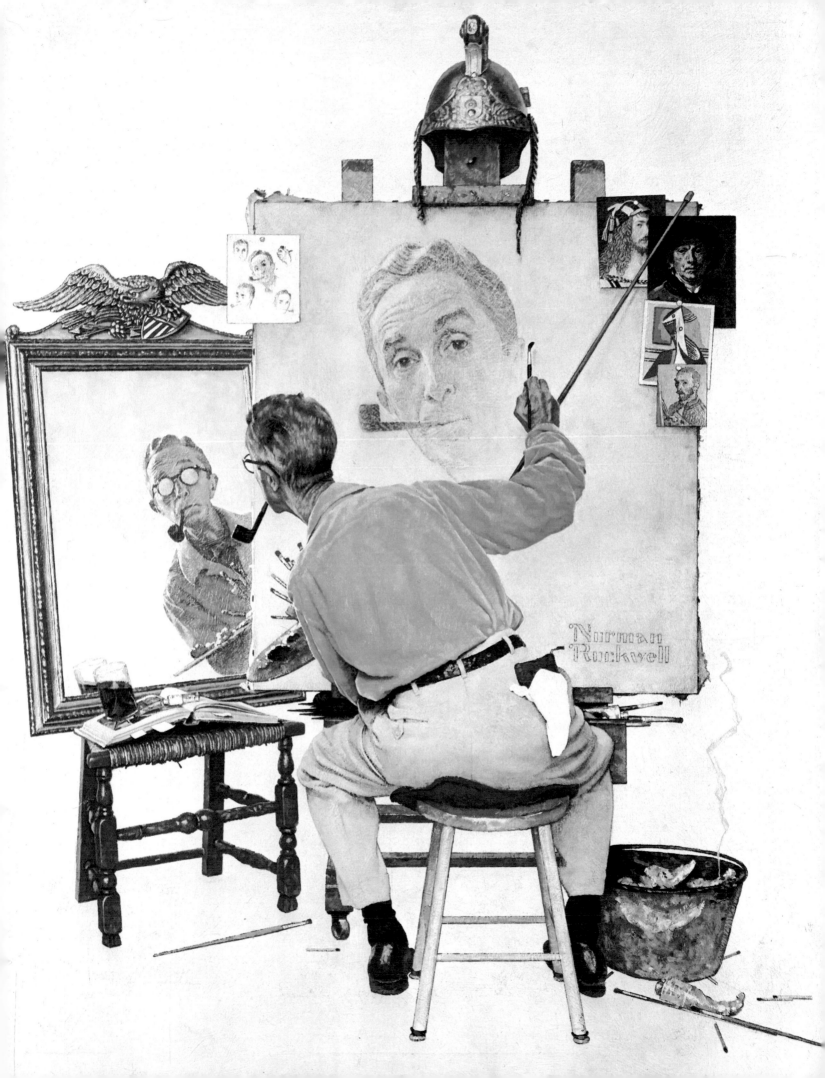

detailed setting for whatever incident was portrayed. A third factor was World War II.

Rockwell's best-known production of the war period was the *Four Freedoms* suite, but in its total seriousness it was not the most typical. Rockwell's most characteristic response to the war was his involvement with the plight of the little guy—the clerk or garage mechanic—caught up in the turmoil of the times. Most of Rockwell's wartime work is filled, surprisingly perhaps, with warmth and humor. He invented Willie Gillis, possibly the most sympathetic of all fictional GIs. He painted soldiers, sailors, flyers, and marines, but with few exceptions, he showed them in informal, off-duty situations. Always he was trying to relate them to their everyday, peacetime environment. This meant, of course, that he had to paint that environment, and the war period saw the opening of the era in which a detailed setting became the norm in Rockwell's work. He also painted civilians and their responses to the war. This was, creatively, an extremely fertile period; it marked the birth of Rockwell's mature idiom.

19. *The Gossips. Post* cover, March 6, 1948

20. *The Baker. Post* cover, January 3, 1953

21. *Lion and His Keeper. Post* cover, January 9, 1954

22. *The Examination. Post* cover, May 19, 1956

During the war years Rockwell did a number of documentary studies—documentary in the sense that they were accurate records of specific situations. The burning of his studio was one of the first of these, and he also recorded a trip on a troop train, a visit to the White House, and the meeting of a ration board. Soon after the war he made documentary records of a country school, a country newspaper, a country doctor, and the activities of an agricultural agent. He has continued to make studies of this kind since, but what I find most interesting is the possibility that these earlier documentaries may have had an important effect upon the evolution of his mature style. These studies, commissioned by the *Post,* encouraged him to focus upon specific situations, and the hallmark of his later work has been specificity. Even when he is working with an imaginary situation, he treats it as though it were a documentary. This is, I believe, the strength of his later work.

The period from the mid-forties until the late fifties was perhaps Rockwell's time of greatest achievement. His themes had not changed too greatly from the thirties, but they were presented in a fresh and rewarding way. We might say that during these fifteen years or so he realized everything that had hitherto been latent in his work. In his best paintings of this period—paintings such as *Breaking Home Ties, Shuffleton's Barber Shop,* and *Marriage License*—he transcended the category of illustration and produced canvases that can stand out in any company. In 1953 Rockwell moved from Arlington to Stockbridge, Massachusetts, where he still lives. In 1959 Mary Rockwell died and in 1963 Norman Rockwell parted company with the *Post* after forty-seven years. It was the end of an era, but it was also the beginning of a new one.

In 1961 Molly Punderson became Rockwell's third wife. As the decade progressed, he began to work for *Look, McCall's,* and even *Ramparts* (for whom he painted Bertrand Russell). The character of his work changed again—not so much in terms of idiom this time as in terms of subject matter. The climate of the times demanded a new approach and Rockwell turned his attention to such diverse matters as racial integration, the Peace Corps, and the space program. He traveled in the Soviet Union, Tibet, Mongolia, and Ethiopia—drawing and painting all the while.

At the time of this writing, Norman Rockwell has been a professional artist and illustrator for sixty years.

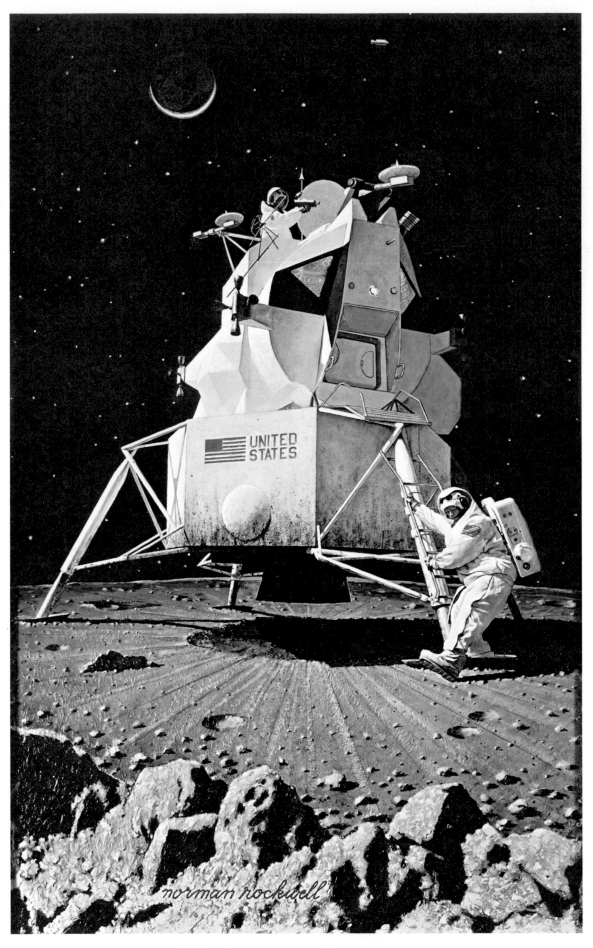

23. *Astronauts on the Moon.* Original oil painting for *Look* illustration, January 10, 1967.
© Cowles Communications, Inc. National Air and Space Museum, Smithsonian
Institution, Washington, D.C.

The Setting

24. *The Blacksmith's Shop.* Illustration for *Post,* November 2, 1940

THE SATURDAY EVENING
POST
NOVEMBER 16, 1946 10¢

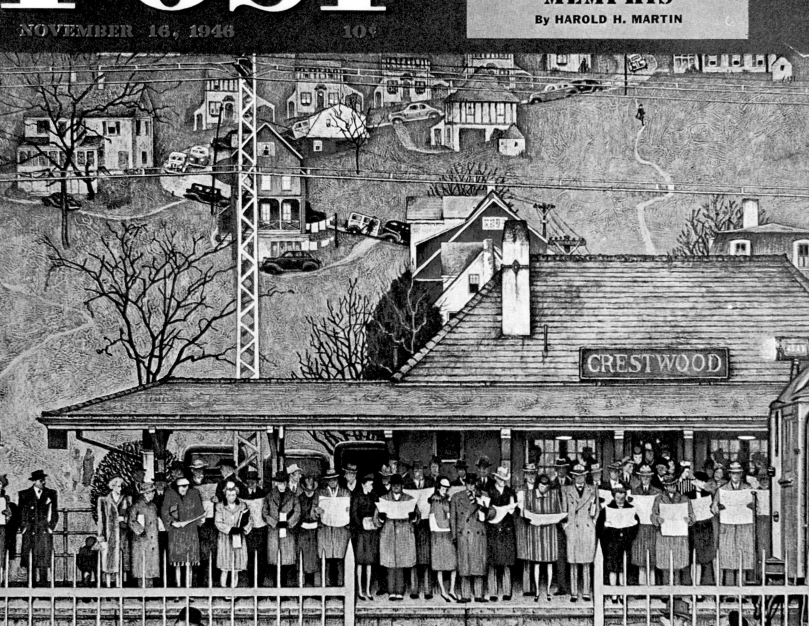

Norman Rockwell is a brilliant storyteller within a particular American tradition. What makes his work so effective is that he appears to have shared with millions of other Americans a particular set of assumptions about life in the United States; and he has blended his skills as an illustrator with a wealth of careful observation to bring the consequences of these assumptions to life. The fact that Rockwell has habitually worked for large-circulation magazines has helped to sustain the authenticity of his position within the tradition. While the ideas for his *Post* covers originated with Rockwell himself, they were never executed without the prior approval of the magazine's editorial staff—a staff which, very understandably, was concerned with its circulation figures and thus with the tastes of its readers.

When Rockwell began his career, an artist had only to present the figure or figures central to any incident that might be portrayed, while the setting itself could be taken for granted. Rockwell has, however, outlived this situation, and it has led to changes in his art which give it a special interest. In his later work—since the early forties—he has gone beyond the simple presentation of incident to the more complex portrayal of incident within a very specific environment. There are some purely practical factors to be taken into account in any consideration of this shift. Starting with the issue dated June 27, 1942, the *Post* changed the layout formula of its cover, giving Rockwell a good deal more flexibility. Also important is the fact that Ken Stuart, who was appointed art editor in 1944, decided that the cover should present, week by week, a cumulative and almost documentary portrait of the changing face of the nation.

What we find in Rockwell's later work is a shift toward naturalism without any abandonment of his old values. Occasionally this made for a clash of interests which led to unresolved work. At his best, however, Rockwell has been able to resolve these elements into a new and unique synthesis, blending the values of America's recent past with the realities of a present that could no longer be ignored. Since millions of Ameri-

25. *Commuters. Post* cover, November 16, 1946

cans were presented with the problem of making a similar adjustment in their own lives, they were immediately able to identify with this changed mood in Rockwell's art.

Rockwell's new interests led him to the detailed documentation of interiors and architectural settings, and this brought with it its own dividend. Rockwell's later covers and illustrations give us an accurate record of this highly particularized environment. Often the paint on the walls is no longer fresh and there is garbage in the streets (Rockwell's portrait of America is seldom as flattering as many people seem to think it is); Rockwell's later work is packed with unadulterated, carefully observed information.

Looking at Rockwell's *Post* covers of the forties, fifties, and sixties one becomes involved not only with the incident portrayed but also with the American mythology that is encoded in its setting.

In 1946 Rockwell painted for the cover of the *Post* a suburban train station during the rush hour (Fig. 25). In this work we are given an unusually expansive glimpse of the kind of setting he favors. We see across the station roof to a hillside punctuated by winter trees and modest homes. Power lines, a pylon, and telephone wires cut across this scene (at this date rooftops are still innocent of television aerials). Automobiles clutter the narrow roads that wind toward the station. We see all or parts of a dozen homes. Some of these are pleasant, wood-frame structures with high gables and porches for summer evenings; then there is a quaint coach house, but we are also shown a row of dreary buildings, each the same as the next, which the developer has ineffectually embellished with a half-timbered appearance. This is not a noble landscape but it is a friendly one. Any of these homes could accommodate the events that Rockwell delights in portraying. They are homes where people are not unfamiliar with baby-sitting problems, where teen-agers take dates and high-school proms very seriously. If we could walk among these homes we would probably find Red Cross stickers in the windows and basketball hoops above garage doors. If we could enter the living rooms we would not be surprised to find a Sears catalogue beside the radio. We feel immediately that we know the kind of people who live here.

In the foreground—crowding onto a platform (a train is pulling into the station) or hurrying to reach it—are the commuters. These commuters are the stuff of Rockwell's art, but here they are shown in what is, for him, an unusual light. Generally he isolates them from their daily routine and awards them the honor of some subdued but highly personalized dramatic situation. In this instance, however, the routine is accepted and they are reduced to anonymity. Faces are undifferentiated; clothes become uniforms; everybody seems to be either reading or at least holding a newspaper. Two elements in the entire composition relieve the anonymity. First, there is a boy selling newspapers at the station entrance. Certainly he is busy, but he is nonetheless static—not part of the anonymous rush—and he has a clear personality of his own. Secondly, there is the distant tiny figure strolling casually down a footpath toward the station. That figure is too far away to allow for any detailed characterization, but such detail is not necessary since the figure's isolated position suffices to give it a distinctive note.

These two figures are typical Rockwell touches, but it would have been more typical still if he had concentrated on one or the other of them (had he done so, of

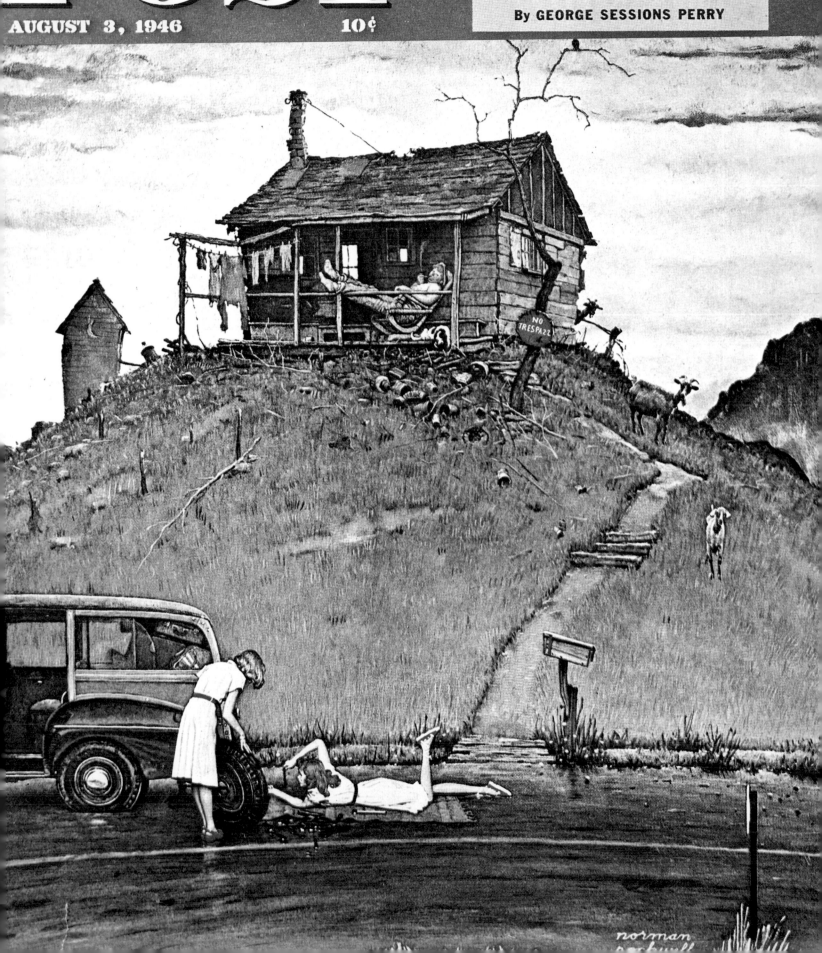

THE SATURDAY EVENING

POST

AUGUST 3, 1946 10¢

27. *The New Television Set.*
Post cover, November 5, 1949

course, we would not have the panoramic view which makes this particular composition so interesting).

Most often, as in the example just discussed, Rockwell focuses on suburban and small-town situations—but this is very far from being an exclusive rule. He will sometimes make use of other settings, from the rural to the urban. The picture of country life given by Rockwell in his earlier work is often rather conventional, tending toward the idyllic. In his later work this tendency is considerably modified, as may be judged by another 1946 *Post* cover. In this composition (Fig. 26) the central incident concerns two young ladies vacationing in a "woody" station wagon. These young ladies (we may guess from their crisp, white summer frocks that they have small-town or suburban backgrounds) have had a flat tire in mountain country, right beneath the ramshackle cabin of an unenergetic hillbilly.

The incident itself is typical enough and completely self-explanatory, but Rockwell's treatment of it merits close study. This is by no means an idyllic vision of rural America (if there is a capsule of idealization here, it is reserved for the two girls, who are shown to be pretty, neat, and practical). The cabin is patched and decrepit—barely weathertight. It is surrounded by trash and debris; its outhouse seems ready to collapse as does the mailbox at the foot of the pathway. One can easily form the impression that the occupant of the cabin lives on fairly intimate terms with his goats. The atmosphere created is as much ominous as humorous; this feeling is sustained by the tree to which the "no trespass" sign has been fixed—a tree quite desolate and devoid of leaves although

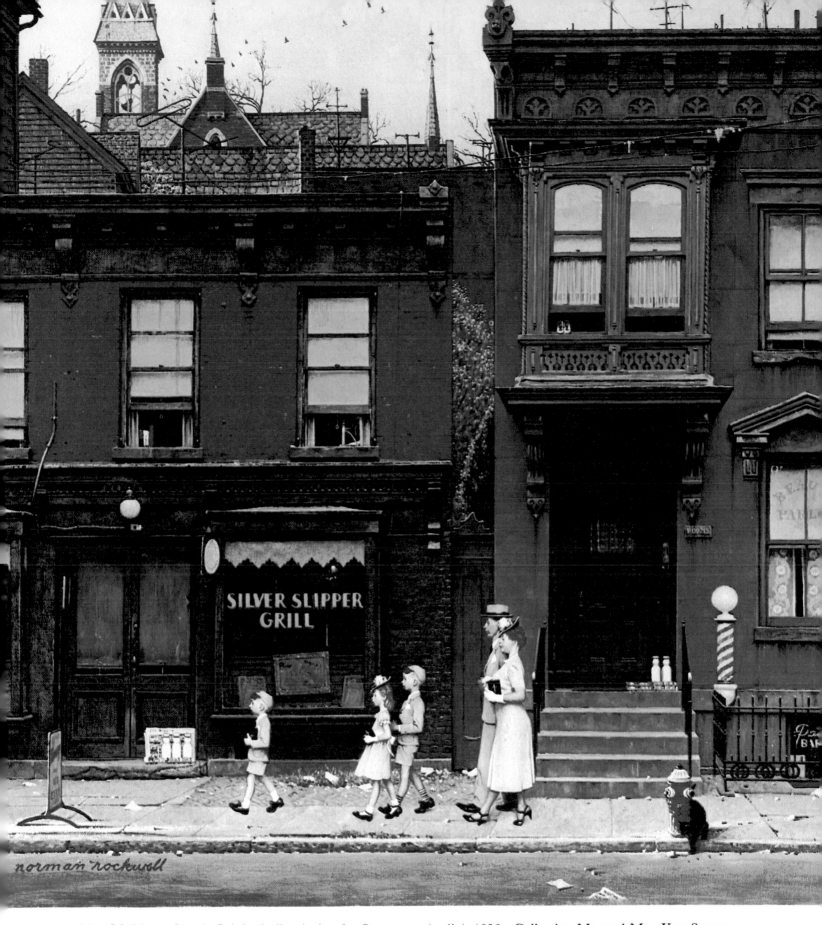

28. *Walking to Church*. Original oil painting for *Post* cover, April 4, 1953. Collection Mr. and Mrs. Ken Stuart

the girls' and the rustic's clothes, as well as the flowers beside the highway, tell us that this is a summer incident. The sky, too, is threatening.

If Rockwell's view of rural America does not always conform to the strict tenets of the American dream, neither does his view of urban America. Take, for example, a 1949 *Post* cover (Fig. 32). Here a truculent bulldog has brought a truck to a halt in a narrow alleyway between two tenement buildings. This subject is picturesque but hardly idealized. The couple on the porch at the right of the picture are worth noting. The woman in the apron is brought close to hysterics by the absurdity of this new problem. The man, on the other hand, seems to welcome the incident as a relief from boredom. By way of contrast with these two, the younger people in the street seem much more detached from their surroundings. The cyclist, the boy headed for his music lesson, the little girl by the truck—for them this incident with the dog obeys all the rules of American folklore, and they appreciate it to the full.

Another unidealized slice of American life is to be found in a November, 1949, cover (Fig. 27). The subject is topical for the date. A television set is being installed in the garret apartment of an elderly man. We can see from his reaction that it will bring a new dimension to his life (we can almost guess his taste in entertainment). Television represents a new kind of hope for him; the fact that he lives in this unglamorous attic will not be able to detract from that. The roofscape gives us another unretouched glimpse of small-town America (we know it is a small town because the outline of nearby hills can be glimpsed in the background). The setting is clearly established.

One of Rockwell's most detailed portraits of the American small town is to be found in the 1953 painting *Walking to Church* (Fig. 28). Rockwell has said that the figures in this painting are a little weak because they are too caricatured; no such fault can be found with the background he has given them. The gloomy classical echoes of the terrace facades fail to conceal the mysteries of the lives that are acted out behind them. It would not be difficult to reconstruct the menu of the Silver Slipper Grill; we can easily picture the men who rent rooms in the shabby brownstone and imagine the conversations that take place on other days in the beauty parlor and the barber shop. The buildings have become saturated with the lives of the men and women who live and work in them; the architecture expresses a way of life and, as usual, Rockwell has not attempted to falsify it. There is garbage in the street, but there are signs of spring in a back yard, glimpsed between buildings; the two colors of brick on the church steeple indicate that it has been recently repaired. The family walking to church seems a lonely little group. Other people are still in bed. Milk bottles and the Sunday papers wait on doorsteps.

Architectural exteriors of this kind are comparatively rare in Rockwell's work; what we encounter with much greater frequency are detailed renditions of interiors. These again are packed with information. Rockwell is not the kind of artist to gloss over details in order to achieve some slick effect. In his later work he attempts to give as literal a representation of his subject matter as possible.

A 1949 *Post* cover (Fig. 30) shows a teen-age girl in her bedroom. She wears dungarees, bobby socks, and what might be her brother's shirt; but she has just

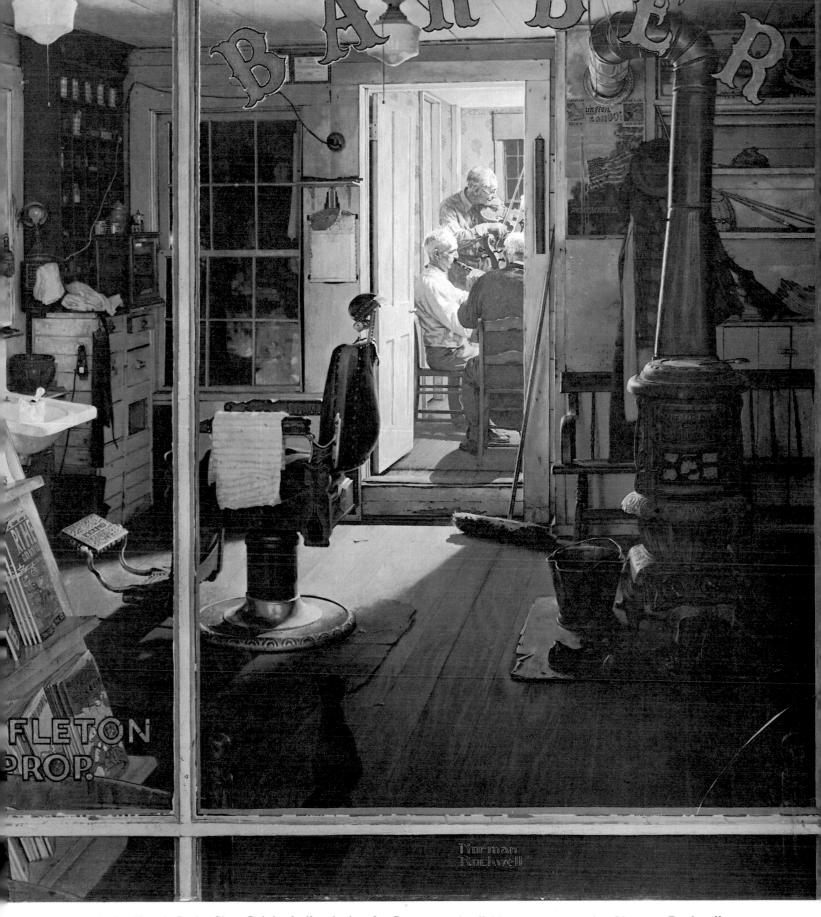

29. *Shuffleton's Barber Shop*. Original oil painting for *Post* cover, April 29, 1950. Collection Norman Rockwell

unwrapped a full-length gown—bought perhaps for the junior prom or some sorority formal—which she holds in front of her as she stands at her mirror. Not wanting to fake the interior, Rockwell used the actual bedroom of the girl who served as his model. Everything is just as he found it—the clothes in the closet, the skates hanging from the door. We might ask—if an accurate portrayal of what already exists is all that is required—why the artist did not just take a photograph and be done with it. I think the answer is that it is the painstaking reconstruction of reality that gives the image its special quality. The very fact that this reconstruction has taken place makes for little touches which are barely perceptible but which add up to a quality of warmth that a photograph could not be expected to achieve. A photographer working with an interior such as this would probably have been forced to use supplementary lighting in order to produce a satisfactory image. Rockwell, relying upon his own hand and eye, could bypass this problem and attempt to reconstruct the quality of light within the room (and the quality of light is an item of information as important as any other).

One of Rockwell's finest interiors—and one in which the quality of light played a key role—is *Shuffleton's Barber Shop* (Fig. 29), painted for the *Post* in 1950. It is nighttime. Three elderly men are playing music in the back room of an old barber shop. We glimpse the scene through a street window (one pane of glass is cracked). Many photographs were taken to assist Rockwell in the realization of this composition, but the finished work has a quality which transcends these aids. *Shuffleton's Barber Shop* has a particular fidelity to its subject matter which could be achieved only in a painting.

This work—impressive by any standards—gives us a detailed account of one small corner of an American arcadia. It is not the hygienic arcadia of television commercials, but a handmade environment; it seems to have been secreted, slowly, by time; it is a perfect fusion of myth and reality. All the information is there: the hunting rifle and fishing rods on the shelves behind the potbellied stove; the frayed cork matting around the barber's chair with its wrought-iron footrest; the shaving bowl in the washbasin; the soft-wood cabinets with their single coat of cream paint; the posters and the comic books; the broom, the facecloths, and the razor strop; the extension cord hung across warped chipboard paneling. The quality of the light as it filters out into the shop is handled with extreme delicacy. Reflected on the porcelain of the washbasin, it becomes warm and creamy although at its source it is white and almost harsh. The blurred reflection in the rear window turns the room in on itself, cutting it off from the outer world.

There is often a touch of sadness to Rockwell's interiors. His may be an America of eternal optimism, but it is certainly not an America of universal fulfillment. In a 1950 cover for the *Post* (Fig. 31) he shows a sales representative in his rented room sitting up in bed playing solitaire on his suitcase. He is the personification of boredom. The sample cases that have eased him through the day in this strange town are stacked at the foot of the bed—useless till the morning. The room itself is not prepossessing. The wallpaper is peeling, and paintings, little more than sorry reminders of another era, hang on the walls. The rep's pinstripe suit and his gaily colored necktie are draped over the back of a chair. His hat hangs from a peg on the door, partially obscuring the framed copy of the

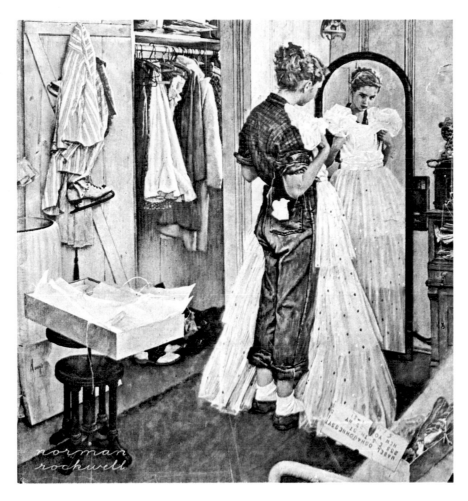

30. *The Prom Dress. Post* cover,
March 19, 1949

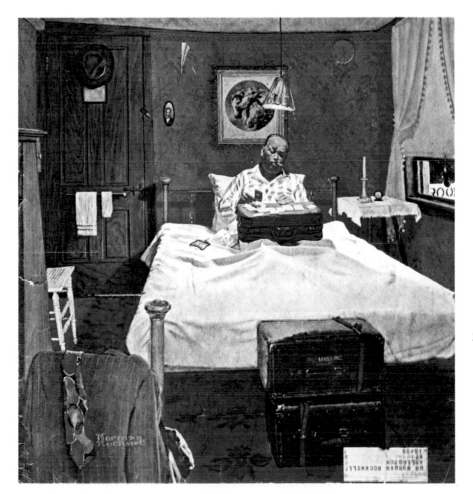

31. *Solitaire. Post* cover,
August 19, 1950

house regulations. The door itself provides Rockwell with another way of indicating that he is dealing with a small-town environment. The locking devices shown are scarcely burglar-proof; this is no big-city hotel. The entire scene is illuminated by a single lamp above the bed (its shade almost inevitably askew).

So much of the mythology that Rockwell offers is keyed to home life—or, at the very least, to the social structure of the neighborhood or home town—that he has only to remove his characters from their familiar context to introduce an element of pathos. Not that his characters willingly submit to this pathos. *Saying Grace* (Fig. 33) was the most popular of all Rockwell's *Post* covers. Painted for the 1951 Thanksgiving issue, it shows an old lady and her grandson saying grace over their trays of food in the cafeteria of a railway station, watched by a porter and other travelers. It is the adherence of this couple to the standards of home life in an alien environment that serves as his vehicle for emotion, and this relies entirely upon the authenticity that Rockwell brings to his portrayal of the environment.

The floor of the cafeteria is strewn with cigarette butts (a surprisingly common motif in Rockwell's work); more cigarettes and a cigar have been stubbed out on a saucer in the foreground. A cup of coffee nearby looks cold and abandoned. The entire scene is illuminated by a bleak natural light that has been filtered by clouds, rain, and smoke. We could go on listing the details which add up to authenticity, but there is little point since they are so self-evident. One interesting technical device might be noted in passing. Of the nine people whose presence can be distinguished in this composition, all but the four at the central table have been cut off by the edges of the canvas. This contributes substantially to the impression that this is a scene we have just chanced

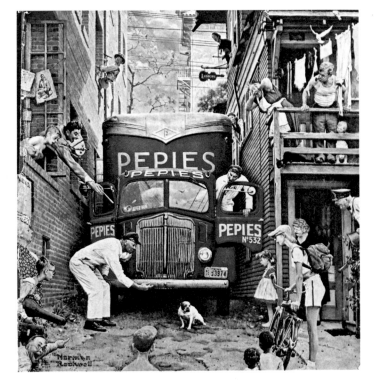

32. *Traffic Conditions.*
 Post cover, July 9, 1949

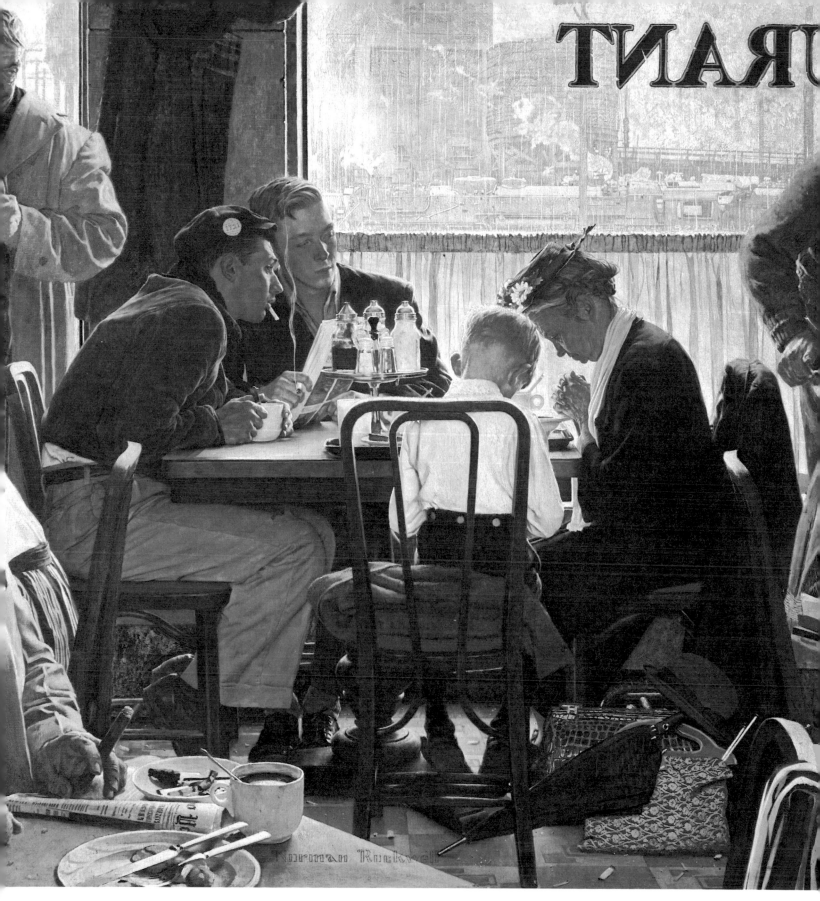

33. *Saying Grace.* Original oil painting for *Post* cover, November 24, 1951. Collection Mr. and Mrs. Ken Stuart

upon. It is a device borrowed from photography, but one that photographers are seldom able to employ so effectively.

Throughout the entire range of Rockwell's work we are given little glimpses of the American scene. He seldom concentrates his whole attention on it, but it is always there and he tells us a great deal about it. Just as importantly, it tells us a great deal about him. Whenever these specific environments are brought into play, we are confronted with the phenomenon of myth merging into common-sense realism and common-sense realism fusing with myth. This, I believe, is the quality which gives Norman Rockwell his special character as an illustrator.

Growing Up in America

34. Advertisement for Massachusetts Mutual Life Insurance Company, Springfield

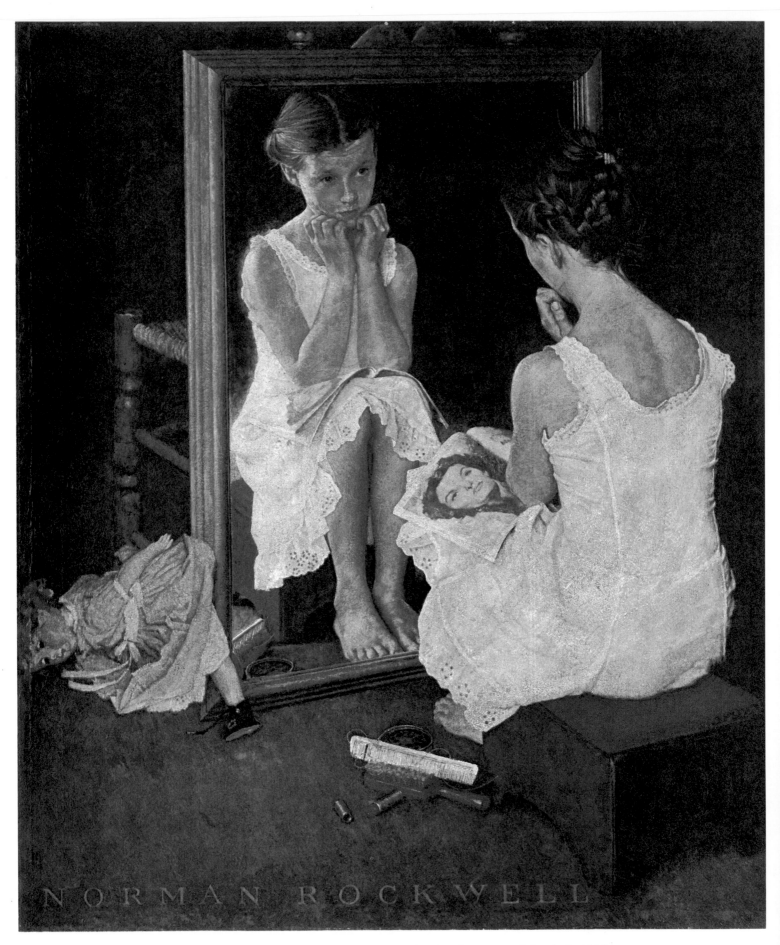

35. *Girl at the Mirror*. Original oil painting for *Post* cover, March 6, 1954

36. *Marble Champion. Post* cover,
September 2, 1939

37. *The Hot Rod. Post* cover,
January 9, 1926

In 1954, Norman Rockwell painted a girl at a mirror (Fig. 35). Seated, in her slip, on a low stool—her doll thrown aside—she has carefully combed and pinned her hair, and even tentatively applied a little color to her lips. The inspiration for her experiment—a photograph of some glamorous woman, a movie star perhaps—can be seen in the periodical that is open on her knees.

In this painting Rockwell comes as near as he ever has to catching the essence of growing up. Anecdotal detail is kept to a minimum. The subject is very specific, yet, at the same time, universal. The painting transcends the illustrational. It is one of Rockwell's finest.

From the very outset of his career, children and adolescents have provided Rockwell with an important class of subject matter. His illustrations from the years 1913 to 1915, done for Boy Scout publications and for magazines such as *St. Nicholas,* do not yet have his personal touch, but they are accomplished professional works and young people are their chief subject. Rockwell's very first *Post* cover (Fig. 3) showed three children and an infant. Of the two dozen covers which he painted for the *Post* between May, 1916, and the end of 1919, only four did not include at least one child or young adolescent. Covers

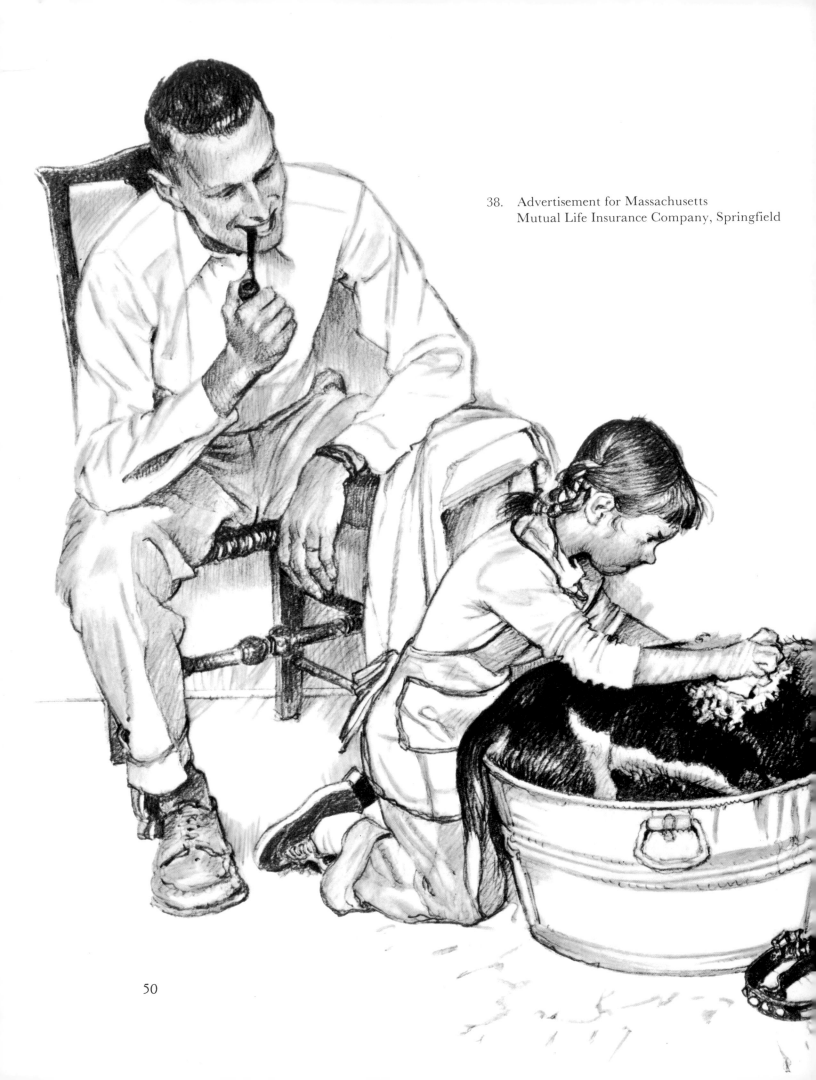

38. Advertisement for Massachusetts
 Mutual Life Insurance Company, Springfield

50

for other magazines, such as *Country Gentleman* and *Life,* also relied heavily upon the appeal of children.

Rockwell soon developed a number of basic themes using children. One that he particularly favored centered upon the misfortunes of a bespectacled city boy—arrogant but ineffectual—who is the unwilling butt of his country cousins (Figs. 39, 40). The yokels have a rather cruel sense of humor but are nonetheless assumed to have the sympathy of the reader.

Occasionally (Fig. 60, for instance) the boys are confronted by their contemporaries of the opposite sex. The girls, on the whole, are less "cute" than their male counterparts. They generally seem to be more mature for their years; at times they appear to be almost aggressive. The boys are shown to have a more relaxed relationship with their dogs; over the years Rockwell worked through a fine assortment of mutts, tykes, and other mongrels (a peculiarly symbiotic relationship is shown to exist between boy and dog).

We might ask ourselves to what extent Rockwell's work up to, say, the mid-thirties reflects the reality of growing up in America. Clearly it does not reflect the entire picture. He does not give us any idea of what it was like to grow up on the Lower East Side of

39. *Cousin Reginald Goes Fishing. Country Gentleman* cover, October 6, 1917

40. *Cousin Reginald Is Cut Out. Country Gentleman* cover, November 17, 1917

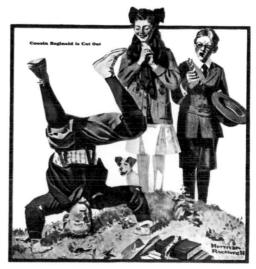

Manhattan or the Hamtramck section of Detroit (this is not a criticism—he does not pretend to supply any such record). What he does give us is a log of the kind of episodes which were supposed to add up to the ideal American childhood—from playing ball with Gramps (Fig. 51) to the enjoyment of scientific novelties (Fig. 58). This is, then, the myth of childhood, but it is a myth which, if it was to make any sense, had to be tied to an experience of reality. Thus Rockwell did not offer us, in this period, the documentary evidence that he was to present later; but what he shows us does, nonetheless, tell a great deal about the notions that controlled the reality of growing up in America.

On the whole, the myth of American childhood—as portrayed by Rockwell in his earlier works—is marked by a remarkably permissive attitude toward youthful high spirits. The fact that children are not always well behaved is seen almost entirely as a matter for approbation. "No Swimming" notices, for example, are there to be ignored. This fact provided Rockwell with two of his most durable *Post* covers—the first (Fig. 42) painted in 1921 and the second (Fig. 50) in 1929. In the earlier example we are given a picture of three boys—inevitably accompanied by their faithful mutt—making a hasty getaway. The image is skillfully framed in order to emphasize the speed of their forced exit (they seem to be bursting through the boxed-off area). The framing device is also used to make the nearest figure—his hair still flattened by water—seem to leap forward from the cover.

In the later example we do not see the culprits themselves, only their belongings (including a slingshot), which they have arrogantly draped over the "No Swimming" sign. The little girl who is passing the scene of the misdemeanor does her best to ignore the terrible facts that confront her. She follows the example of Lord Nelson, who at the battle of Copenhagen placed his telescope to his blind eye so that he could truthfully say that he had not seen the signal to break contact with the enemy. Exactly what disturbs the girl is a little ambiguous. Since we may be sure that she has been taught to be truthful, it may simply be that she dreads being called as a witness to the crime; but if we assume that the boys are skinny-dipping, then that too could provide an explanation for her embarrassment.

Idyllic visions of childhood continue into the thirties with images such as those Rockwell provided for Coca-Cola calendars (Figs. 45, 46) and illustrations such as the

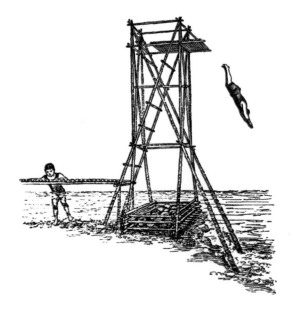

41. *The Port Chester Signalling Tower Becomes a Diving Tower.* Illustration for Boy Scout guidebook

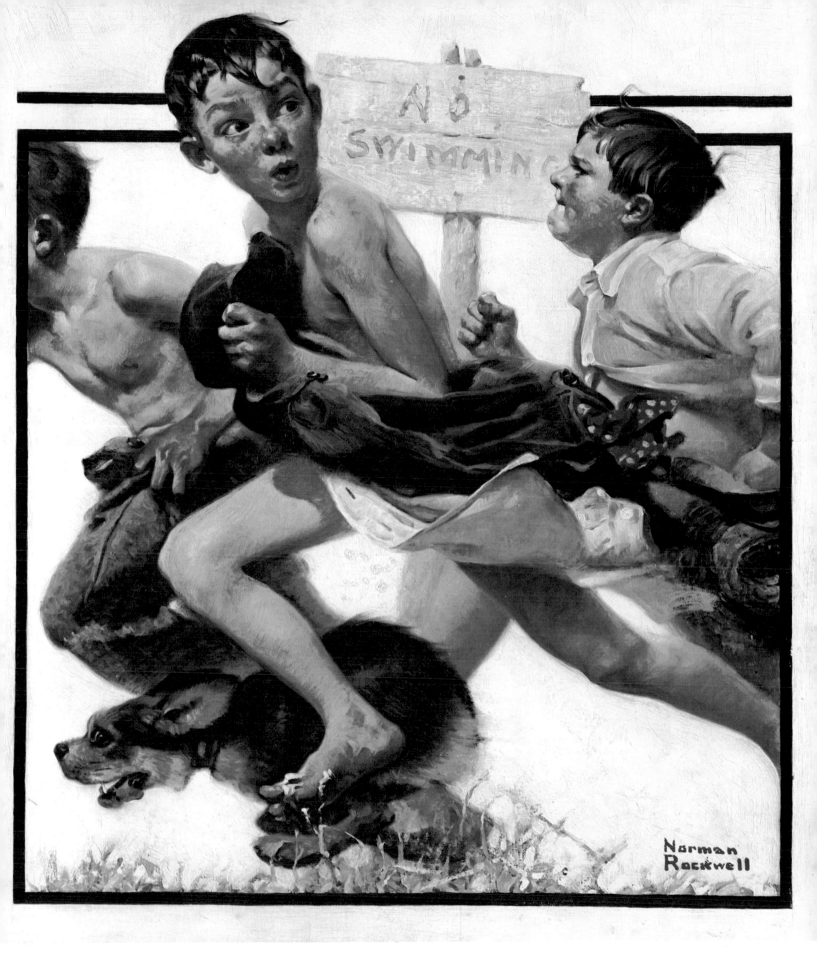

42. *No Swimming.* Original oil painting for *Post* cover, June 4, 1921. Collection Norman Rockwell

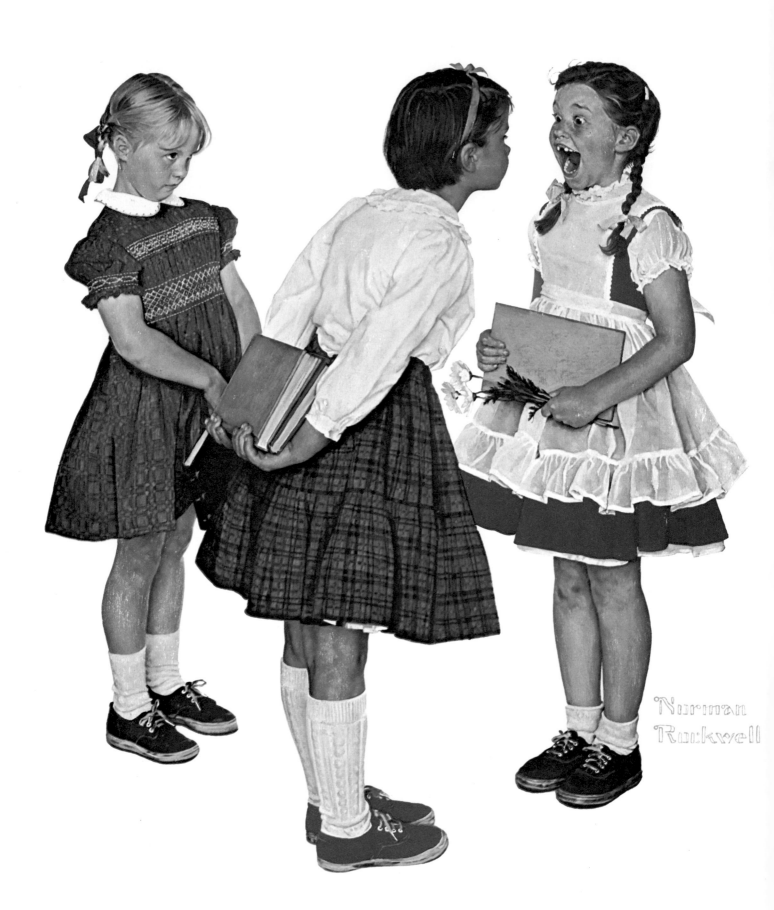

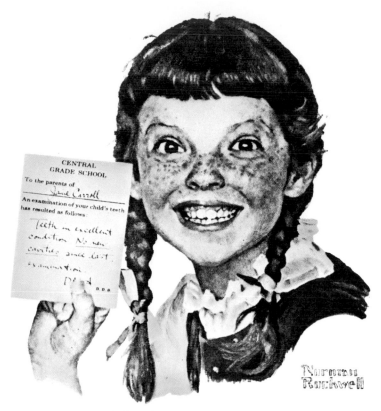

43. *Checkup.* Original oil painting for *Post* cover, September 7, 1957

44. Advertisement for Crest toothpaste

Land of Enchantment (**Fig. 49**). By this time, however, another tendency was beginning to appear in his work.

This was the tendency toward a naturalism of treatment which was to become the hallmark of his later work. That does not mean that he abandoned the myths which had inspired him up till that time; rather, it means that he chose to dress them up in the trappings of realism. Also Rockwell began to admit that growing up involved—growing up; we find, for example, students cramming for exams (Fig. 74). The 1934 cover showing a young man unwillingly dressed to represent "The Spirit of Education" for his part in a pageant (Fig. 70) is in no way idealized. We do not feel that in his day-to-day existence he is one of the happy ragamuffins that tended to populate Rockwell's earlier work. The 1939 cover showing a young lady marble champion (Fig. 36) could, with the addition of a little background, have been painted in the fifties. Three years later, Rockwell painted a small boy reading his sister's diary. Typical of his work in the late thirties and early forties, this is very much a transitional composition. The boy is not one of the idealized free spirits of the earlier work (the model was, in fact, one of Rockwell's sons). The background is naturalistic, but still very schematic in comparison to the later work.

By the mid-forties the transition had been completed. A 1946 cover (Fig. 71) shows a small boy (again the model was one of Rockwell's sons) in the dining car of a train coming to grips with the thorny problem of leaving a tip. The setting is fully articulated; the situation is real. The following year, another cover portrayed an adolescent girl wrestling with the enigmas of baby-sitting. Once more we have a fully realized situation. The lack of specific settings in the early covers gave the figures an almost abstract quality; they were archetypes. In the later work, these archetypes have been absorbed by

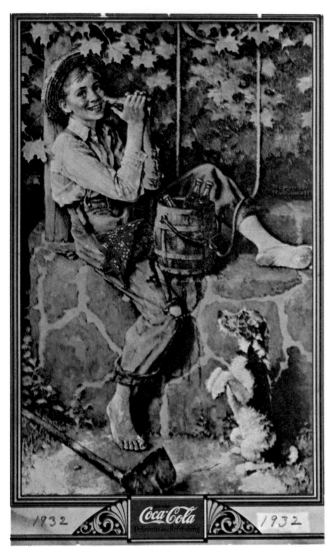

45, 46. Coca-Cola calendars for 1932 and 1935.
Courtesy Archives, Coca-Cola USA,
a division of The Coca-Cola Co., Atlanta, Ga.

47. Advertisement
for Massachusetts Mutual
Life Insurance Company,
Springfield

48. Advertisement for
 Massachusetts Mutual Life
 Insurance Company, Springfield

reality. The same roles are still acted out, but the friction of contact with the everyday world gives them a rather different character.

Occasionally, as in the immensely popular *Day in the Life of a Boy* and the less well-received *Day in the Life of a Girl* (Figs. 52, 53), Rockwell did revert to a style reminiscent of his earlier idiom, but in these instances we find a lightness of touch and a flexibility which had not existed before. *Checkup* (Fig. 43), a 1957 cover, also dispenses with a setting—and for a very good reason. It was essential to this subject that all attention should be focused on the three figures. Because of this, a plain background was preferable to a detailed environment which would have been distracting. In any case, the books the girls are holding tell us that they are on their way to school. The teacher's birthday cover, painted for the *Post* the previous year, is more typical of Rockwell's treatment during this period. We might note, in passing, that his postwar children seem, on the whole, to be better behaved than those from the prewar era.

A fine example of the collision between myth and reality is the 1958 painting showing the encounter in a diner between a would-be runaway and a friendly cop (Fig. 83). The runaway kid, we may suppose, is trying to live up to the Huck Finn-like standards of the characters Rockwell portrayed so frequently in his early work. The fantasy is still alive in the boy's mind and this fact is clearly appreciated by the cop and by the hardened but sympathetic short-order cook behind the counter. The deadpan treatment of the diner's interior adds considerably to the poignancy of the situation. A

51. *Gramps at the Plate. Post* cover, August 5, 1916

52. *A Day in the Life of a Boy. Post* cover, May 24, 1952

53. *A Day in the Life of a Girl. Post* cover, August 30, 1952

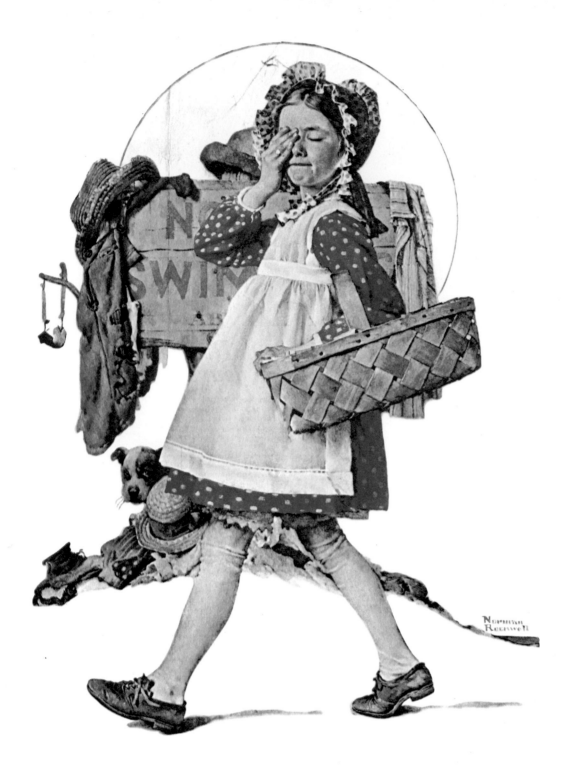

50. *No Swimming. Post* cover, June 15, 1929

◄ 49. *Land of Enchantment.* Original oil painting
for *Post* illustration, December 22, 1934.
New Rochelle Public Library, N.Y.

54. *After the Prom.* Original oil painting for *Post* cover, May 27, 1957. Collection Mr. and Mrs. Thomas Rockwell

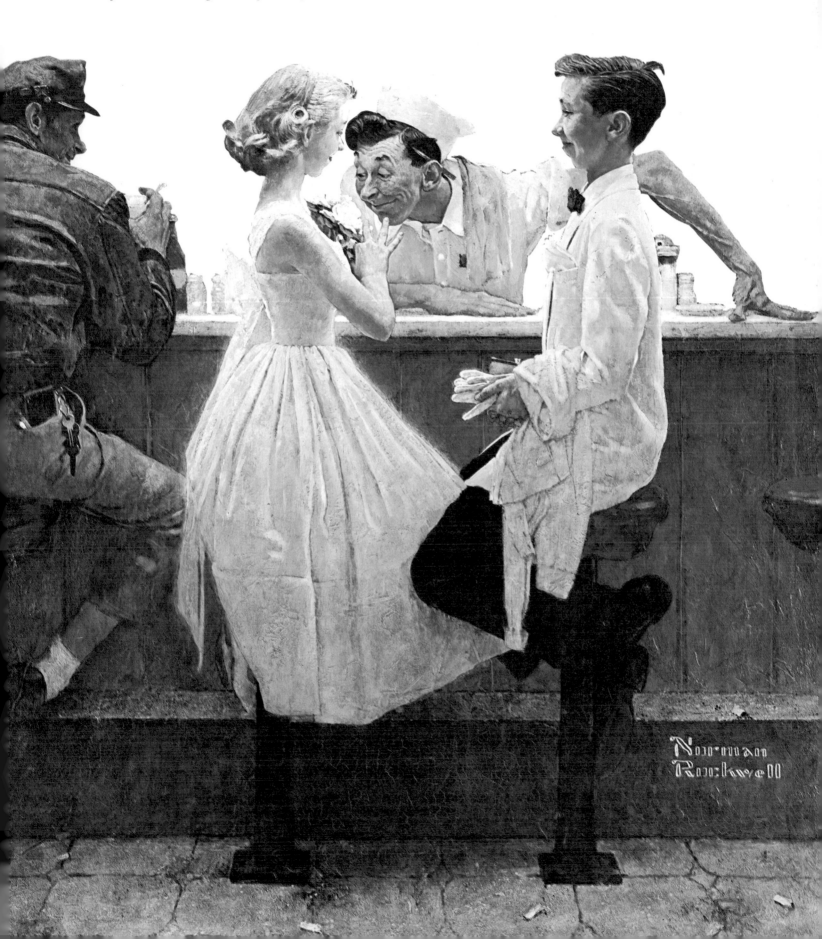

55. Advertisement for Massachusetts Mutual
Life Insurance Company, Springfield

similar interior is shown in a 1953 *Post* cover illustrating, as Rockwell has said, the
popularity enjoyed by a soda jerk who finds himself in the happy position of being able
to slip extra scoops of ice cream into the sundaes of girls who catch his fancy. The
counter top, the soda jerk's hat, the languid pose of the girl with the permanent, and the
pertness of the other two—all these have an authentic place in the myth of growing up in
America.

A 1951 cover (Fig. 76) in which a father is shown in the process of introducing his
son to the facts of life is a study in embarrassment that is universal enough in general
theme but specifically American in its detailing. With *After the Prom* (Fig. 54) we are back
to a situation that is entirely American. Again the setting is a diner. The contrast
between the formal clothes of the boy and his date and the working clothes of the others
is splendid.

One of Rockwell's finest paintings is *Breaking Home Ties* (Fig. 63). He painted this for
the *Post* in 1954. A boy is leaving for college. His father—a dirt farmer perhaps (this is
clearly a rural situation)—sits with him on the running board of a beat-up pickup truck
as they await the train. The contrast between them is striking. The father is dressed in
well-worn coveralls and holds two hats—his own, weatherbeaten; his son's, brand new.
He seems preoccupied and a little sad, as one can well understand. The son, by contrast,
is eagerly looking down the track, anticipating the arrival of the train. His eagerness can
also be gauged by the fact that there are bookmarks in the books that rest on his cheap
suitcase, indicating that he is impatient to begin his studies. He wears a smart, light-col-
ored suit, a hand-painted tie, new shoes, and brightly patterned socks. His mother is not
there to see him off, but the package of sandwiches which she has tied with pink ribbon
is clasped in his hands. The family's collie rests its head on the boy's knee. Besides the
contrasts, however, we are also aware of the things that link the two figures. The boy

56. Advertisement for Massachusetts Mutual
Life Insurance Company, Springfield

57. *Schoolboy Gazing out of the Window. Post* cover, June 10, 1922

58. *The Sphinx. Post* cover,
January 14, 1922

59. *New Kids in the Neighborhood.* Original oil painting for *Look*
illustration, May 16, 1967. © Cowles Communications, Inc.

60. *Pardon Me! Post* cover,
January 26, 1918

61, 62. Advertisements for
Massachusetts Mutual
Life Insurance Company,
Springfield

63. *Breaking Home Ties.* Original oil painting for *Post* cover, September 25, 1954. Collection Don Trachte

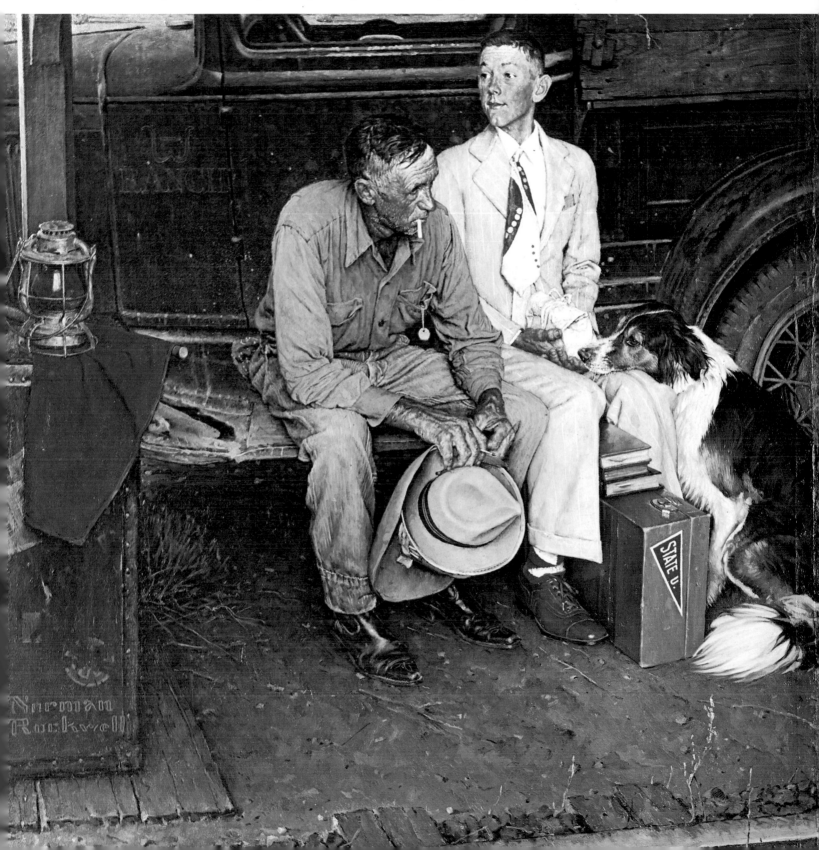

64. *The Haircut.* © *Top Value Enterprises, Inc., Stamps* cover, 1972

65. Advertisement for Massachusetts Mutual Life Insurance Company, Springfield

68. *Redhead Loves Hatty Perkins.*
Post cover, September 16, 1916

66. *Bully Before. Country Gentleman* cover,
June 4, 1921

67. *Bully After. Country Gentleman* cover,
June 11, 1921

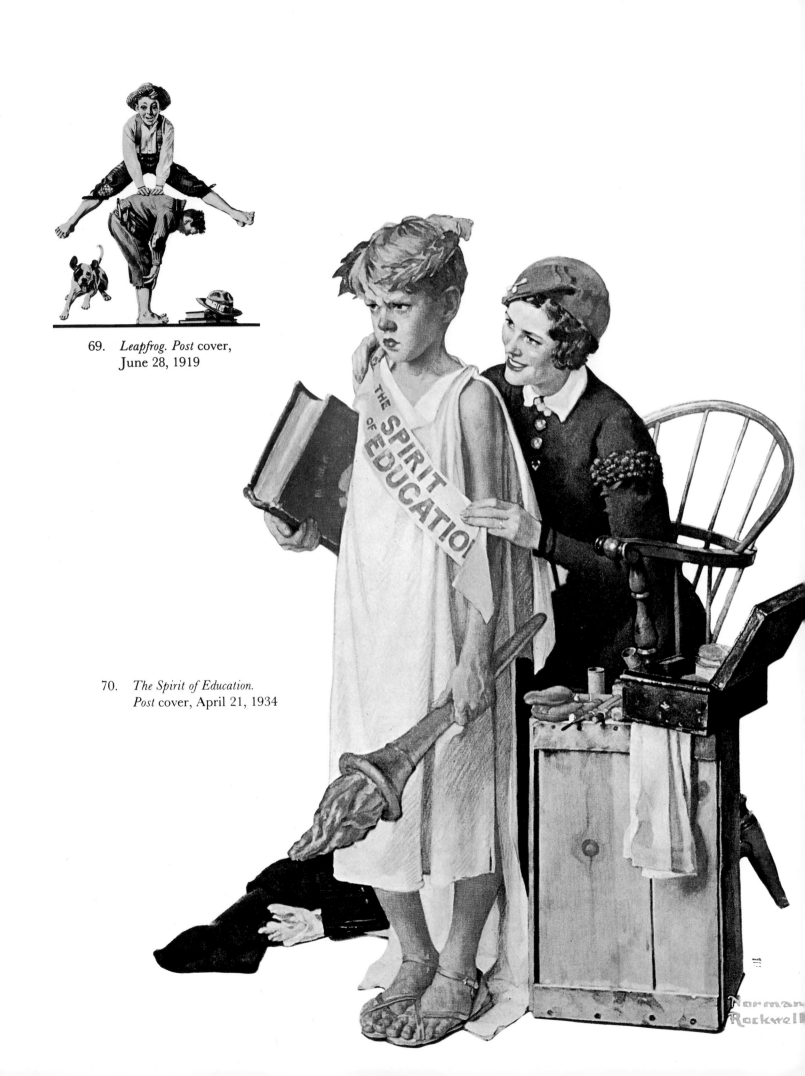

69. *Leapfrog. Post* cover,
June 28, 1919

70. *The Spirit of Education.*
Post cover, April 21, 1934

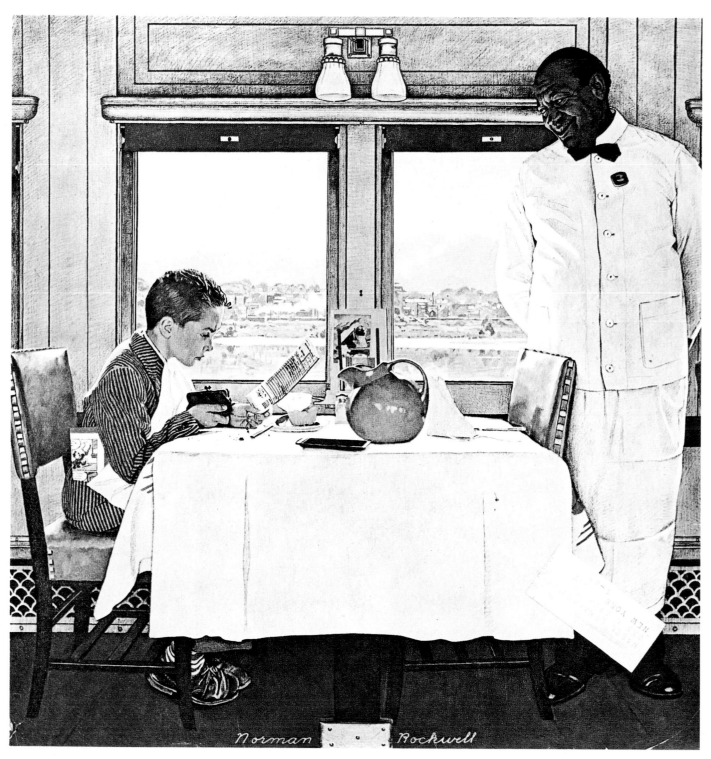

71. *New York Central Diner. Post* cover, December 7, 1946

73. *The Scholar. Post* cover,
June 26, 1926

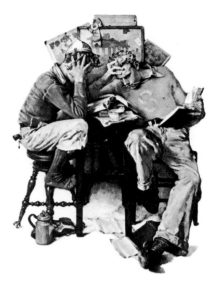

72. *Vacation's End. Post* cover,
January 8, 1927

74. *Cramming. Post* cover,
June 13, 1931

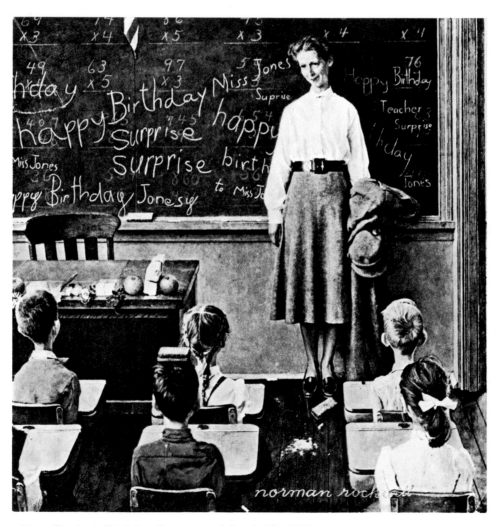

75. *Teacher's Birthday. Post* cover, March 27, 1956

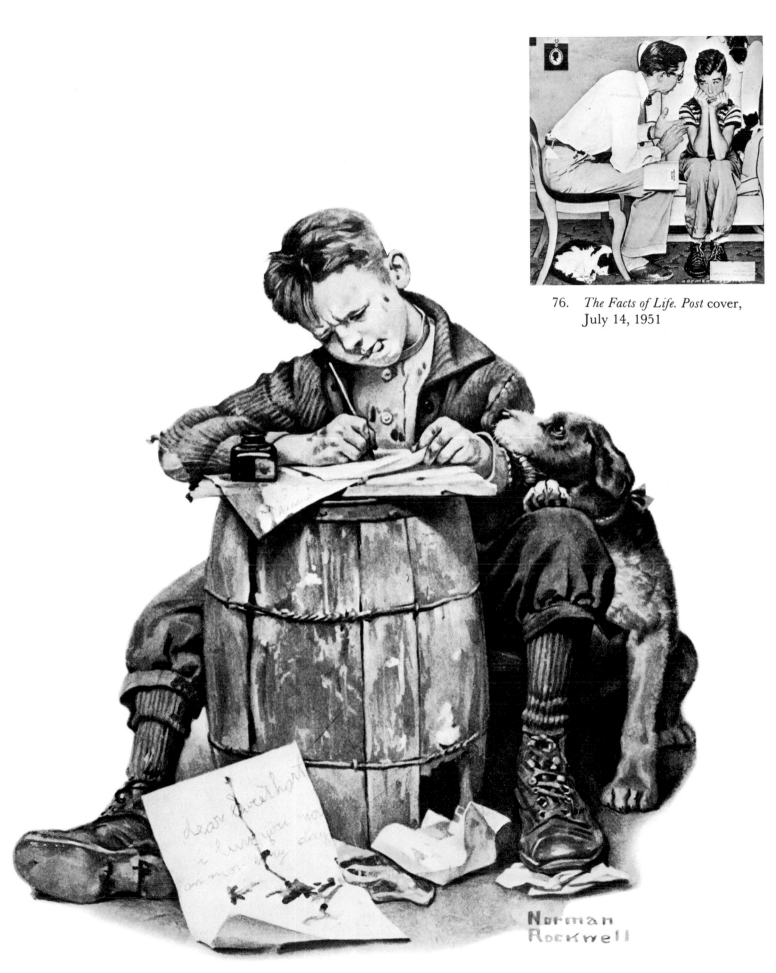

76. *The Facts of Life. Post* cover,
July 14, 1951

77. *Love Letters. Post* cover, January 17, 1920

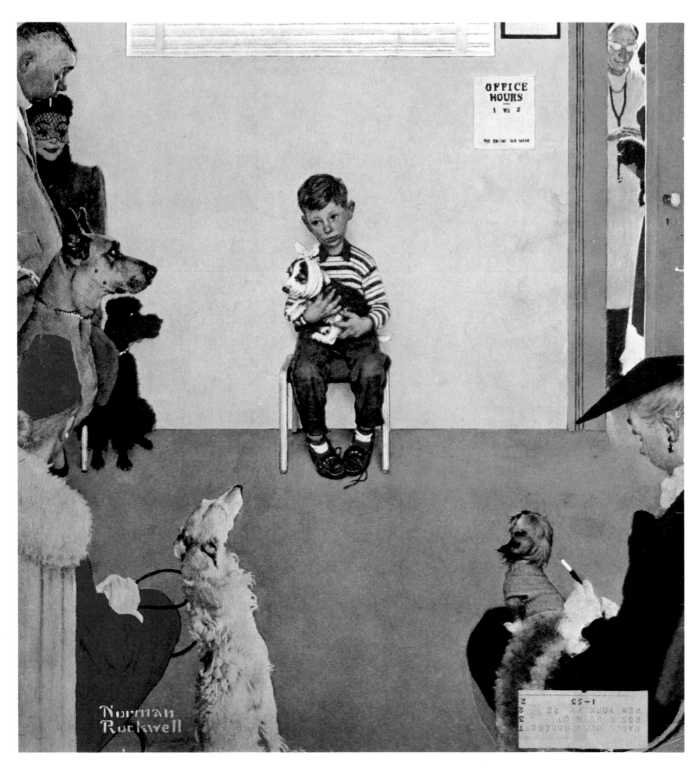

78. *Waiting for the Vet. Post* cover, March 29, 1952

79, 80. Advertisements for Massachusetts Mutual
Life Insurance Company, Springfield

81. *Home from Camp.* © *Top Value Enterprises, Inc., Stamps* cover, 1968

shares with his father a ruddy complexion, large feet, strong hands. These similarities work against the contrasts to set up a delicate tension which gives the painting its strength.

Breaking Home Ties is one of the most telling moments in Rockwell's continuing story of growing up in America.

Of course, growing up in America is a constantly changing proposition. *New Kids in the Neighborhood* (Fig. 59), painted for *Look* in 1967, recognizes this and attempts to come to terms with it. The confrontation between black and white is shown in terms of children. This is not an unfamiliar device, but Rockwell brings his own touch to it. In this painting, and throughout his career, children have provided Rockwell with a vehicle for optimism.

82. Advertisement for Massachusetts Mutual Life Insurance Company, Springfield

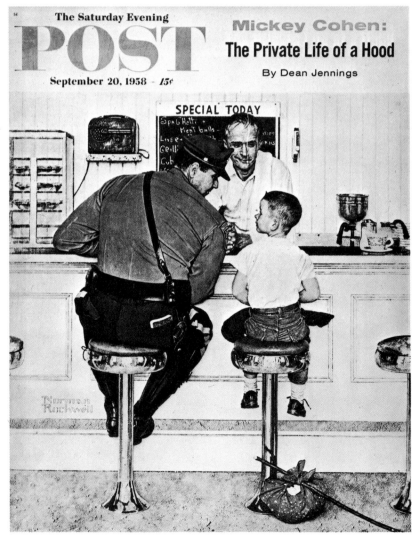

83. *The Runaway. Post* cover, September 20, 1958

Young Love

84. Advertisement for Massachusetts Mutual
Life Insurance Company, Springfield

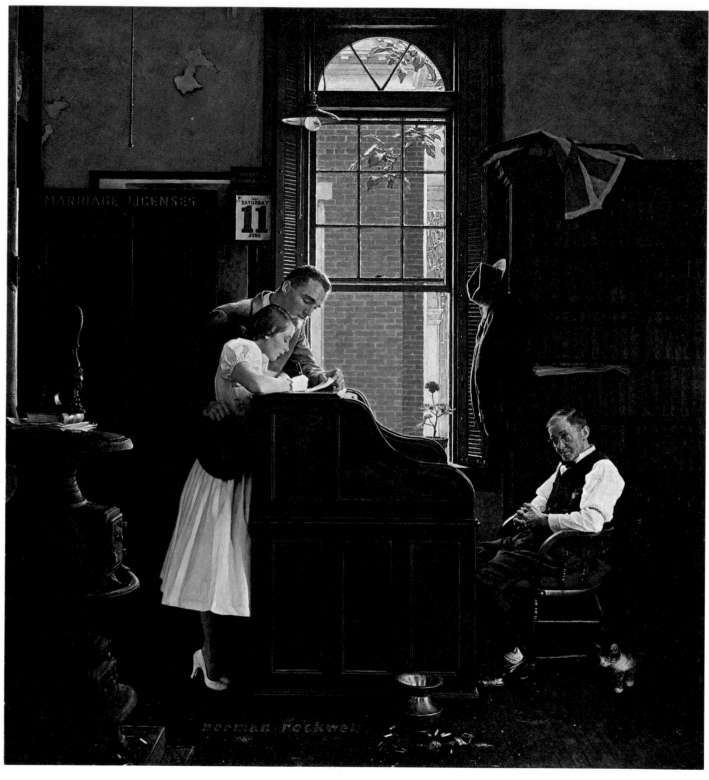

85. *Marriage License.* Original oil painting for *Post* cover, June 11, 1955. Collection Norman Rockwell

86. Advertisement for Massachusetts Mutual
Life Insurance Company, Springfield

Young love is a recurring theme in Rockwell's work—a theme upon which he has
worked many variations. He first turned to this subject in 1917 and it cropped
up very frequently over the next twenty-five years or so. Since World War II he
has chosen it less often as a main subject, but this is not to suggest that he has lost
sympathy for lovers. We need only look at *Marriage License* (Fig. 85), painted in the
mid-fifties, to realize that this could not be the case.

Marriage License is one of the handful of works in which Rockwell managed to pull
all his skills and powers of observation together—in which he has defied deadlines and
produced something that transcends the category of good illustration. (We have already
discussed some of the other works that fall into this group: *Saying Grace,* for instance, *Girl
at the Mirror, Shuffleton's Barber Shop,* and *Breaking Home Ties.*) The old man in the license
bureau sits slumped in his chair. His mind is absent from the situation at hand; he has
seen it all a thousand times before. For the young couple, by contrast, this is a unique
experience. The young man holds a pose of calm strength, but grips his hat a little
nervously. The girl, standing on tiptoes in her simple yellow frock, is the picture of

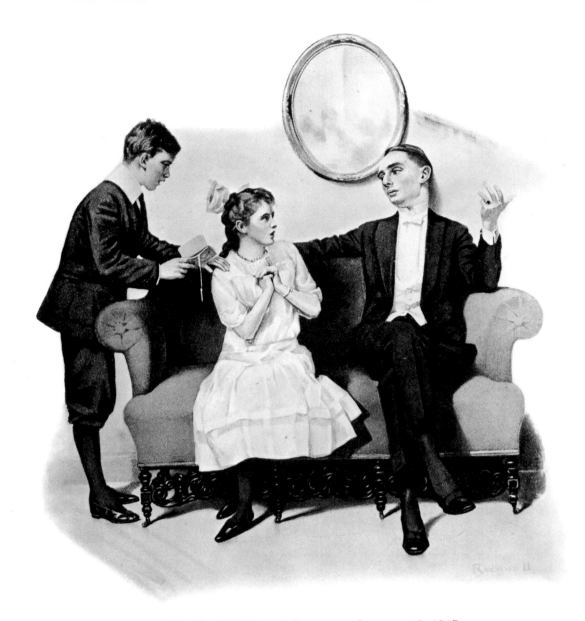

87. *Shall We Dance? Post* cover, January 13, 1917

concentration. The act of signing her name has become a matter of high seriousness, and she is giving it all the attention that it deserves. The setting is beautifully handled; Rockwell brings to it a mellowness which matches the venerability of the architecture. Paint is peeling from the walls, there are cigarette butts on the floor, and the ancient volumes on the bookshelves seem to be little used; but the window beside the desk is a tall, gracious affair and through it we catch a delicious glimpse of a springtime that is rapidly becoming summer. The calendar tells us that this is Saturday, June 11. This illustration appeared on the cover of the *Post*, Saturday, June 11, 1955.

Rockwell's first *Post* cover to deal with young love (though perhaps infatuation would be a better description in this instance) appeared in January, 1917. It is the party season. A charming young maiden with an enormous bow in her hair is listening, with awe, to the sophisticated small talk of a gentleman who seems to be a year or two older than she. We may suppose that this gentleman is home from Cambridge or New Haven for the Christmas vacation. A rather younger gentleman is about to remind the girl that

she owes him a dance (Fig. 87). A little later that year (Fig. 88), we are shown a lady teacher being courted in the classroom while one of her charges—who has been kept after school—writes the phrase "knowledge is power" innumerable times on the blackboard. He is evidently becoming aware that his teacher can draw upon reserves of power that have little to do with knowledge.

Both of these covers fall into the category of "joke" ideas, but they are subtle jokes, handled with a nice sense of discretion. Young love is quite often a source of sympathetic amusement for Rockwell. A 1919 cover (Fig. 89) shows the lovers on a sofa being interrupted by the arrival of midnight. A 1920 cover (Fig. 94) shows another couple engaged in entertaining themselves with some kind of Ouija board. Their knees touch and we are made aware that the board will answer "yes" (though to what question remains in the realm of the imagination). The following year (Fig. 95), our star-crossed lovers are suddenly disturbed by a kid brother who has been hiding beneath the settee. This is visually one of Rockwell's most successful works of the period, using the *Post*'s cover format to great effect. Although he does not give us a complete environment, the

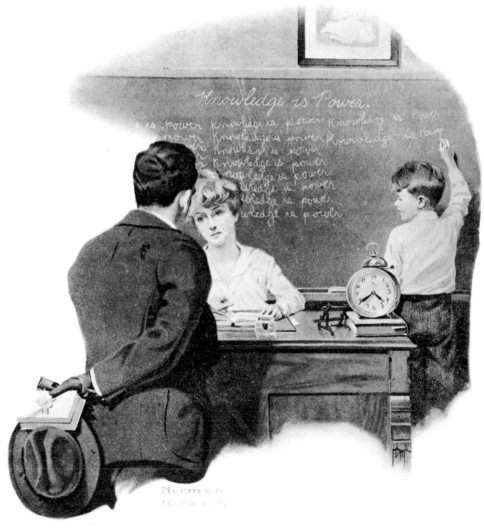

88. *Knowledge Is Power. Post* cover, October 27, 1917

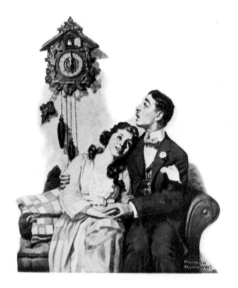

89. *Courting Couple at Midnight.*
 Post cover, March 22, 1919

90. *Look What Time It Is?* ©*Top Value Enterprises, Inc., Stamps* cover, 1970

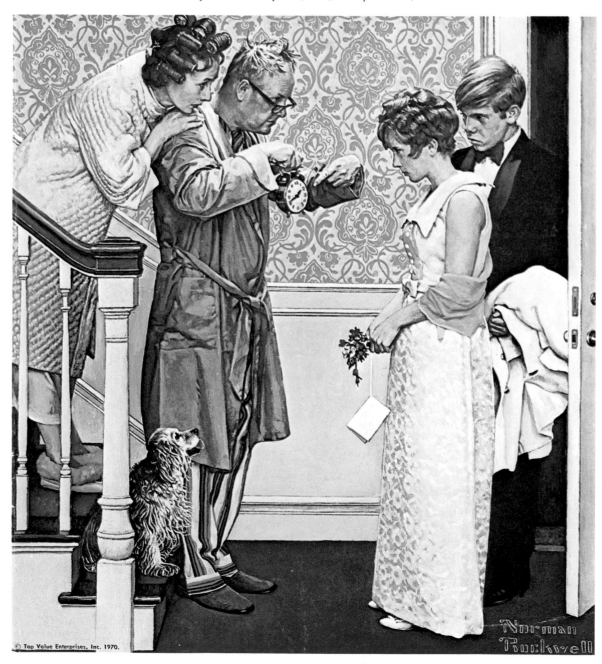

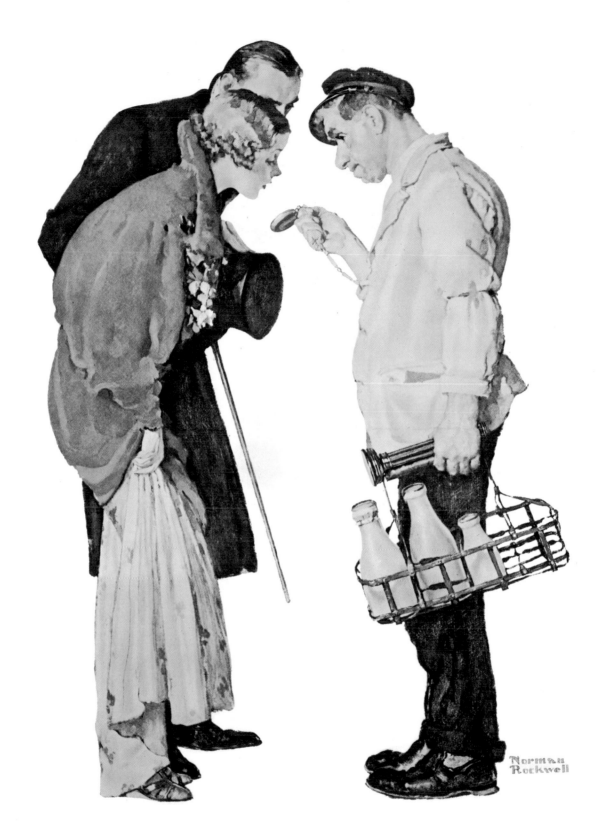

91. *The Partygoers. Post* cover, March 9, 1935

artist hints at things to come by establishing very specific details—notice the Chinese drapery over the arm of the settee. This cover presents not only an idea, but also a time and a place.

Sometimes Rockwell chose to place his young lovers in a period context. In some instances he selected the recent past. Typical of this is the accordion serenade (Fig. 92), though its humor lacks the lightness of touch which we find in Rockwell's best work. The couple in the buggy (Fig. 93) provided him with a more successful subject. The young man is falling asleep, but the girl remains wide-awake, if dreamy-eyed. Two covers from the early thirties (Figs. 98, 102) placed the lovers further back into the past. In one, a sailor seems to be spinning yarns around his adventures in the Spice Islands or the Sargasso Sea, while the rather prim young lady clasps her half-read novel—pale stuff by comparison to his voyages—nervously on her lap. In the other, a young man in a tricornered hat kisses a milkmaid on a rather fragile bridge beneath which bullrushes grow.

A 1935 cover (Fig. 91) brings us right back into the twentieth century. A pair of partygoers returning home have stopped to consult a milkman's watch. The couple appear to be a little surprised to discover how late it is, but they are hardly overcome by shock. This is, after all, the thirties. Not the thirties of the Depression, but the thirties which produced the compensating myth of Hollywood and the Great White Way. This is the thirties of Katharine Hepburn, Cary Grant, Clark Gable, and Jean Harlow; of *The Philadelphia Story* and *Flying Down to Rio;* of Cole Porter, Rodgers and Hart, Irving Berlin, and Noël Coward. Any self-respecting pair of partygoers returning home would stop a milkman to ask the time; it would be the final seal of approval on a successful date.

The young couple sitting upon a knoll, which Rockwell painted the following year, is altogether less worldly (Fig. 97). This is young love at its most innocent.

Later in 1936 (Fig. 96), we find a couple on a bench unintentionally disturbing the concentration of an elderly man who is trying to read. This is an ordinary enough concept, but Rockwell manages to bring it to life. (A vital necessity for anyone working to deadlines is the ability to fall back on sheer competence when everything else fails.) A less routine idea is to be found as the subject of a 1938 cover (Fig. 101) which shows two girls in a college dormitory gazing with ill-concealed infatuation at a photograph of a movie star that has been removed from the pillow in which it is evidently kept. The treatment in this instance is sketchy but sensitive.

That same year Rockwell produced a classic. A high-school football player has won his letter and an admiring cheerleader is sewing it to the front of his jersey (Fig. 103). The girl wears the same expression of significant concentration that we find on the face of the girl in *Marriage License*. The boy kneels in the attitude of a warrior saint—St. George, perhaps—and this attitude is amplified by a halo which floats above his head. The inspiration of this cover does not reside in the area of novelty or innovation; it is simply a matter of rightness. This is an archetypal situation, central to the mythology of Rockwell's America. The treatment is simple but perfect for the subject. Rockwell is showing us a very special kind of love and is allowing us to glimpse this love in a private moment before it becomes public knowledge.

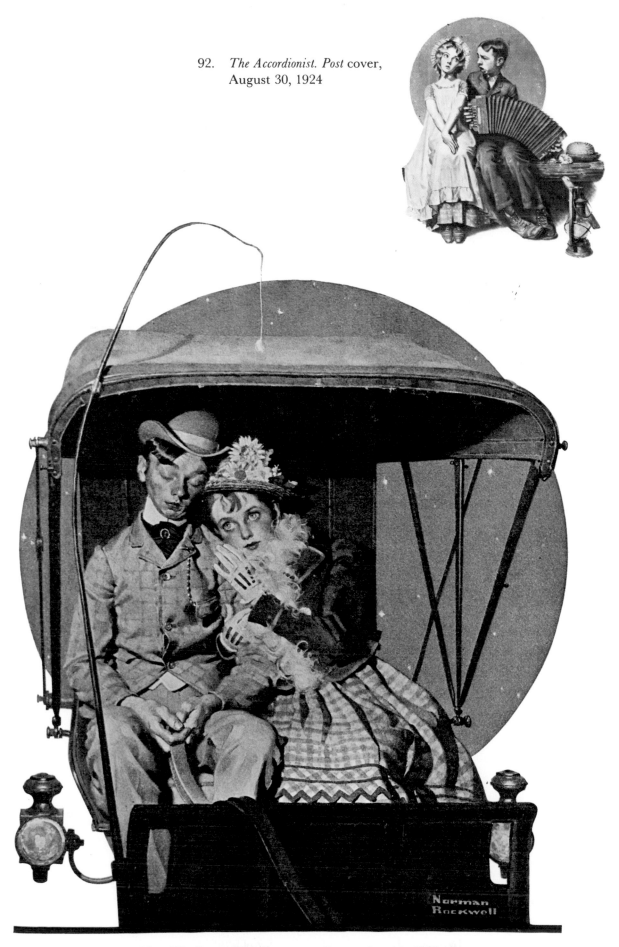

92. *The Accordionist. Post* cover,
 August 30, 1924

93. *The Buggy Ride. Post* cover, September 19, 1925

95. *Sneezing Spy. Post* cover,
October 1, 1921

94. *The Ouija Board. Post* cover,
May 1, 1920

96. *Overheard Lovers. Post* cover,
November 21, 1936

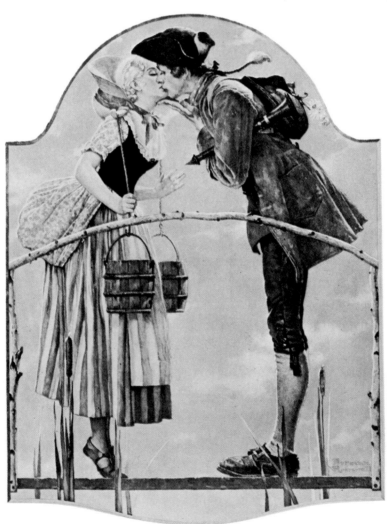

98. *The Milkmaid. Post* cover, July 25, 1931

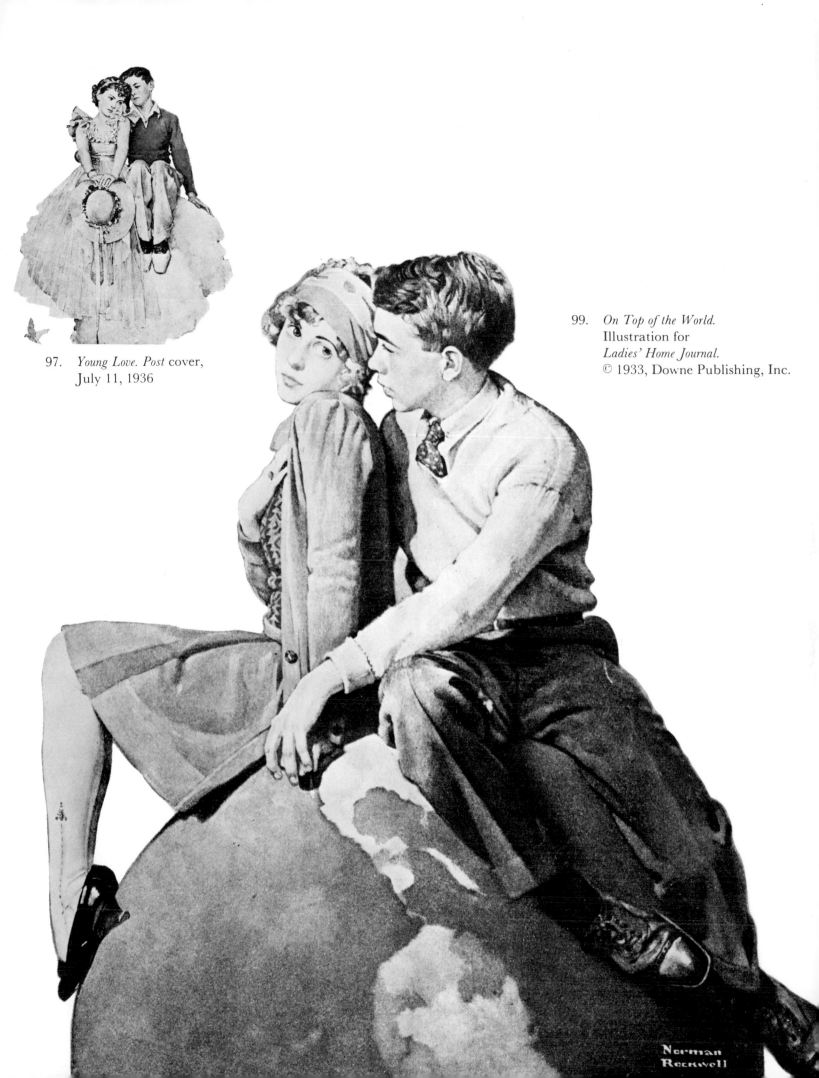

97. *Young Love. Post* cover,
July 11, 1936

99. *On Top of the World.*
Illustration for
Ladies' Home Journal.
© 1933, Downe Publishing, Inc.

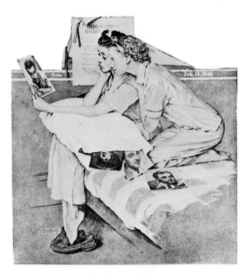

100. Advertisement for Massachusetts Mutual
Life Insurance Company, Springfield

101. *The Movie Star. Post* cover,
February 19, 1938

Rockwell is at his best with these archetypal situations; they are what he is always looking for. Taking his work as a whole, we will find that he constantly returns to certain basic themes. It is as if he is circling them, studying them from different angles, trying to pin them down, attempting to extract the essence. In most cases he does succeed, sooner or later, in extracting this essence, and when he does, we experience that feeling of rightness as in this example of footballer and cheerleader.

Rockwell touched upon the theme of young love several times during the war years—notably in some of the Willie Gillis covers, which we shall consider in a later chapter. A 1944 *Post* cover (Fig. 106) showing a couple on a train watched by an interested little girl is a good example of the informal approach Rockwell was refining at that time. This is one of the earliest covers in which we can find a completely realized setting, but what makes it more remarkable is the fact that it displays an intimacy that had never really been seen in his work prior to that time. Possibly this can be seen as a reflection of the open-mindedness of the wartime cultural climate. Whatever the reason, it introduces an informality that was never to disappear from Rockwell's art.

In Rockwell's later work the subject of young love is seldom approached as directly as it was in the twenties and thirties. *Marriage License* is a distinguished exception to this rule; another is the 1949 cover showing a young couple preparing for a date (Figs. 104, 105). This composition is treated as a split image—the girl and the boy are seen in their respective rooms. She is pinning up her hair, he is combing his. She has a photograph of him beside her mirror and he has a photograph of her beside his. Both rooms are in a state of mild disorder; but there is a kind of order within this disorder since one example of chaos is essentially feminine and the other evidently masculine. The lighting, too, serves as a means of contrast. The girl is dressing in a room where the drapes have evidently been closed. The source of light is strong but artificial. The boy's room is illuminated by bright natural light from a window through which we can see a mass of September foliage. This is a wholly delightful cover. It does not have the mellow perfection of *Marriage License,* but such a perfection would have been inappropriate since,

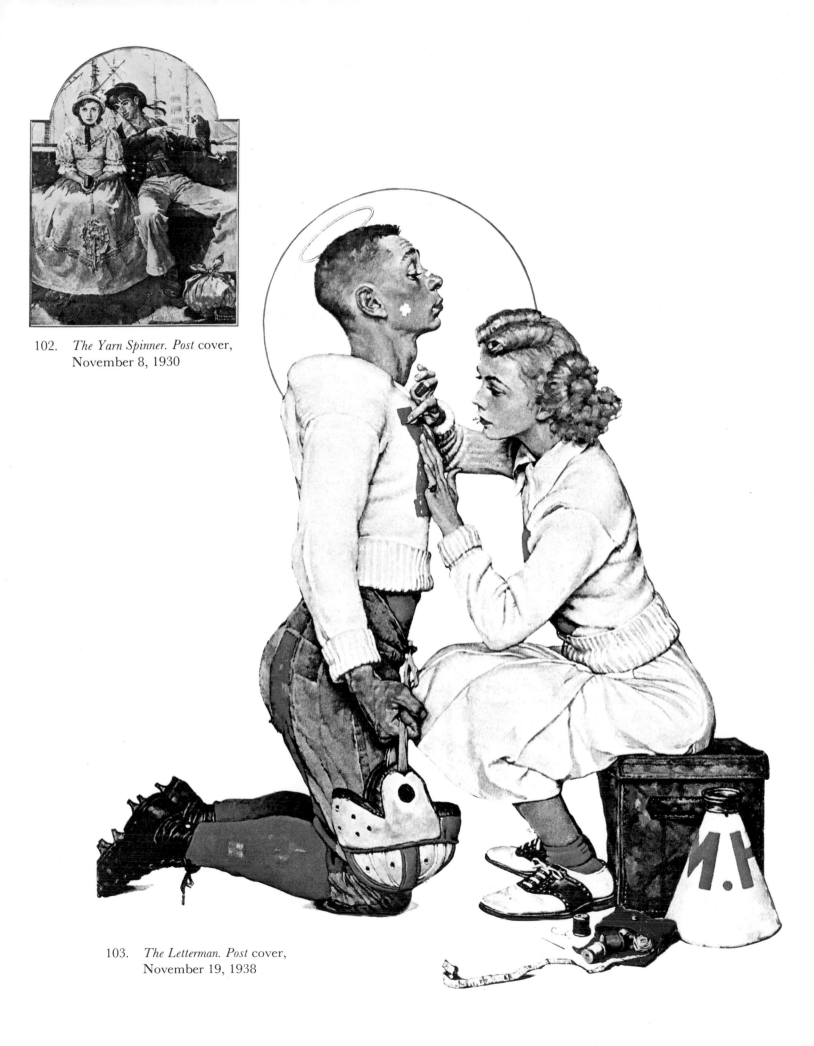

102. *The Yarn Spinner. Post* cover,
November 8, 1930

103. *The Letterman. Post* cover,
November 19, 1938

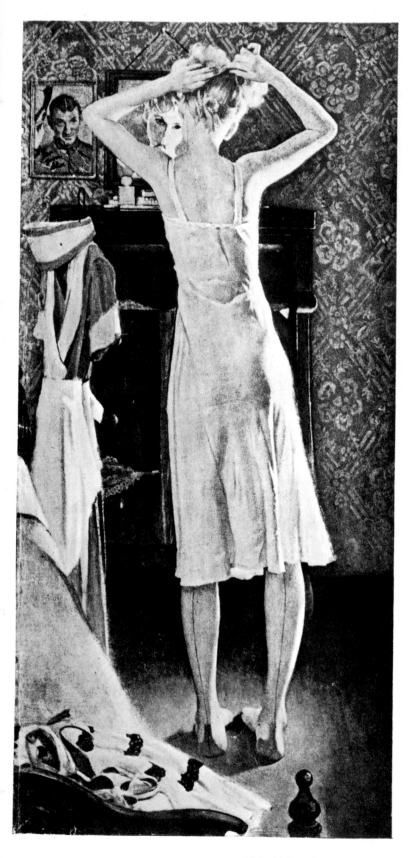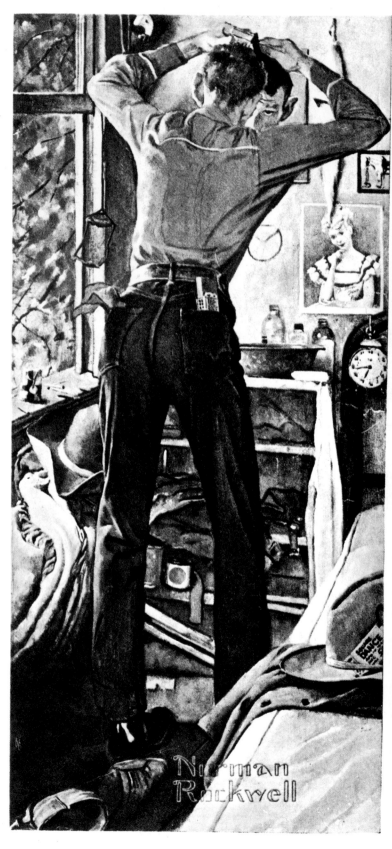

104, 105. *Before the Date. Post* cover, September 24, 1949

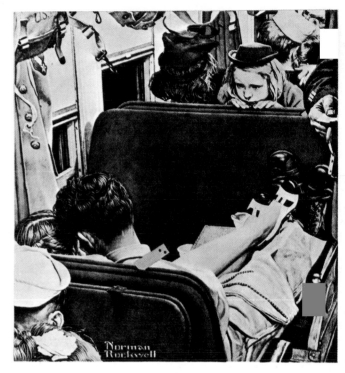

106. *Voyeur. Post* cover, August 12, 1944

in order to be convincing, Rockwell had to capture the slight awkwardness of the youngsters.

Another fine cover—and one of the last "story-line" covers done for the *Post*—shows a sailor talking to a pert young lady outside the University Club on Fifth Avenue in New York City (Fig. 107). This chance encounter is shown on a diminutive scale against the background provided by the massive stonework. The architecture—which holds the entire composition together—has aspirations toward permanence that are in direct contrast to the ephemeral nature of the incident. The elderly men at the windows seem to be greatly attracted to the episode unfolding under their eyes. It may be trivial, but it evidently offers welcome relief from the well-organized continuity of their own lives. A typical Rockwell touch is to include himself in this composition (glancing over his shoulder, at bottom left). His casual attire and the fact that he is in the street link him to the young couple rather than to the club members, whose elevation above the street also isolates them from the everyday world.

Rockwell's young lovers are generally fairly attractive but seldom glamorous. He constantly affirms the fact that everybody has the right to fall in love. He does not give us fashion-plate couples. In his treatment of young love, as in his treatment of everything else, he is devoted to the notion that ordinary folks are capable of a poetry of behavior which is as deserving of our attention as any other kind of poetry.

93

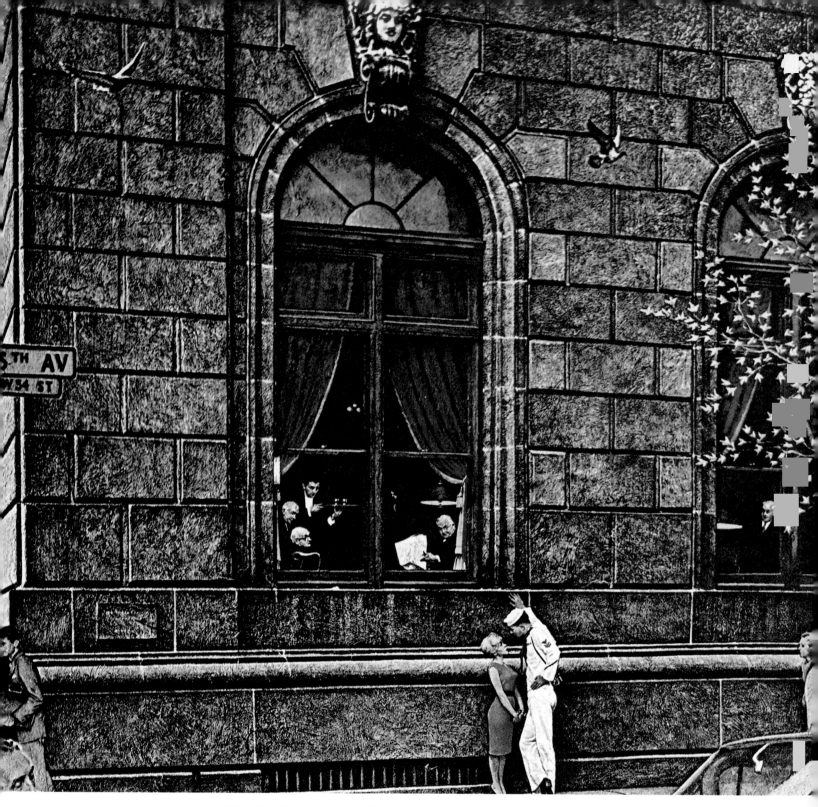

107. *The University Club. Post* cover, August 27, 1960

Home and Family

108. Advertisement for Massachusetts Mutual
Life Insurance Company, Springfield

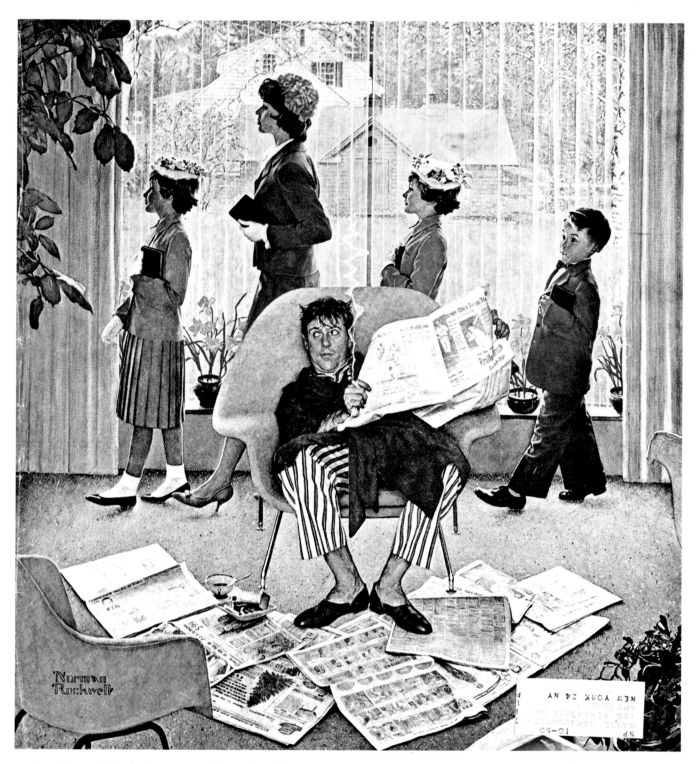

109. *Easter Morning. Post* cover, May 16, 1959

110. Advertisement for Massachusetts Mutual
Life Insurance Company, Springfield

In a broad sense, almost the entirety of Norman Rockwell's published work is geared to the general theme of home and family. The audience he has worked for is essentially the family audience and—even when the incident shown is not specifically set in a family situation—the ideal of family life is always present as a yardstick. Many of his paintings are, of course, set in the precise context of family life. We encounter this context over and over again: in obvious instances, such as his many Thanksgiving covers, but also in less expected instances, such as, for example, compositions that are presenting Americans in times of war. Confronted with a situation that has worldwide repercussions, Rockwell instinctively presents not the event itself but its effect upon home life. Often, however, he will portray the little dramas of home life purely for their own sakes. Typical of these is the one on the *Post* cover for May 16, 1959 (Fig. 109).

It is Sunday morning. The young mother (*too* young, as Rockwell himself has pointed out) and her children cross in front of the picture window on their way out to church. Dressed in their sober Sunday best, they maintain a fair simulacrum of dignity. We may speculate that the subject of church attendance has been raised over breakfast, or perhaps it has been pointedly ignored. At all events, Father—still in slippers and bathrobe—is sunken in a chair, making a pretense at hiding from this formal exodus. The small drama has temporarily distracted him from the sports pages of the Sunday paper, which he is already well into. Smoke rises from a cigarette clenched in his right hand. An almost empty coffee cup and an ashtray lay on the floor along with other sections of the newspaper. The young mother and her two daughters face resolutely ahead; but her son, who is trailing in this procession, casts an envious glance toward his father. The incident is completely self-contained and perfectly explicit. The setting, too, is splendidly rendered. The choice of chairs, the profusion of indoor plants, the wall-to-wall carpeting, the drapes—all these tell us a great deal about the family. The view through the window is actually the view from Rockwell's studio, but it might be a glimpse of an affluent suburb or small town almost anywhere in the United States. This is not just any family; it is a

111. *Planning the Home. Literary Digest* cover, May 8, 1920

112. Advertisement for Massachusetts Mutual Life Insurance Company, Springfield

very specific family, but it is one with which readers of the *Post* in any part of the country could identify without difficulty. In that sense, this cover is a typical example of Rockwell's later idiom: the specific incident and the general attitude are skillfully combined.

Early in his career, Rockwell sometimes chose to show very straightforward and typical incidents in the lives of young married couples. Two covers for the *Literary Digest—Planning the Home* and *First of the Month* (Figs. 111, 113)—are good instances of this. They show in simple, direct terms situations that any married couple is likely to be confronted with, and they show these situations in good-humored but slightly idealized terms. I use the word "idealized" here in the sense that these paintings tend to show man and wife thinking as one person. Similarly, during the same period, if we are shown children with older members of their own family, we are made aware of the same feeling of empathy. In Rockwell's later work this is not always the case.

Take, for example, the 1930 cover (Fig. 115) showing a married couple at the breakfast table. The man is buried in his morning paper, totally cut off from his wistful spouse. This is a familiar enough situation which we are aware of from cartoons, Edgar Kennedy movies, and televised situation comedies—but Rockwell brings his own sense of

98

113. *First of the Month. Literary Digest* cover, February 26, 1921

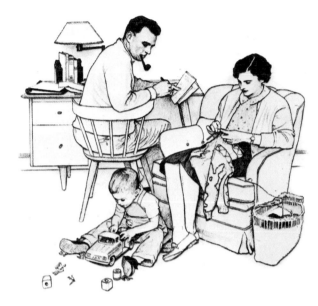

114. Advertisement for Massachusetts Mutual Life Insurance Company, Springfield

subtlety to it. The whole thing is handled with great delicacy. Rockwell has put as much care into portraying the woman's frock and shoes as she has put into selecting them. Her position is extremely poignant. She sits with her rib cage right up against the table, her legs tucked under the chair but with her knees thrust forward in the hope that they might brush against her husband's knees and thus win his attention. The chairs have been carefully chosen with some image of the ideal home in mind. The same can be said of the cups and coffee pot (this might be the same couple that was planning for the future in the 1920 cover). Looking at the woman, we can see that she will not easily give up her image of home life. Yet this is not a tragic picture; we sense that she will be able to modify this image in order to accommodate petty irritations such as the one we are shown. Emerging from the fantasy world of young love, she is on the verge of developing a sense of humor—that sense of humor which is essential to the realities of family life.

Am I reading too much into this picture? I don't think so. I may have, in thematic detail, misrepresented the artist's intentions; I may have slightly falsified the story in the retelling; but there is a story and it is subtle and complex. What I am saying is that Rockwell, in his mature work, does not attempt to oversimplify the problems that are involved in functioning as a family unit. What is remarkable is that he has been able to

99

115. *The Breakfast Table. Post* cover,
August 23, 1930

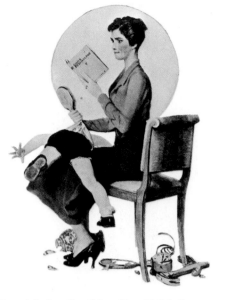

116. *Mother Spanking Her Child. Post* cover,
November 25, 1933

117. *Going Out. Post* cover,
October 21, 1933

118. Advertisement for
Massachusetts Mutual
Life Insurance
Company, Springfield

compress into single images the kinds of emotional situations that provide for writers the material for longer stories. It is as if he is able to crystallize whole slices of narrative in the details of his settings and in the gestures of his characters. The best part of this is that the narrative he suggests is completely open-ended, so that we can provide our own beginnings and our own conclusions. All the necessary information is given, but no eventualities are spelled out.

Other covers of the early thirties introduce children into the family picture. Children are sometimes irritating and Rockwell took note of this fact in a 1933 cover (Fig. 116) which shows a young mother torn between the teachings of child psychology and more traditional methods of discipline. (Rockwell's own remarks on this composition are interesting: "This November 25th cover was poorly conceived and painted, but it was timely enough to save it from its just desserts. Child psychology had hit the public like a bombshell. I was personally going through a very low period at this time, doing terrible work. . . .") Another, and rather more successful, 1933 cover (Fig. 117) shows a situation which is seen very much more from the child's point of view. A small girl, about to brush her teeth on her way to bed, pauses to watch her mother, who is checking her coiffure, presumably prior to a social engagement of some kind (a number of invitation cards are in evidence against the glass of the dressing-table mirror). The artist may consider this work to fall within his "very low period," but it is still a rather pleasing work. His handling of the satin of the woman's dress is especially fine and contrasts beautifully with the coarser fabric of the little girl's pajamas. An excellent 1930 cover (Fig. 120) shows a family united by their common exhaustion. A poster behind them tells us that they have been vacationing, and the flowers in the wife's hand and circling the brim of the husband's hat tell us that they have probably had a pretty good time.

In 1940 Rockwell painted a cover which shows us what might be described as the prelude to a family incident (Fig. 127). The wife—who is somewhat reminiscent of Lauren Bacall—has brought home swatches of fabric with the apparent intention of re-covering her husband's favorite sofa. The exchange of opinions that is about to commence could be reconstructed without too much difficulty.

A 1947 cover (Fig. 129) shows a rather large family—there are four children and a grandmother—embarking upon, and returning from, an outing to the country. In this before-and-after treatment the upper half of the composition shows them heading out among the lush summer vegetation in their somewhat ancient car, a dinghy tied to its roof. Spirits are high. Father sits upright at the wheel, his wife and youngest child alert beside him. His eldest son and the family pet lean out of a window into the balmy slipstream. One daughter blandly inflates a piece of bubble gum and another T-shirted son indicates, in no uncertain terms, his contempt for the driver of a late-model automobile which is about to overtake the family car. The lower half of the composition shows them heading back into the city (a pennant tells us that they have been to Bennington Lake). Father is slumped over the wheel, Mother is asleep, the children and the spaniel are exhausted. Only Grandma's composure has enabled her to withstand the pressures of the day.

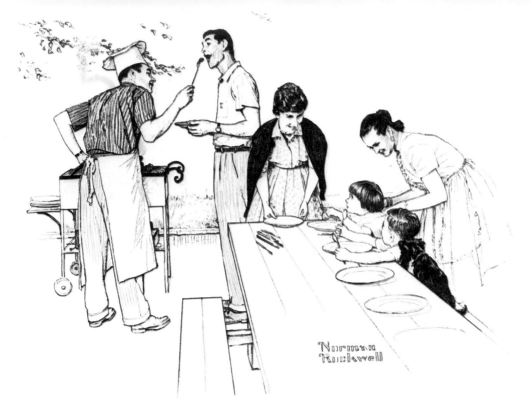

119. Advertisement for Massachusetts Mutual Life Insurance Company, Springfield

120. *Home from Vacation. Post* cover, September 13, 1930

In 1948 Rockwell presented the Truman/Dewey battle for the presidency in terms of its impact on home life (Fig. 130). This breakfast-table scene is self-explanatory, but it does repay close inspection. It is, as usual, beautifully executed, with all the details exactly right—note, for example, the toast waiting but forgotten in the toaster. A curious touch is the baby propped up against one leg of the breakfast table; his expression of total stupor must be unique in Rockwell's oeuvre. A 1946 maternity waiting-room illustration for the *Post* is again completely self-explanatory (Figs. 143 A and B). It is an interesting example of Rockwell's involvement with the representation of character. Of course, in almost all of his work he is concerned very directly with the representation of character, but usually he combines it with a number of other elements and so we are not so immediately aware of it. The maternity waiting-room illustration teeters on the edge of caricature without ever slipping.

Rockwell's evident understanding of the chemistry of family life has made him an obvious choice for certain kinds of advertisement. Some of his drawings for corporations such as the Massachusetts Mutual Life Insurance Company and Parker pens (Figs. 144, 146) are of considerable interest. The little girl thanking her father for the pen he has just presented to her is especially good: it is a small thing but perfectly realized.

Rockwell's picture of family life is in many ways a capsule of his picture of America. He takes its mythology seriously, but without permitting it to become devoid of humor. He does not show us any major breakdowns, but neither does he attempt to gloss over all the problems. He brings to it—especially in his later work—a realism which prevents him from overidealizing his subject matter. His kitchens are real kitchens and they demand a certain life-style. Attitudes to this life-style might vary from person to person, but there is nothing vague about it. One can react to it as one would to a slice of reality. Some critics may find themselves out of sympathy with the life-style that Rockwell presents, but they cannot argue with the fact that he presents it with a faithfulness to appearances which can only command respect.

102

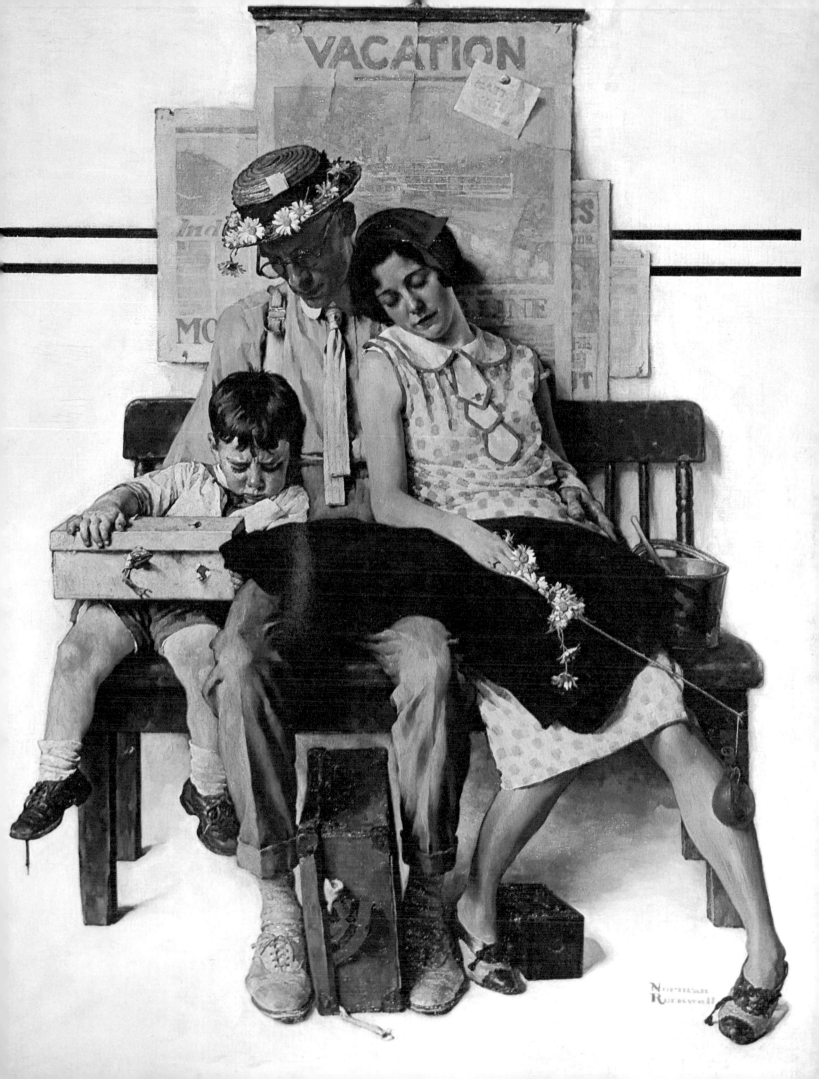

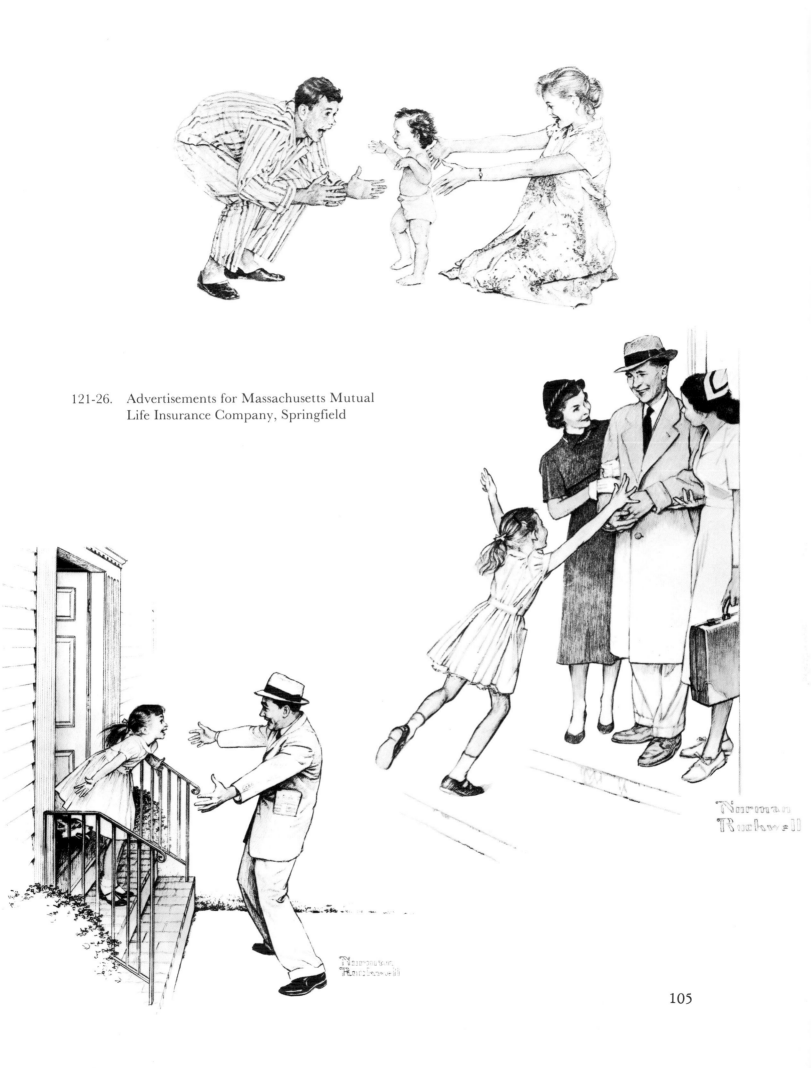

121-26. Advertisements for Massachusetts Mutual
Life Insurance Company, Springfield

127.	*The Decorator. Post* cover, March 30, 1940

128.	Advertisement for Massachusetts Mutual
Life Insurance Company, Springfield

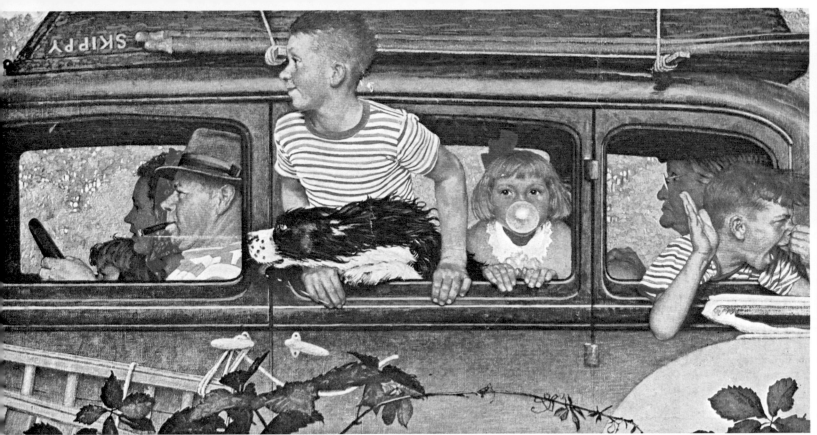

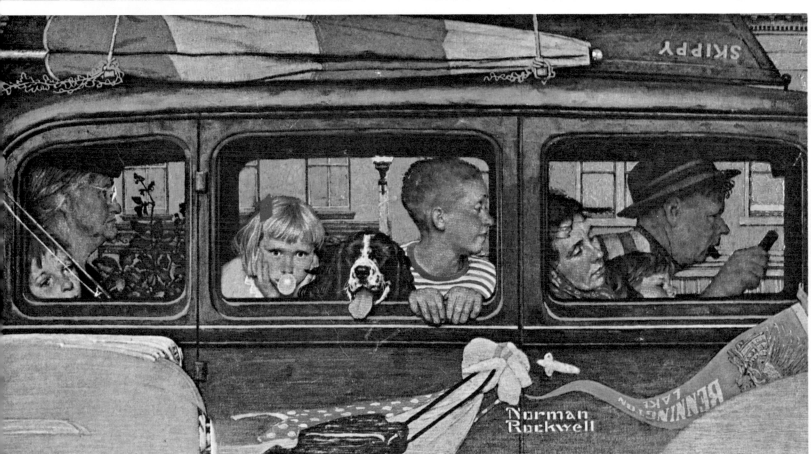

129. *The Outing. Post* cover, August 30, 1947

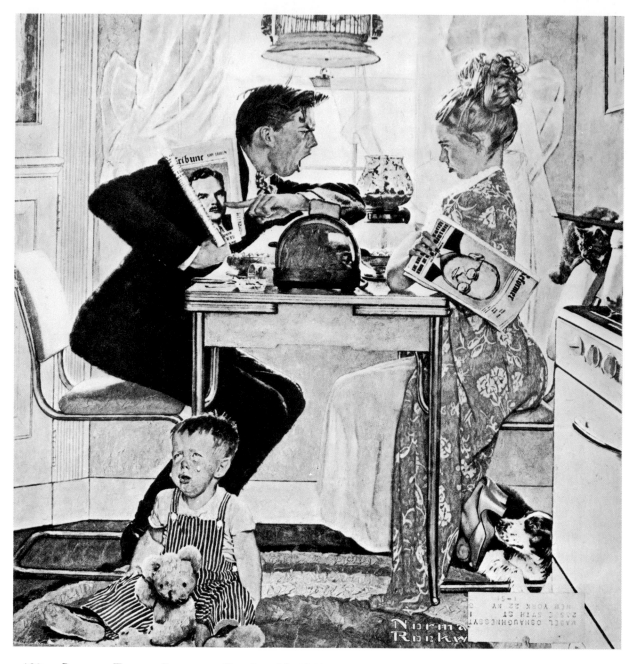

130. *Dewey vs Truman. Post* cover, October 30, 1948

131-34. Advertisements for Massachusetts Mutual
Life Insurance Company, Springfield

135-42. Advertisements for Massachusetts Mutual
Life Insurance Company, Springfield

144. Advertisement.
Courtesy The Parker
Pen Company

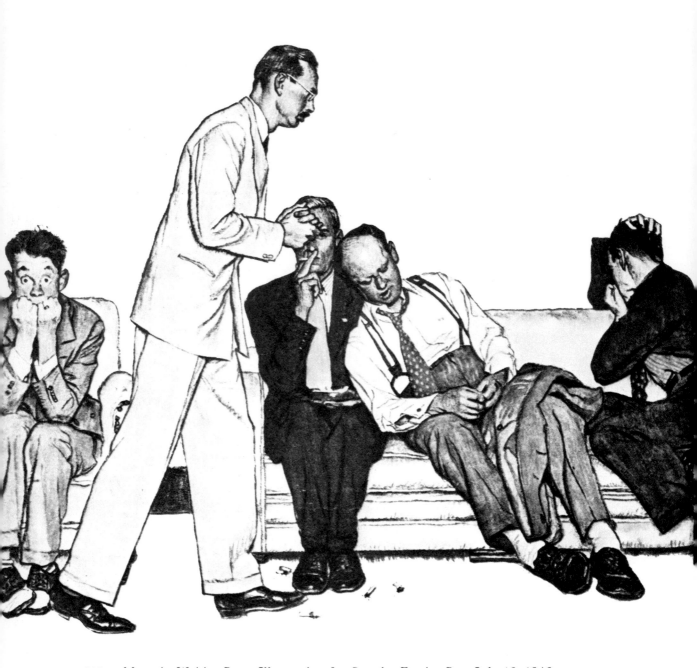

143. *Maternity Waiting Room.* Illustration for *Saturday Evening Post,* July 13, 1946

◄ 145. *Norman Rockwell Visits His Country Doctor.*
Illustration for *Saturday Evening Post*, April 12, 1947

146. Advertisement for
Massachusetts Mutual
Life Insurance Company,
Springfield

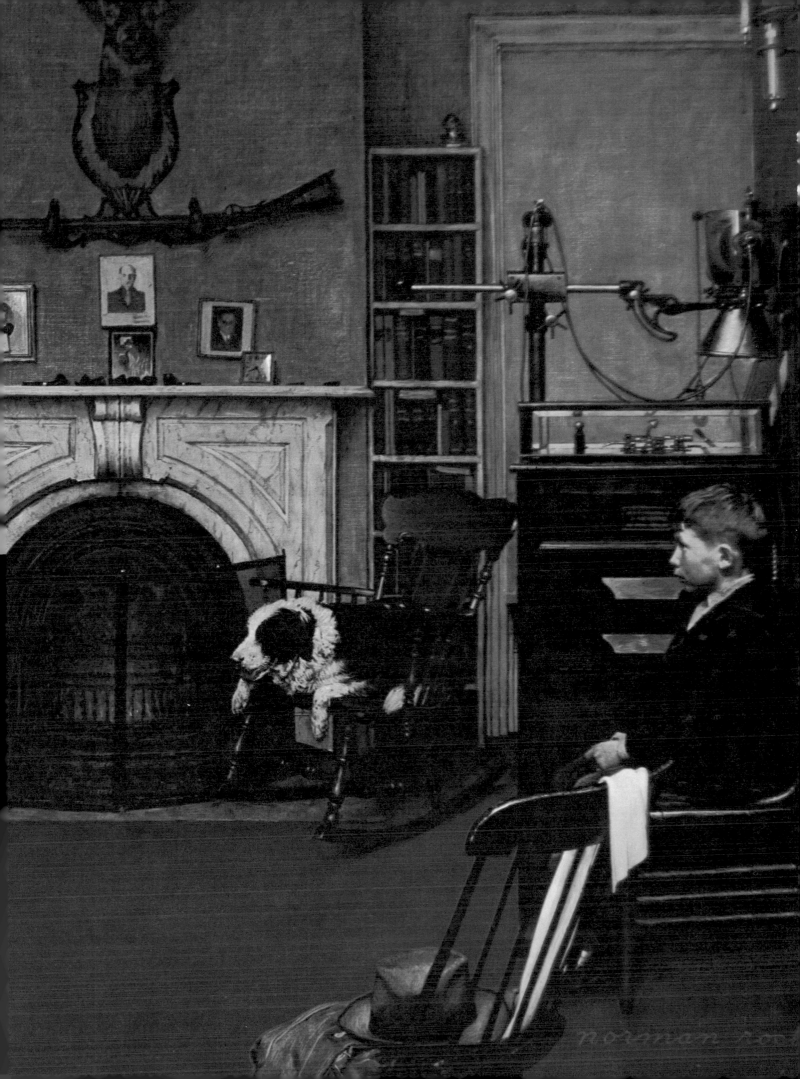

147. Advertisement for Massachusetts Mutual
Life Insurance Company, Springfield

Growing Old in America

148. Advertisement for Massachusetts Mutual
Life Insurance Company, Springfield

149. *The Old Couple. Literary Digest* cover, April 15, 1922

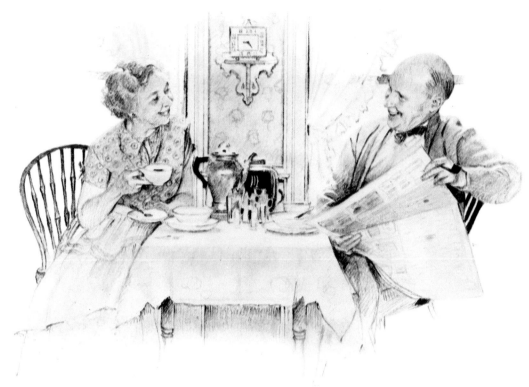

150. Advertisement for Massachusetts Mutual
Life Insurance Company, Springfield

Growing old in America is a subject that Norman Rockwell has always approached with considerable sympathy. Even in the work which he did as a young man, it is evident that he assumes that the old people he portrays have earned the privilege of enjoying their retirement. In 1930 Rockwell painted a classic image of carefree retirement (Fig. 151). An elderly man relaxes in his dinghy. A pipe is in his mouth, a flyswatter in his hands; a battered umbrella protects him from the July sunlight. A number of fishing lines have been cast into the water, but they are ignored except by his dog. The old man himself is asleep or close to sleep; any fish that he catches will be a bonus on top of the real business of the afternoon, which is the pursuit of peace, quiet, and happiness. Rockwell's old people aspire to much the same condition of timelessness that is evident in his portrayals of children. This fisherman typifies that condition. He is beyond the cares of making a living; he has earned his and is reaping his reward. It is interesting to note that Rockwell was in his mid-thirties when he painted this cover and was working, as usual, to the demands of deadlines—demands from which he has never entirely escaped, since he has continued to work long past the age at which most people have chosen to go fishing.

Not that Rockwell's senior citizens always choose such tranquil pastimes as fishing for their retirement. For a number of them, old age offers an opportunity to search for knowledge. Time is—at last—available to them and is not eaten into by the demands of day-to-day living and petty ambitions. Intellectual inquiry is high on the list of priorities for these folks. They approach every subject with an evident enthusiasm, as though they were discovering it for the first time.

Take, for example, the two old men studying a globe which Rockwell painted for the cover of the *Literary Digest* in 1922 (Fig. 153). They are like a couple of young students. Advertisements painted for Edison Mazda Lamp Works and for the Encyclopaedia Britannica also show this same enthusiasm. In one instance we see a Rembrandt-like image of an elderly man writing with a quill pen in a heavy book (Fig. 161). The electric lamp that illuminates the scene becomes a symbol of the light of reason. It is interesting that Rockwell should have chosen an elderly person for this idea (he could equally well have used a young scholar to tell the same story); age, in this instance, is seen as a repository of wisdom. The scene of two old men arguing, on the other hand (Fig. 162), is altogether more humorous. It shows these friends in a search for knowledge—a search that is facilitated by the leisure of retirement—but the hint is clear that this search may be somewhat erratic. Rockwell's Christmas covers tell us that Dickens is one of his favorite authors, and there are a whole host of characters in Dickens' novels who could have provided inspiration for an illustration of this kind.

A 1922 *Post* cover shows an elderly couple listening to opera through the grace of that wonder of the age, radio (Fig. 152). Such reminders of technical and social innovations crop up in Rockwell's work from time to time (the child-psychology cover which we discussed in the last chapter is another example). What is interesting in this particular instance is the idea of contrasting novelty with age. This contrast is not exploited humorously; it is essentially sympathetic.

This radio cover appeared on May 20. A week later, on May 27, 1922, another Rockwell cover reached the newsstands; this one was painted for the *Literary Digest* and shows a quite different image of old age. Instead of using age as a contrast for novelty, this second cover uses age as a symbol of the continuity of traditional values. Titled *Mending the Flag,* its subject is exactly that (Fig. 154); a Betsy Ross-like old lady sits in front of a window restoring Old Glory to its former condition. It is interesting to note, in passing, that Rockwell's covers for the *Literary Digest* at this time are often more fully rendered than his covers for the *Post* of that same period. *Post* covers were not reproduced in full color until a little later in the decade, and there was, therefore, a tendency to treat them in a rather more abstract, more design-oriented way; the trick was to set character studies against the abstract background provided by the *Post*'s logo. Often, as in Rockwell's study of an old salt and a boy with a telescope, the lettering of the logo is partially concealed by the image (Fig. 163). The format was so much taken for granted that this kind of liberty became very commonplace. *Digest* covers, by contrast, were printed in color but were simpler in concept—consisting, in effect, of a painted image surrounded by type. As covers they are less sophisticated, less modern-looking, than the *Post* covers; but they did, in certain respects, give the artist more leeway. *Mending the Flag* is a good example of what Rockwell was capable of producing at this time when given the opportunity.

A 1923 cover (Fig. 155) shows an elderly man on a cruise. The porthole behind his head actually seems to punch a hole through the *Post* masthead. The format is skillfully handled. Of course, the emphasis is ultimately placed on character study, and in this

151. *Gone Fishing. Post* cover, July 19, 1930

152. *The Wonders of Radio. Post* cover,
 May 20, 1922

153. *Settling an Argument. Literary Digest* cover, June 24, 1922

154. *Mending the Flag. Literary Digest* ▶
 cover, May 27, 1922

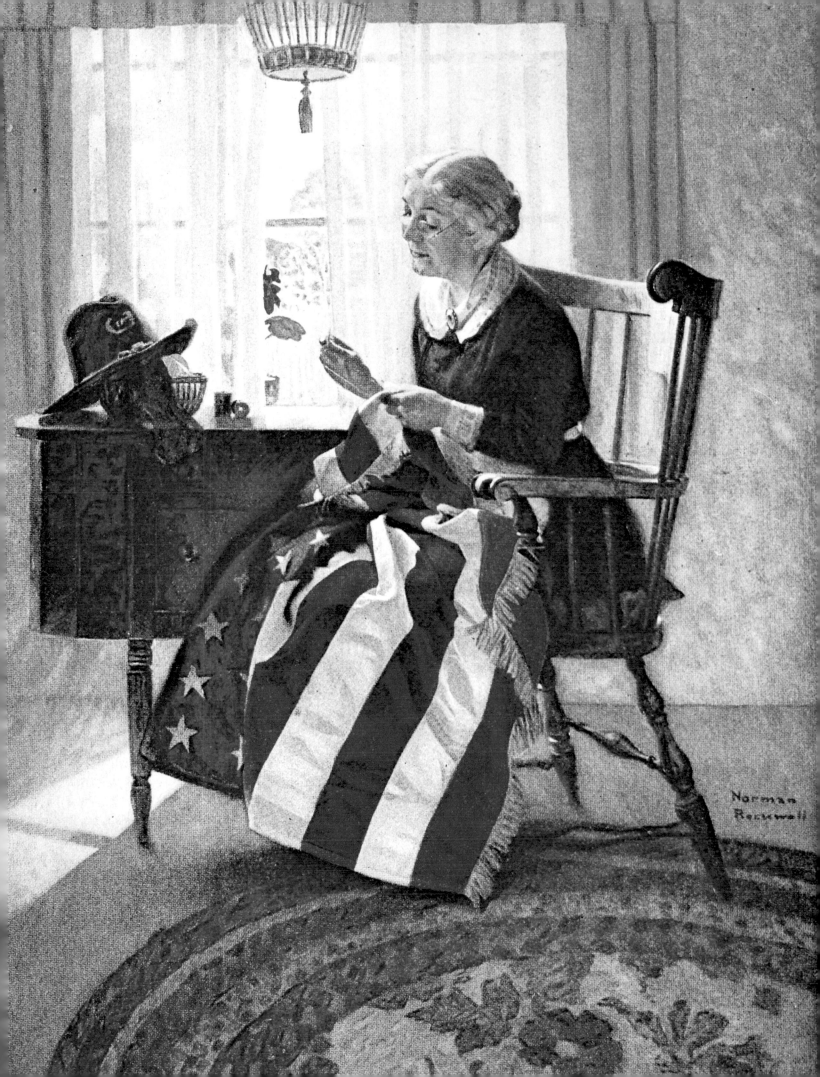

155. *The Cruise. Post* cover,
September 8, 1923

instance we have once again a portrayal of a man who has paid his dues and is now enjoying his leisure (though possibly suffering from seasickness). Not that Rockwell imposes a strict rule of a life of hard work as the prerequisite for happiness in old age. In the first half of his career, tramps were a favorite subject of Rockwell's, and he did not treat them with any less sympathy than he displayed toward his bourgeois old folks. The elderly bum cooking sausages on an improvised spit (Fig. 156) is a good example. In a 1927 illustration we find another old person who, though not a tramp, has fallen upon hard times. In Norman Rockwell's America he is not a forgotten man, however; friendships last, and his buddy has taken the trouble to seek him out, bringing a hamper of Christmas goodies.

For the most part, Rockwell's old folks are subject to the chemistry of eternal optimism. The flautist who was the subject of a May, 1925, cover (Fig. 168) is playing a composition titled "Spring Song." It may be that in spring a young man's fancy turns to love, but in Rockwell's world an old man's fancy turns to the formal celebration of spring. Rockwell's old folks are always trying to make the most of the time that remains—even if their vehicle is the medium of gossip (Fig. 164).

A fine late-thirties cover (Fig. 166) shows an old lady making her first flight. A chart of the aircraft's route is open in front of her and she peers out at the landscape which slips by beneath. We are able to gauge from her slightly nervous pose that she has probably experienced some minor apprehension regarding this experience; but at the same time we can tell that she is beginning to enjoy herself. Rockwell's old people are essentially reassuring. They tell us that growing old is not necessarily something to be frightened of, that age need not be an impediment to living a full life, and that it brings with it its own compensations. The old man swimming in a 1945 cover (Fig. 174) is certainly still capable of enjoying himself.

As the subject of his 1956 Four Seasons calendar, Rockwell chose the theme of two old friends (Figs. 170-73); this series is almost an anthology of his attitudes toward growing old in America. Spring finds the friends in their garden, excited by the appearance of the year's first blossoms. By summer they are challenging the wrath of authority by revisiting the old swimming hole (the composition of this image is based closely upon the 1921 swimming-hole cover which we discussed in an earlier chapter). Autumn brings

156. *The Hobo. Post* cover,
October 18, 1924

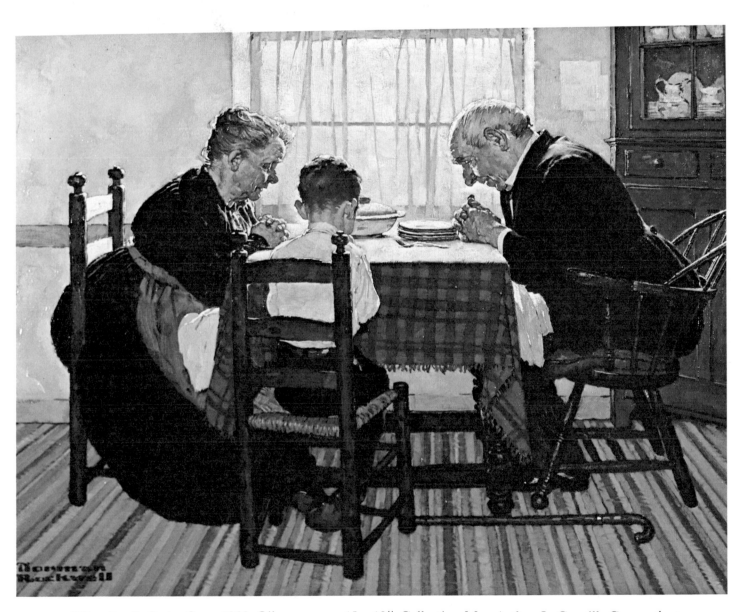

157. *Family Saying Grace.* 1938. Oil on canvas, 15 x 19″. Collection Mrs. Arthur L. Guptill, Connecticut

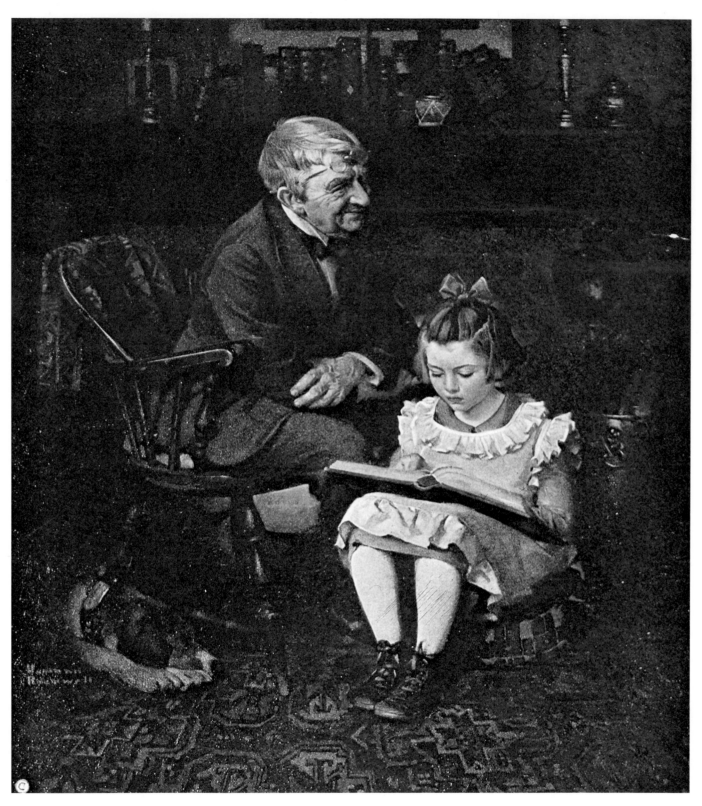

158. *Reading Hour. Literary Digest* cover, March 25, 1922

159. *Grandpa and the Children. Literary Digest* cover, December 24, 1921

160. Illustration for "A Christmas Reunion," *Ladies' Home Journal*, December, 1927. © Downe Publishing, Inc.

elections and political arguments outside the polling booth. In the winter these two old friends are already looking forward to the next summer as they heatedly discuss prospects for the baseball season in front of a potbellied stove. In all of these situations they are accompanied by a faithful mongrel. The two oldsters are clearly the ragamuffins of Rockwell's early illustrations discovered at a later stage in life. Their bodies may have aged, but their characters are little changed.

163. *Setting One's Sights.*
Post cover,
August 19, 1922

161. Advertisement for
Edison Mazda Lamp Works

162. *The Argument.* Oil on canvas, 30 x 36″.
Encyclopaedia Britannica, Chicago

165. *The Puzzle. Post* cover,
January 31, 1925

164. *The Gossips. Post* cover, January 12, 1929

167. *Tea Time. Post* cover,
October 22, 1927

166. *Airplane Trip. Post* cover, June 4, 1938

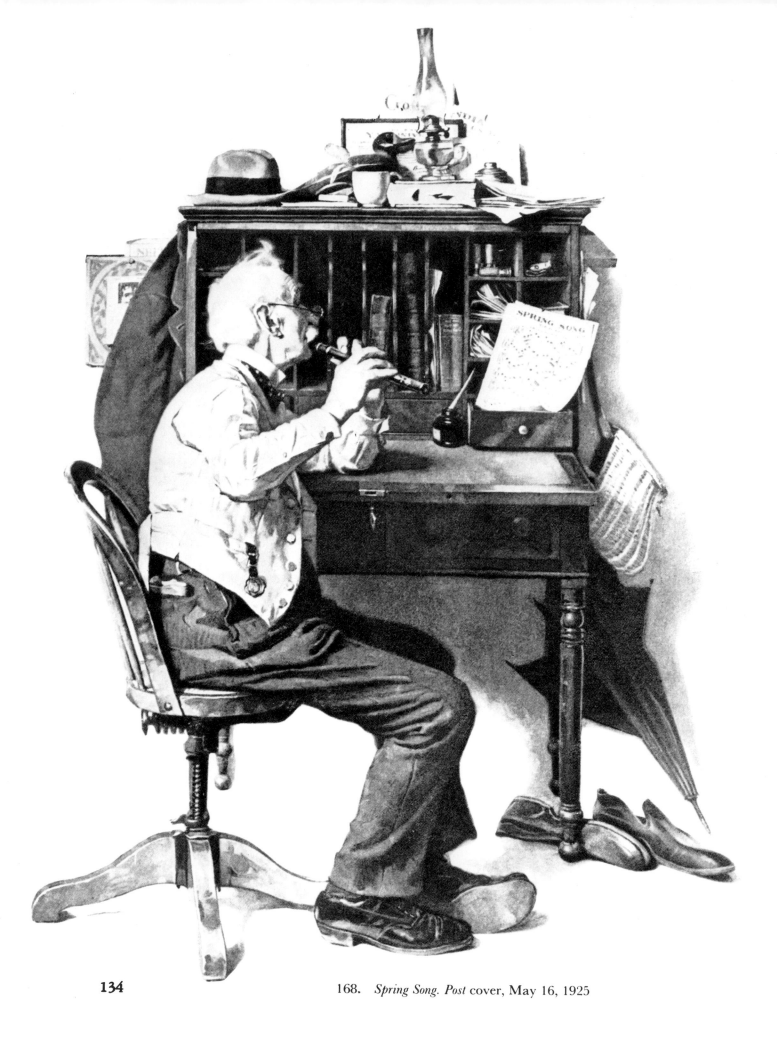

168. *Spring Song. Post* cover, May 16, 1925

169. *The Violinist. Literary Digest* cover, February 25, 1922

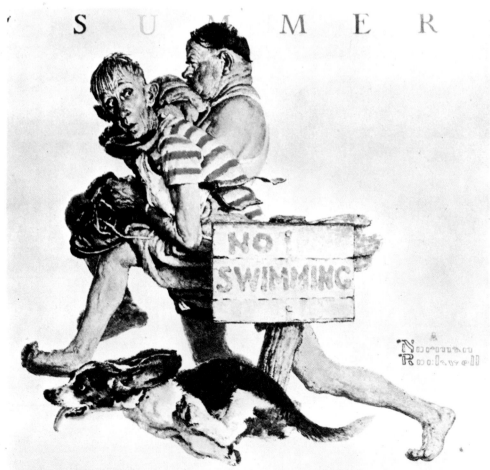

170-73. Four Seasons calendar:
Two Old Friends. 1956.
© Brown and Bigelow,
a division of Standard
Packaging Corporation

174. *The Swimming Hole. Post* cover, August 11, 1945

The American Past in Fact and Fiction

175. *King George III Inn.* Linoleum cut for "The New Tavern Sign" (fig. 182)

176. *George Washington Inn.* Linoleum cut for "The New Tavern Sign"

177. *A Family Tree.* Original oil painting for *Post* cover, October 24, 1959. Collection Norman Rockwell

178. *Thanksgiving (The Glutton).*
Life cover, November 22, 1923

For the cover of the *Post* dated October 24, 1959, Rockwell painted an American family tree (Fig. 177). It is, of necessity, a little abbreviated, but in its compressed form it takes us through nearly three centuries of American history. The tree is rooted on a treasure-strewn shoreline off which a Spanish galleon burns against the sun, its wooden hull still under fire from the cannons of a pirate ship. Our first couple, then, consists of a fierce-looking pirate with eye-patch, pigtails, and earrings, and a proud Spanish beauty who, we can assume from the quartered shield beside her, is of noble descent. The mother of us all, in this brief history of the New World, is the booty of a buccaneer. The next generation shown takes us into the Colonial era. The husband, in his tricornered hat, has the ruddy features of an English squire. His redheaded spouse might have a touch of Irish blood. The male partner of our third couple is a handsome young gentleman who affects the bewigged elegance of European society, but he owns a pair of eyes that seem fixed upon some vision of a new order (his wife's sideways glance hints at more down-to-earth interests). This young man may not actually have affixed his signature to the Declaration of Independence, but we need have no doubts as to where his sympathies lie. We move on to a swarthy gentleman in a top hat and a plump lady in a bonnet who displays a comfortable smile and a peaches-and-cream complexion. They seem to represent a new middle class—a middle class that is about to be torn asunder by civil war. The tree divides and we find, on the one hand, a Yankee soldier and, on the other, his Confederate counterpart, each with his own appropriate spouse. The division is perpetuated. We come to a serious-looking reverend and his equally serious-looking partner. They are the epitome of Middle Western Protestant rigor. Balancing this couple is a bearded prospector, or pioneer, who has married into one of the great Indian nations. The spirit of adventure is matched against the value of conservatism. The next phase sees a cowboy and his saloon-girl partner, set off against a pair of

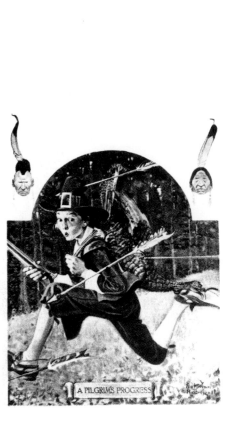

179. *A Pilgrim's Progress*
Life cover, **November 17, 1921**

180. Advertisement for
Interwoven socks.
**Courtesy Kayser-Roth
Hosiery Co., Inc., New York**

sophisticates who have certainly read Henry James and might even find their way into some story by F. Scott Fitzgerald. Then, finally, the two branches of the tree come together once again and we are in the postwar world (not quite the modern world, since by now the young fellow who tops the tree may have grown long hair and look more like his pirate ancestor than any of his immediate forebears).

This direct treatment of the American past is comparatively rare in Rockwell's later work. In 1946 he wrote, "At one time I did a great many of these historical illustrations of one kind or another—mostly Colonial. They were fun to do for a while; I liked the elaborate costumes and romantic settings. In recent years, the everyday happenings have been so exciting that I have preferred to interpret them. . . ."

Rockwell has, in fact, dealt with many different periods of American history—quite apart from his detailed picture of Middle America in the twentieth century. In the early twenties (Figs. 178, 179) he painted Thanksgiving covers for *Life* which drew upon the Pilgrim Fathers for their imagery, showing them in a light which is not wholly devoid of humor. The glutton in the stocks is, one must admit, something of an unusual Thanksgiving image. The boy returning from his turkey hunt, pursued by Indians, illustrates an aspect of Thanksgiving that does not fall within our present field of experience. The humor of these works is typical of what we shall see in Rockwell's treatment of historical subjects. His aim, when he deals with this kind of subject, seems to be to make American

142

history easily available—to humanize it by presenting it in terms of situations with which his audience can easily identify.

Rockwell's large mural painting for the Nassau Tavern in Princeton, New Jersey, is typical of this (Fig. 181). It owes its character to an idiom that falls somewhere between naturalism and caricature. The redcoat soldiers to the right of the composition and the figures at the tavern doorway verge on the edge of caricature; both poses and facial characteristics are exaggerated. The English officer at the left of the composition and the girl with whom he is flirting are handled in a much more straightforward manner. The treatment of Yankee Doodle himself is interesting. His face suggests that he is a very self-contained person. He sits proudly on his pony. His frame is slender but erect; his mouth and jaw are delicate, but his profile, taken as a whole, is strong; his hands seem exceptionally powerful for a person of his build.

Another painting very closely related to this mural was done as an illustration for "The New Tavern Sign" and appeared in the *Post* in 1936 (Fig. 182). It shows a young artist applying the final touches to the new sign. The "King George III Inn" has become the "George Washington Inn." Little explanation is required, but it is interesting to note that the treatment of the figures in this work is more consistent than in the Nassau Tavern mural. None of them is subjected to anything approaching caricature. The inn signs themselves have a charming primitive quality which Rockwell reproduced in a pair of linoleum cuts (Figs. 175, 176). Both the Yankee Doodle mural and The New Tavern Sign are horizontal compositions, a format which Rockwell was learning to handle with considerable skill. Another illustration which appeared in 1939 also exploits the horizontal format to show an imaginary episode in the life of the great statesman and orator Daniel Webster. Two unpublished studies of Ichabod Crane, by contrast, make effective use of vertical formats (Figs. 185, 186).

These Ichabod Crane studies were intended for a proposed series of illustrations of famous characters from American fiction. The series was never carried out because, rather surprisingly, Rockwell could not find a publisher who was interested in the idea. One of his great successes, however, was achieved in the same general area with what are perhaps the best known of all American fictional characters. He was invited by the Heritage Press to make illustrations for new editions of *Tom Sawyer* and *Huckleberry Finn*. It is hardly surprising that Rockwell should have thrown himself into this project with characteristic thoroughness, since in the two books and the characters that inhabit them we find in a pristine form all the American myths that Rockwell himself has so assiduously explored. He traveled to Hannibal, Missouri, to familiarize himself with the actual setting of Mark Twain's stories. He walked Hannibal's streets and through the surrounding countryside; he talked to the town's inhabitants, including some who were contemporaries of Samuel Clemens. He felt Hannibal's pulse. Then, armed with a mass of study material, he returned to his studio and composed the illustrations that were to become familiar to so many Americans (Figs. 190-97).

Even as Tom and Huck were growing to manhood in Hannibal, a whole new world was opening west of the Mississippi; in 1966 Rockwell was to illustrate this in a series of promotional paintings for the movie *Stagecoach*. Apart from painting portraits of some of

YANKEE DOODLE CAME TO TOWN · RIDING ON A PONY

181. *Yankee Doodle.* Mural for the Nassau Tavern, Princeton, N.J.

the chief characters, he contributed a panoramic view of the stagecoach under attack by Indians, the incident being set against a background of arid, Southwestern hills. This is, we might remark in passing, one of Rockwell's comparatively rare compositions to be concerned with the depiction of speed. The fact that the team of horses is pulling the mail coach up a slight incline contributes greatly to the overall sense of urgency.

In *Tom Sawyer* and *Huckleberry Finn,* Rockwell had dealt with some of the most popular characters in American fiction. In his illustrations for *Most Beloved American Writer* he turned his attention to one of the best known of all American authors—Louisa May Alcott. Just as he had visited Hannibal, Missouri, for the Twain books, he now set out to

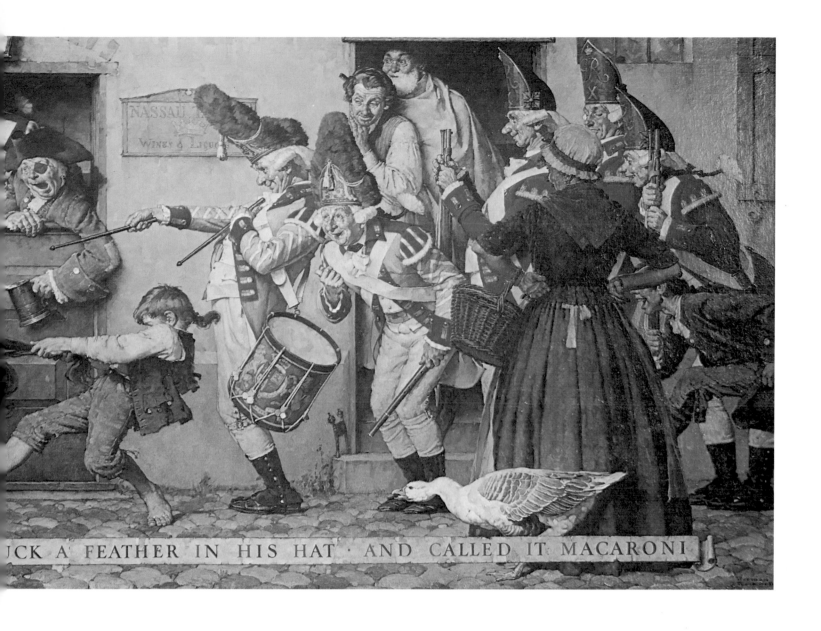

...CK A FEATHER IN HIS HAT · AND CALLED IT MACARONI

familiarize himself with the Alcott home at Concord, Massachusetts. He spent several days there in the company of Henry Quinan, then director of the *Woman's Home Companion*, who had commissioned the illustrations. The house remained exactly as it had been when Louisa May Alcott lived there. Rockwell saw her room, her lamp, her swing—everything. Many of the illustrations he did in this series are line drawings (Figs. 189, 198), and these are handled with a delicacy and lightness of touch which is extremely appropriate to the subject matter. Rockwell's sympathy with his subject matter has seldom been more evident than in this series.

A few years before Rockwell sold his first drawing, Henry Ford built his first

avern Sign
painted by NORMAN ROCKWELL

183. *Matthew Brady Photographing Lincoln.* Original oil painting. © 1975, by Jack O'Grady Galleries, Inc. All Rights Reserved

automobile. For its fiftieth-anniversary calendar, the Ford Motor Company commissioned Rockwell to paint Henry Ford driving this automobile, the progenitor of a long line, through the streets of Detroit. The result was a typical Rockwell blend of humor and naturalism (Fig. 200), rather reminiscent of *Walking to Church*. The automobile and the architecture are handled with a loving concern for accuracy of detail; a whole era is evoked. Henry Ford himself and the startled citizens who have come out to see him verge upon caricatures. The entire scene has a sharpness which almost convinces us that Rockwell must have been present on the occasion of this inaugural drive.

Perhaps it would be more to the point to say that, in his treatment of historical

148

subjects, Rockwell attempts to give to his audience the feeling that *they* could have been there and that, if they had been, they would have understood what was going on.

When Rockwell deals with the American past, he does not, as a general rule, attempt to give us the great moments of history. Rather, he has chosen to explore the byways and backwaters of history—but byways and backwaters that are in some way significant. In this sense, his approach to the past is typical of his work as a whole. Just as an art connoisseur may determine the authenticity of a painting by looking at apparently insignificant details—the handling of an ear lobe or a toe—so Rockwell attempts to find the little idiosyncrasies which give the authentic feel of a culture.

Becky Sharp
by
Norman
Rockwell

◄184. *Becky Sharp.* Color sketch (unfinished)

185. *Ichabod Crane* (first version). Oil painting.
Never used as an illustration.
Collection Norman Rockwell

186. *Ichabod Crane* (second version). Oil painting.
Never used as an illustration.
Collection Norman Rockwell

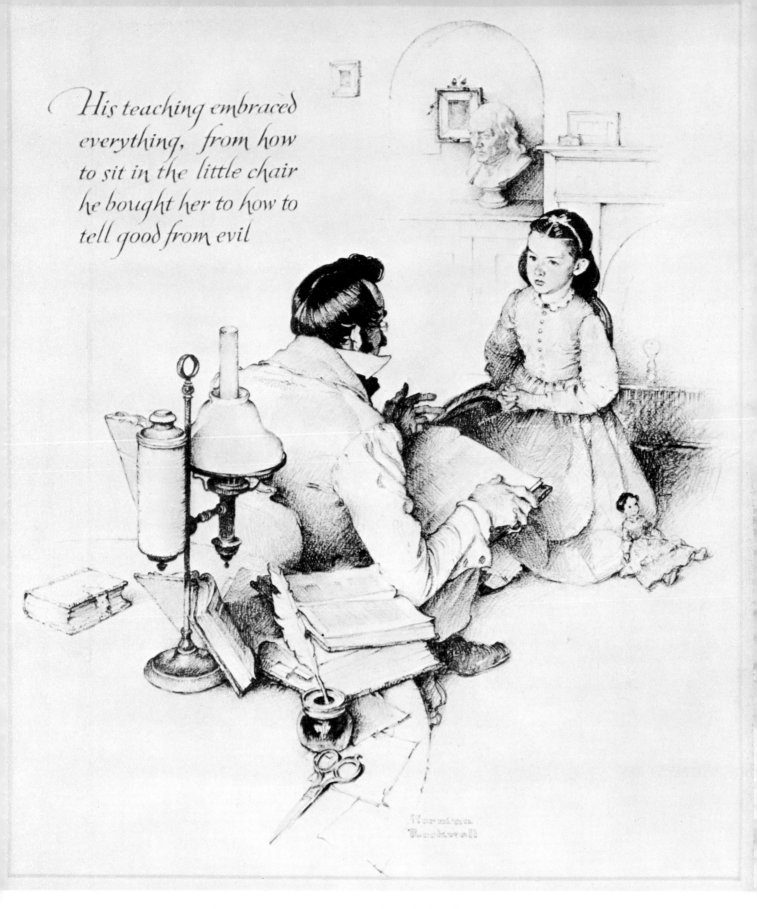

His teaching embraced everything, from how to sit in the little chair he bought her to how to tell good from evil

189. Illustration for "Louisa May Alcott: Most Beloved American Writer" by Katharine Anthony, *Woman's Home Companion,* December, 1937–March, 1938

188. *The Chase.* Illustration based on the film "Stagecoach," 1966. Twentieth Century Fox Film
Corporation and Martin Rackin Productions.

◀187. Illustration for "Louisa May Alcott: Most Beloved American Writer"
by **Katharine Anthony,** *Woman's Home Companion,* December, 1937–March, 1938

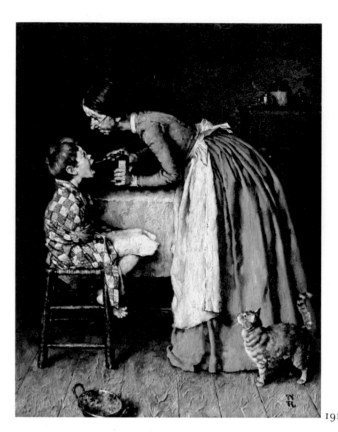

190-93. *The Adventures of Tom Sawyer.* © 1936, 1964, by The George Macy Companies, Inc., New York

194-97. *The Adventures of Huckleberry Finn.* © 1940, 1968, by The George Macy Companies, Inc., New York

192

193

196

197

She came to a standstill, feeling none of the cold as she read the "delicious words"

198: **OPPOSITE PAGE**, 199. **ABOVE**:
Illustrations for "Louisa May Alcott: Most Beloved American Writer"
by Katharine Anthony, *Woman's Home Companion*, December, 1937-March, 1938

200. 50th Anniversary calendar of Ford Motor Company. Oil on canvas, 15¾ x 15½″.
Detroit Historical Museum, Industrial History Division

Democracy

201. *The Debate. Post* cover, October 9, 1920

202. *A Time for Greatness.* Original oil painting for *Look* cover, July 14, 1964. Private collection

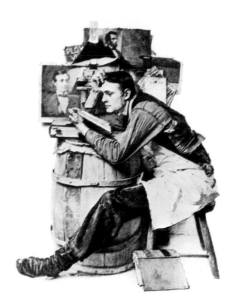

203. *The Law Student. Post* cover,
February 19, 1927

Norman Rockwell painted John F. Kennedy a number of times, both as a candidate and as the President. One of the most interesting of these studies, painted for the cover of *Look* almost nine months after the President's tragic death, takes as its title Kennedy's own slogan, *A Time for Greatness* (Fig. 202). What makes it particularly interesting is the fact that in this instance Kennedy is shown in the context of a party convention. In this painting, the presidency is not treated as something which separates the chief executive from other men; rather, it is seen as something which links him to them. Rockwell seeks to remind us that the President owes his power to the people—to the democratic process. At the heart of this process is the basic notion of freedom, and this is the subject of what are, perhaps, Rockwell's best-known paintings—*The Four Freedoms* (Figs. 204–7).

The Four Freedoms were started in 1941 and drew their inspiration from some celebrated remarks made by Franklin Delano Roosevelt in the President's Annual Address to the Congress:

In the future days, which we seek to make secure, we look forward to a world founded upon four essential human freedoms.

The first is freedom of speech and expression—everywhere in the world.

The second is freedom of every person to worship God in his own way—everywhere in the world.

The third is freedom from want—which, translated into world terms, means economic understandings which will secure to every nation a healthy peacetime life for its inhabitants—everywhere in the world.

The fourth is freedom from fear—which, translated into world terms, means a world-wide reduction of armaments to such a point and in such a thorough fashion that no nation will be in a position to commit an act of physical aggression against any neighbor—anywhere in the world.

ON FOLLOWING PAGES, NUMBERS 204-7: ▶
Freedom of Speech, Freedom of Worship, Freedom from Want, Freedom from Fear.
Original oil paintings for posters, 1943. Collection Norman Rockwell

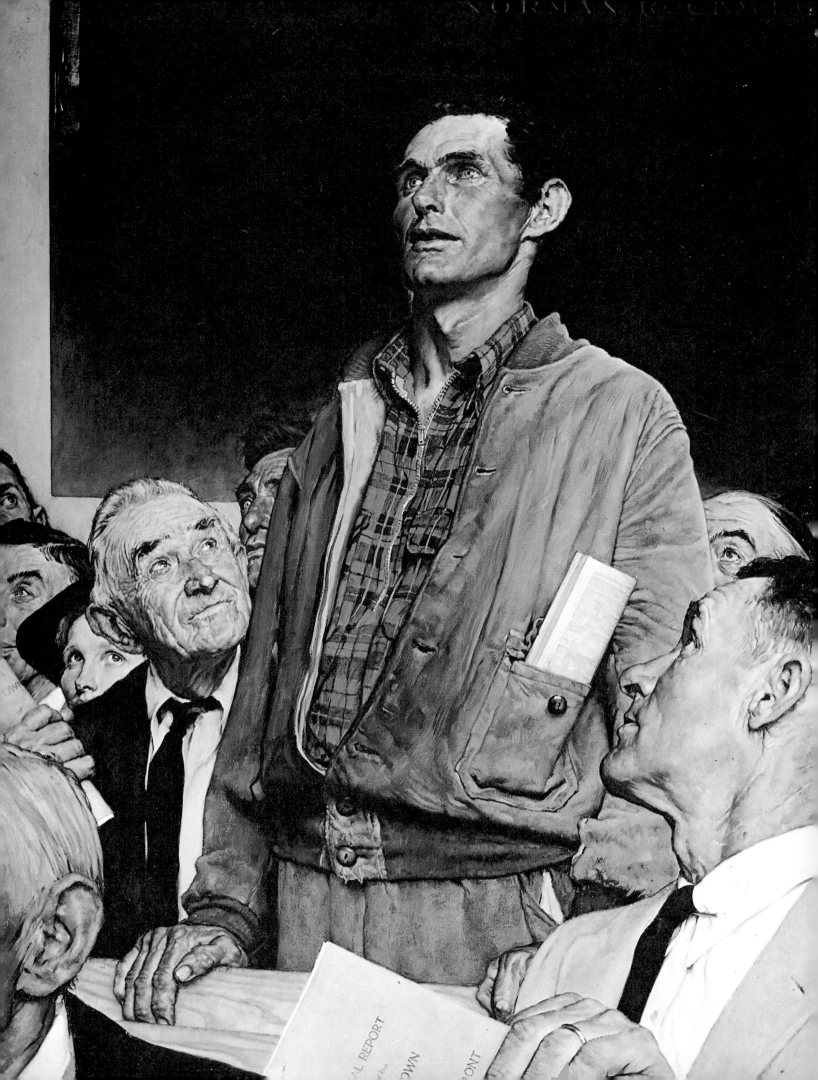

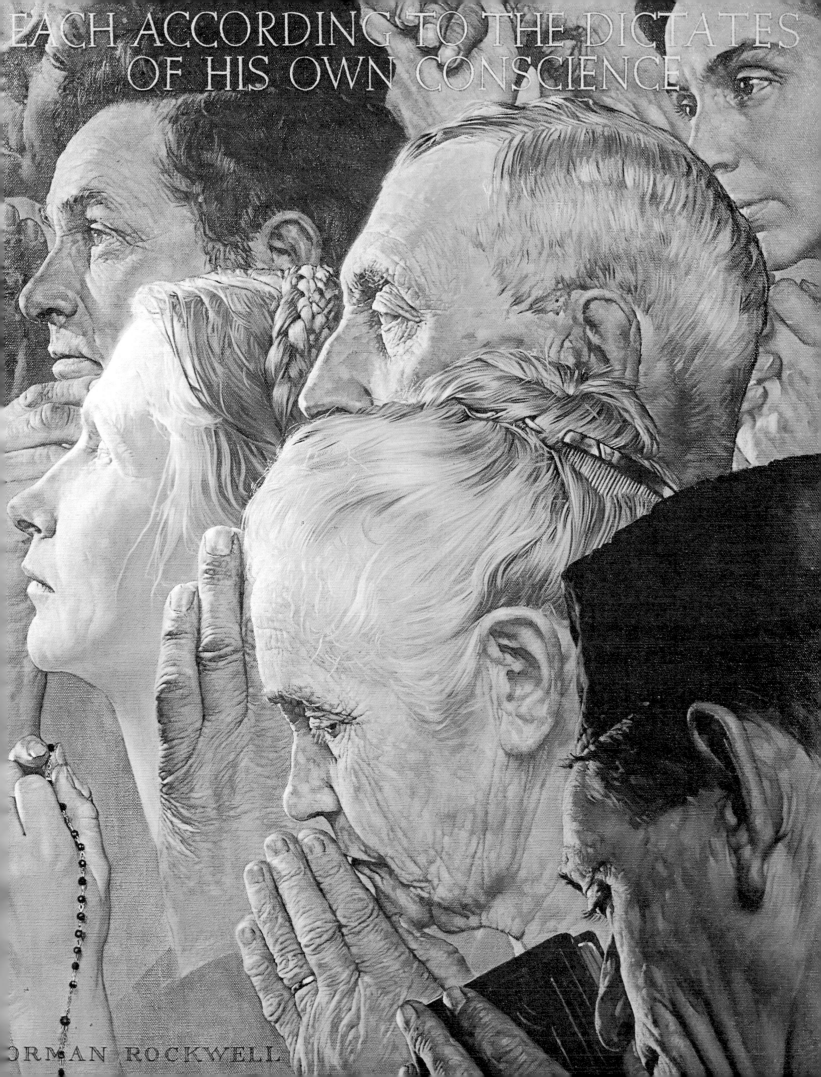

EACH ACCORDING TO THE DICTATES OF HIS OWN CONSCIENCE

NORMAN ROCKWELL

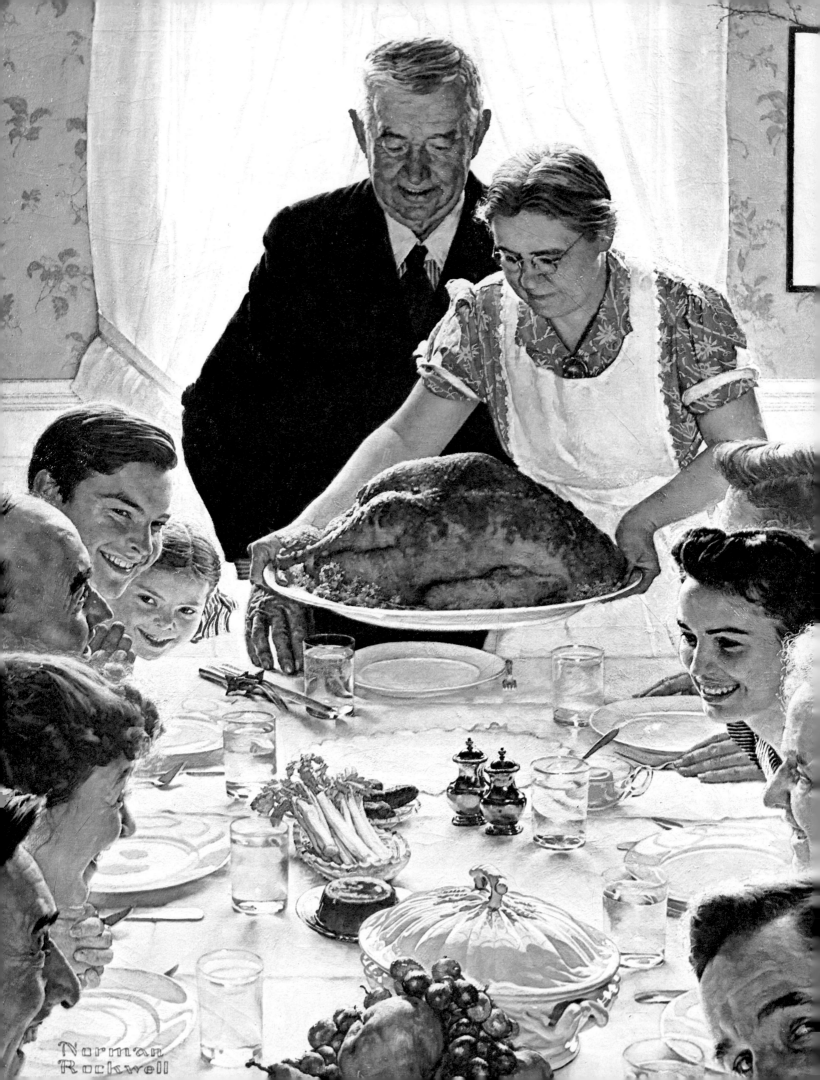

Norman
Rockwell

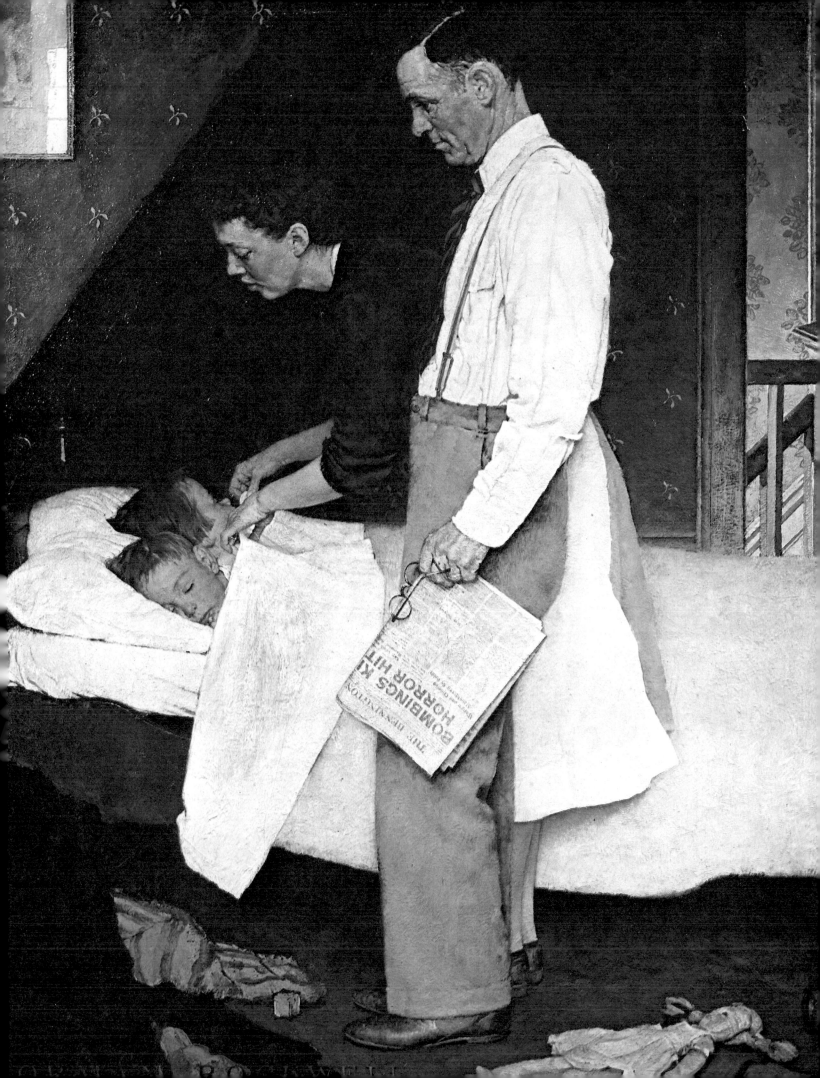

It is fashionable to speak of *The Four Freedoms* as being somewhat naive, as having little relevance to the 1970s. Insofar as F.D.R.'s hopes have not been realized, I suppose this is so, but if Roosevelt was a naive man, perhaps we might profit from having more naiveté in politics today. In regard to Rockwell's treatment of *The Four Freedoms,* we must be careful to judge this by his own standards. These paintings are period pieces, and it would be unfair to consider them outside of that context—1941 was not a year marked by cultural objectivity. These paintings are dealing with a black-and-white sense of right and wrong in much the same way as it can be encountered in a Dana Andrews war movie.

The first thing to notice is that, whereas Roosevelt concludes each of his statements of freedom with the phrase "everywhere or anywhere in the world," Rockwell treats the freedoms within an essentially American setting. This is legitimate enough since he was working for an American audience, and it is difficult to see anyway how one could adequately provide a global setting for this subject matter. Even within the context of the United States, the question of universality was to present Rockwell with a problem. There is no doubt that this series of paintings caught the imagination of the country at the time they were published. The question is, were the paintings successful examples of Rockwell's art? I think that the answer to this is that two are and two are not.

The two failures are, in my opinion, *Freedom of Speech* and *Freedom of Worship.* The basic concept of *Freedom of Speech* is a good one, but Rockwell's treatment does not sustain it. The scene is a town meeting where the annual report is being discussed. A young blue-collar worker is on his feet giving his opinion on some point under consideration. So far so good. Unfortunately, Rockwell has painted him with his eyes lifted as though to heaven and with an expression which might be appropriate to a saint, but which seems to bear little relationship to the worldly affairs that are presumably before the meeting. The people surrounding the young worker—including middle-aged and elderly business-executive types—gaze up at him with looks that are so laden with admiration as to seem unreal. The overall effect is to patronize both the young man and those who surround him. Had this subject been treated in a more deadpan way, it might have been very striking. As it is, we feel we are looking at the dramatization of a slogan, and this is disappointing. Change the costumes and this might be a scene from Act Five of a Victorian melodrama. There are people who have suggested that Rockwell is a Victorian painter who slipped out of his time. I do not believe this to be true; he is essentially a twentieth-century figure—the casual vernacular manner of his best work could not have been achieved at any earlier period. Because of this, I feel that in *Freedom of Speech* Rockwell was not remaining consistent with himself.

Freedom of Worship suffers from another difficulty—inconsistency with the other compositions in this series. The others encapsulate their theme into single concrete images. This was impossible when it came to dealing with a multiplicity of religious beliefs and ethnic backgrounds. Instead of a concrete image, Rockwell gives us a number of representative portraits, symbolically grouped and facing into the light, and attempts to make his point quite clear by adding the rubric: "Each according to the dictates of his own

208. *The Holdout. Post* cover, February 14, 1959

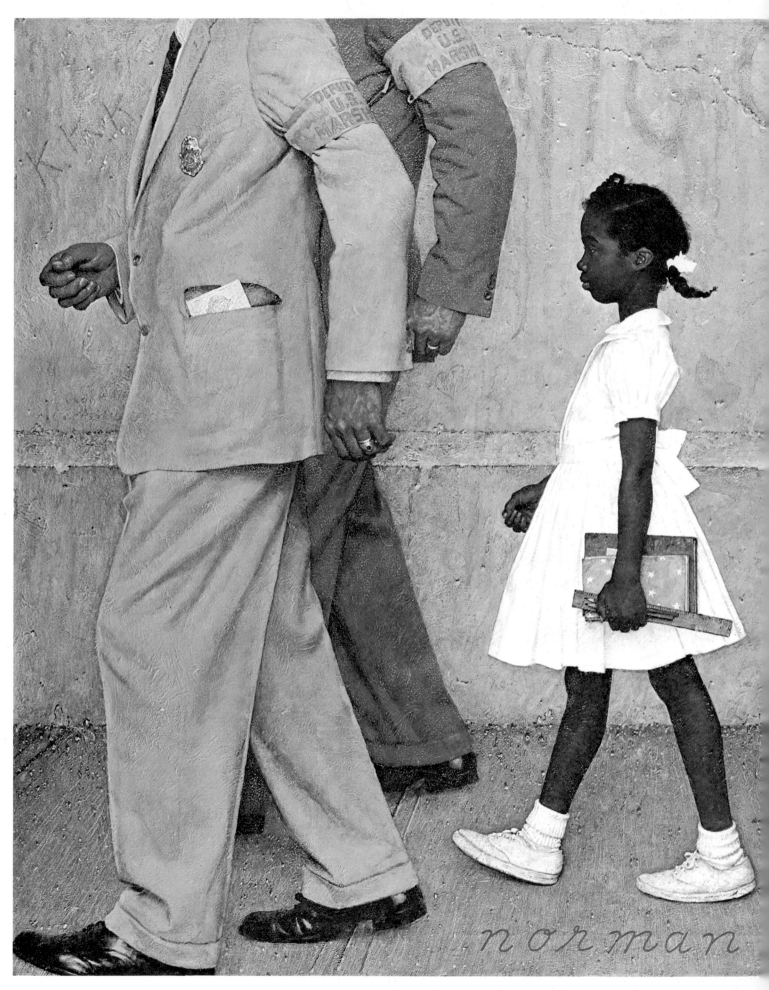

209. *The Problem We All Live With.* Original oil painting for *Look*, January 14, 1964. © Cowles Communications, Inc. Collection Arts International, Ltd., Chicago

conscience." The point *is* quite clear, but the image is rather weak. Again we are given the impression that we are looking at a painted slogan.

Freedom from Want is altogether more successful. A family meal is about to commence; possibly this is Thanksgiving. Grandmother is caught in the act of placing the turkey on the table. Grandfather waits to carve. The rest of the family talks excitedly among themselves. The whole scene is beautifully articulated. Note the way Rockwell has caught the highlights on the glaze of the porcelain, bringing the table setting to vivid life. In *Freedom from Want*, Rockwell succeeded in compressing his theme into a single, concrete image. Nothing is overstated, and this gives the composition a force of authenticity which I find missing from *Freedom of Speech*.

Freedom from Fear is similarly realized as a concentrated and concrete image. Again there is no overstatement. Millions of people were able to identify with the parents looking down at their sleeping children in this friendly attic bedroom. It is interesting to note that Rockwell departs markedly from Roosevelt's statement in this particular instance. Roosevelt had spoken of "a world-wide reduction of armaments . . . in such a thorough fashion that no nation will be in a position to commit an act of physical aggression against any neighbor—anywhere in the world." Rockwell's newspaper headline tells us that this state of affairs has not been achieved in the situation he is giving us. I must emphasize again that, whereas the President's remarks had been couched in universal terms and were, in part, intended for the rest of the world, which was hoping that the United States would not adopt an isolationist role, the artist translates the impact of his speech into domestic terms.

Throughout his career Rockwell has made attempts to present the democratic process—sometimes approaching the subject directly, sometimes indirectly. For election-time covers and illustrations he has often used old friends or married couples engaged in political arguments. We have already seen examples of this; an early version was painted for a *Post* cover in 1920 (Fig. 201). 1920 was, of course, the year in which Warren Gamaliel Harding—idol of Main Street, U.S.A.—was elected to the presidency after winning the Republican Party's compromise nomination (a nomination which prompted Harding to remark, "I feel like a man who goes in on a pair of eights and comes out with aces full"). The idealism of democratic society is well illustrated in a 1927 cover (Fig. 203) which shows a young man studying law. A barrel serves as his desk and pictures of Abe Lincoln as his inspiration. Rockwell illustrated the perplexities of the 1944 election by showing a man entering a polling booth, his vote still uncommitted as he gazes at the candidates' likenesses on the front page of the morning paper (Fig. 212).

The democratic process hinges on the concept of popular elections. Elections produce winners, but they also produce losers: this was admirably illustrated on a 1958 cover (Fig. 210). Our candidate, Casey, has just lost to Smith by a margin of very nearly six to one. His supporters file out of campaign headquarters, and Casey, sprawled in a chair, wears an expression very much at odds with the one he displays on the poster describing him as the people's choice. Amusingly, Rockwell employed a professional politician as his model for the candidate in this painting. Perhaps we may assume that

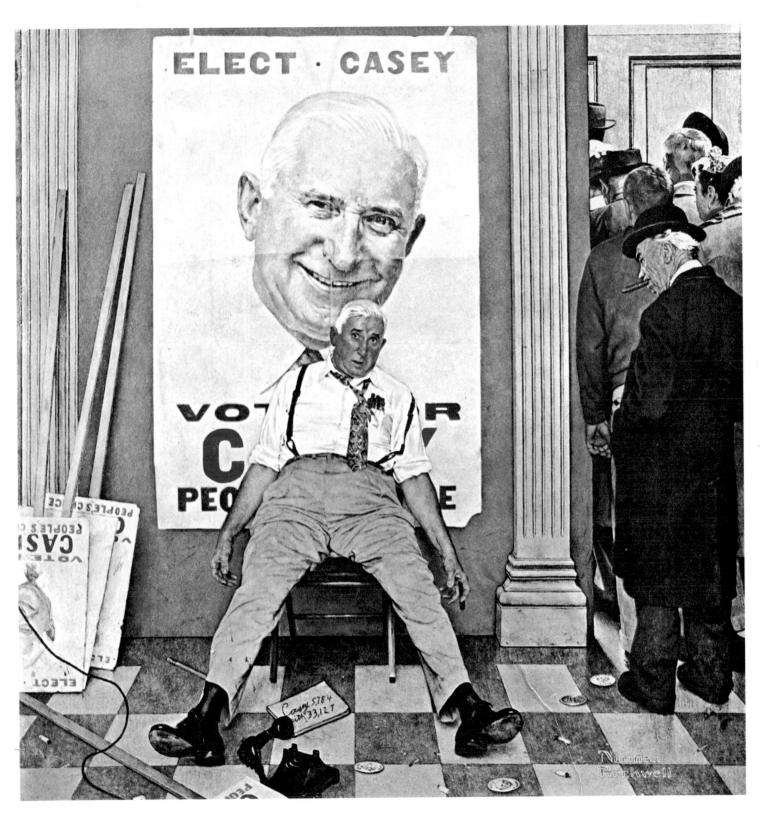

210. *Elect Casey. Post* cover, November 8, 1958

211. *The Right to Know.* Original oil painting for *Look* illustration, August 20, 1968. © Cowles
Communications, Inc. Collection Mr. and Mrs. Irving Mitchell Felt

212. *Undecided. Post* cover,
November 4, 1944

he was experienced in the emotional impact of rejection by the electorate—otherwise, how was it that he could find the time to sit for this picture?

Of course, the democratic process does not end when the voter steps out of the polling booth. Its essence is that it permeates all of our public institutions—the law, for example. Every man has the right to be heard by a jury of his peers and this prompted one of Rockwell's wittiest covers (Fig. 208). The jury has obviously been considering its verdict for some time; the jury room is full of smoke and dozens of sheets of paper lie crumpled on the floor. The sole female juror is holding out against the consensus. Ten of the male jurors (the eleventh is asleep) remonstrate with the young lady, who remains unmoved. Rockwell himself appears in this picture as the juror leaning over the girl's shoulder to plead with her. No doubt he has a deadline in mind.

During the sixties, Rockwell did a number of illustrations for *Look*, many of which deal with serious issues of the sort not usually associated with his work. In some of these illustrations it is admitted that democracy has its problems at a very practical level. Integration is one of these problems, and Rockwell illustrated it by showing a little black girl being escorted to school by deputy U.S. marshals (Fig. 209). They walk in front of a wall on which the word "nigger" and the initials KKK have been scrawled, and against which a tomato has been thrown. The little girl seems very dignified in her crisp white dress, clutching her school books, pencils, and ruler. The marshals, their heads masked out by the top of the picture, seem totally anonymous.

Other paintings for *Look*, such as *The Right to Know* (Fig. 211), seem to me less successful, but they do suggest a real concern on the part of the artist (again Rockwell includes himself in this painting at the extreme right of the composition, pipe in mouth). This is very understandable: Rockwell's entire career is on the line. Only the continuing success of the democratic process can justify it.

176

So You Want to See the President

Entrance Gate

213. Part of four-page feature, "So You Want to See the President," *Post,* 1943

Gentlemen of the Press

Steve Early talks with the Press

Part of four-page feature, "So You Want
to See the President," *Post*, 1943

the Press get a news Flash

In 1943 the *Post* sent Rockwell to the White House, where he spent several days preparing a visual report on the process of getting in to see the President. The resulting picture story (Figs. 213–30) showed a variety of people—from generals to a beauty queen—awaiting their audience. Staff secretaries, the press, and the secret service are all very much in evidence (for obvious reasons, Rockwell was obliged to disguise the identity of the secret-service men by altering their features). We see the President's list of appointments and his lunch being wheeled in on a cart. Only in the final image do we catch a tantalizing glimpse of the President himself.

This series of drawings serves as an elegant introduction to what has become something of a Rockwell tradition—presidential portraits. Since 1956 Rockwell has painted not only each President but also every major presidential candidate.

The images that follow (Figs. 231–40) need no commentary, but they do provoke an interesting thought. Rockwell's career has been built upon the portrayal of everyday folks in everyday situations. In his portraits of politicians he is taken to the opposite extreme of painting people who are in positions of enormous power—people whose everyday decisions may include the future of the human race. Yet Rockwell does not impose any kind of heroic treatment on his subjects. They are shown as men under pressure. Most of them look rather careworn; some of them retain an obvious sense of humor, but others appear to be rather sad. They are, like Rockwell's other characters, essentially human, capable of making errors. Rockwell does not hide his politicians' strengths, but neither does he ignore their weaknesses.

Senators Connally (D. Tex.) and Austin (R. Vt.), and brief case.

What has Miss America got that Wave Ensign Eloise English hasn't got?

Scottish Officer

S. S.

216-21. Part of four-page feature,
"So You Want to See the President,"
Post, 1943

Another Secret Service man keeping both eyes peeled.

Beauty and Publicity man Army, Marines and Navy NR

Secret Service

Famous White House Table
and L.S. men

Fala pursues as President's lunch is wheeled to office.

President's gas mask

The guardian of the visitors' cloak rack hands a departing guest his hat.

222-30. Part of four-page feature,
"So You Want to See the President,"
Post, 1943

A Hero is interviewed

Lieutenant General Stilwell, of Burma fame, is welcomed by the President's military aide, Maj. Gen. Edwin M. (Pa) Watson.

The Presidential appointment list on a typical day.

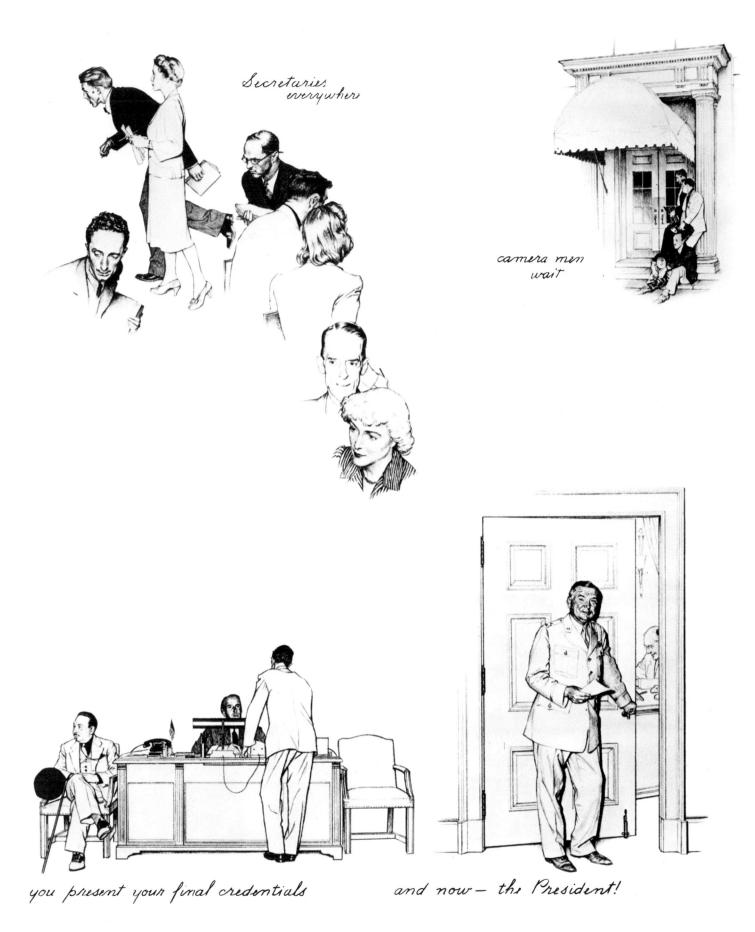

Secretaries
everywhere

camera men
wait

you present your final credentials

and now — the President!

The Saturday Evening

POST

October 6, 1956 · 15¢

The Case for The Democrats
By Speaker SAM RAYBURN

Next Week: **The Case for the Republicans**
By Minority Leader Joe Martin

231. *Adlai E. Stevenson. Post* cover, October 6, 1956

232. *Dwight D. Eisenhower. Post* cover, October 13, 1956 ▶

234. *Barry Goldwater. Look*, October 20, 1964. © Cowles Communications, Inc.

◄ 233. *John F. Kennedy. Post* cover, October 29, 1960

187

236. *Robert F. Kennedy.* Original oil painting

◄ 235. *Lyndon B. Johnson. Look,* October 20, 1964. © Cowles Communications, Inc.

237. *Ronald Reagan. Look,* July 9, 1968. © Cowles Communications, Inc.

238. *Eugene McCarthy.* Original oil painting

239. *Hubert H. Humphrey. Look,* July 9, 1968.
© Cowles Communications, Inc.

240. OVERLEAF: ▶
Richard M. Nixon. Look, March 5, 1968.
© Cowles Communications, Inc.

Norman Rockwell

Americans in Uniform

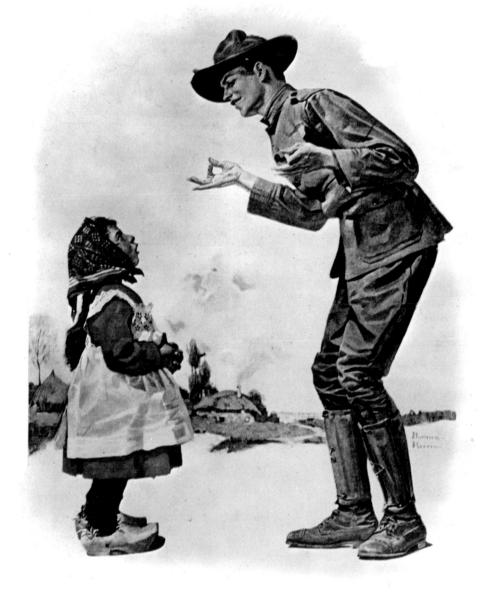

241. *Polley voos Fransay? Life* cover, November 22, 1917

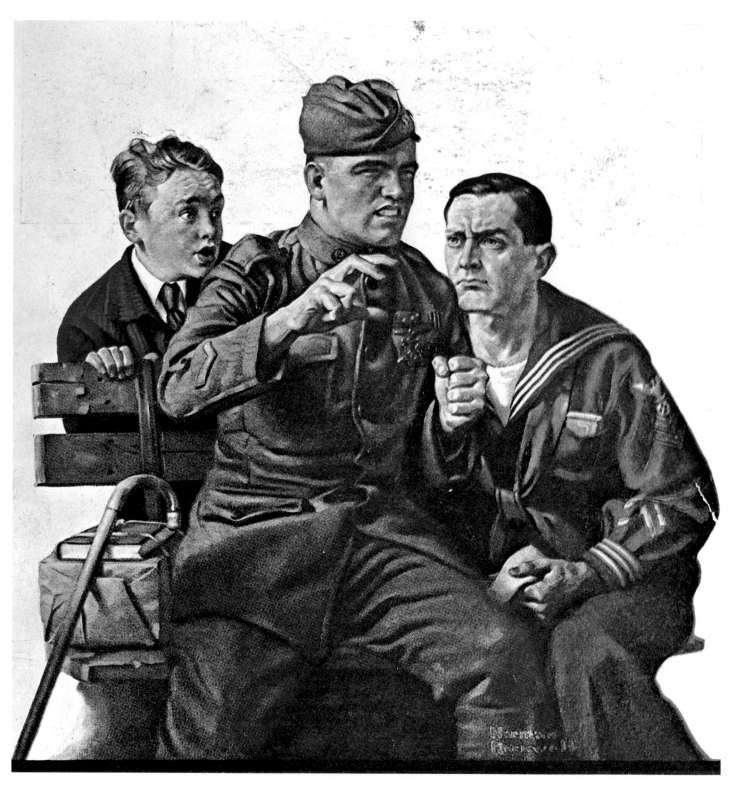

242. *Story of the Lost Battalion. Literary Digest* cover, March 1, 1919

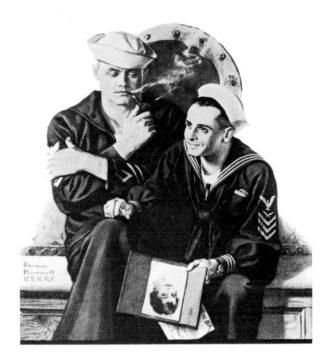

243. *Reminiscing. Post* cover, January 8, 1918

For the *Post* cover of May 26, 1945, Rockwell painted a homecoming GI (Fig. 244). The setting is the back porch and yard of a tenement building. A line of washing hangs above the trodden-down dirt area which—typically for a Rockwell composition—is not free of garbage. This is hardly the adman's image of the American Dream, but the welcome being accorded the returning soldier is no less exuberant for that. He has evidently caught his family by surprise, though it may be that some of the neighbors had seen him coming. The girl next door waits in the wings, wearing an expression of what I can only describe as "confident shyness." The GI himself hardly looks like a hardened veteran, but the enthusiasm of his reception tends to suggest that he has indeed returned from the front line. He seems a trifle stunned to find himself home.

This is not exactly a heroic picture. The redheaded GI is not the representative of some abstract ideal. He may have been fighting for home and country, but we might suppose that his image of "country" is virtually coexistent with his image of "home." It would seem, in fact, that for the most part Rockwell saw war as an interruption of home life—an unwanted, if necessary, disturbance of the status quo. Very few of his wartime paintings glorify the military life. He does not give us the generals' view of the war; neither does he give us the politicians'. Rather he shows us how war affects the man in the street—the man who must contribute to the solutions without having contributed to

the causes. It may or may not be a coincidence, but it was during World War II that Rockwell's work finally entered its fully naturalistic phase. This is not to say that his earlier work was unnaturalistic, but from the early forties onward we now find detailed portrayals of the American scene. It is almost as though the war had provided Rockwell with a reason to celebrate this environment, with all its admitted flaws.

Rockwell's career spans two world wars, during the first of which he himself saw service in the Navy. Even while in the service he continued to provide covers and illustrations for various magazines, but his military-linked work of this period is rather conventional and lacks the personal touch of his later efforts.

Sometimes the treatment is actually humorous, as for instance, in *The Tattooist* (Fig. 245). The composition of this cover is, in fact, highly formalized. The two figures are treated naturalistically enough, but they appear to be floating in midair against a background provided by the tattooist's sample sheet. More typical is the *Post* cover showing a returned war hero telling his story to his old garage buddies (Fig. 246). I call him a war hero since that is how he is described in the newspaper headline pinned to the wall between the two windows. He does not appear to think of himself as a hero; clutching the Japanese flag he has presumably captured, he seems a modest boy. His medal ribbons and the serious expressions of his listeners attest to the fact that he has indeed displayed considerable bravery, but he is not about to make a big issue of it. We may assume that he has seen many other displays of bravery and does not attach too much importance to his own. If anything, he looks a little saddened by his experiences.

Rockwell's 1945 Thanksgiving cover showed a returned veteran with his mother in a country kitchen where they are preparing a traditional New England dinner. This is a charming and simple picture; the expressions of mother and son explain everything (Fig. 247). Two other returning-veteran covers appeared that year. One of these (Fig. 249) shows a sailor reclining in a hammock on his family's lawn, his shoes on the grass, his dog asleep in his lap. This, like the returning GI, is an essentially happy picture, full of sunshine and soft shadows. The other (Fig. 248) shows us a young flier returning to civilian life only to discover that he has completely outgrown his old clothes.

Perhaps the most representative of Rockwell's war covers are those in the Willie Gillis series. There are eleven of these—the first of them appearing October 4, 1941. Rockwell has said that this series grew out of his interest in "the plight of an inoffensive, ordinary little guy thrown into the chaos of war. He was not to be an avid, brave, blood-and-guts soldier, though a perfectly willing—if somewhat ineffective—one." At a square dance in Arlington, Rockwell discovered a young man named Robert Buck, who he thought would make an ideal model. Buck was supposedly unfit for military duty, which suited Rockwell's purposes. After the first several covers had been painted, however, Robert Buck patriotically enlisted in the Naval Air Service, which, we shall see, forced Rockwell to improvise with rather interesting results.

The first of the Gillis covers (Fig. 250) showed Willie as a fresh draftee carrying a food parcel which is attracting the eager attention of his new comrades-in-arms. The fact that Willie is shown as the smallest member of the group adds to the impact of this composition. The second Gillis cover, appearing November 29, 1941, shows Willie home

244. *Homecoming GI.* Original oil painting for *Post* cover, ▶
May 26, 1945. Collection Mrs. Ben Hibbs

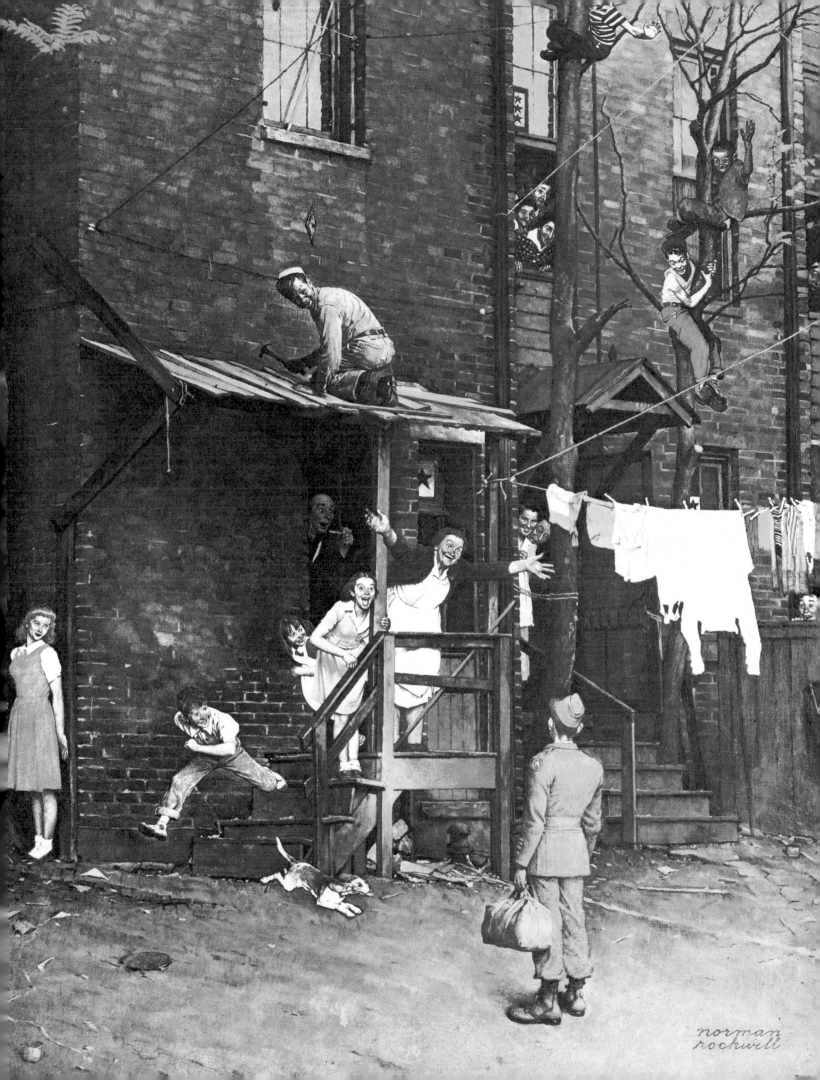

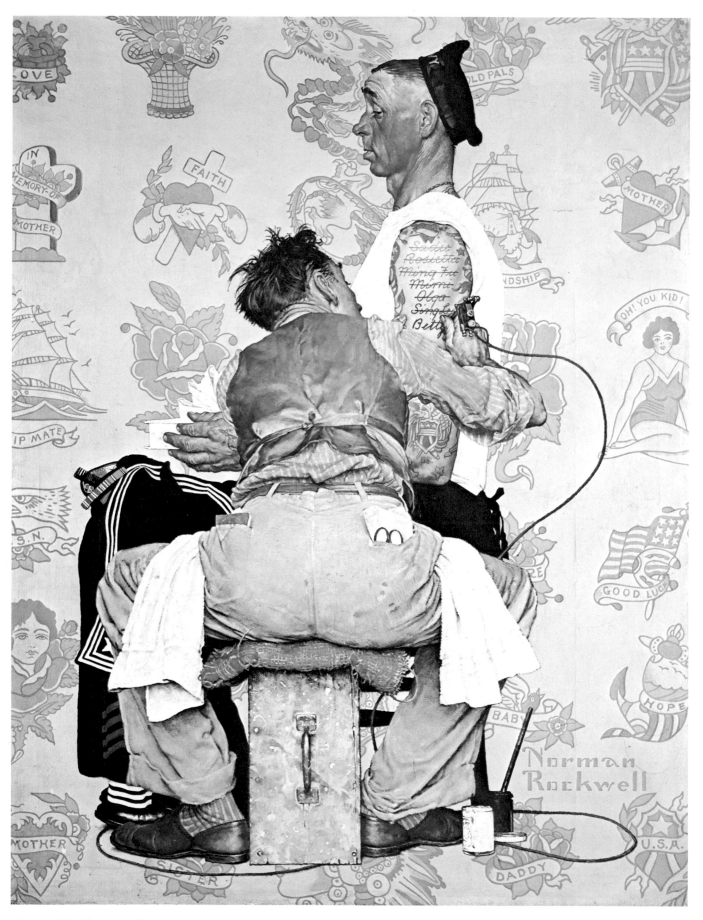

245. *The Tattooist.* Original oil painting for *Post* cover, March 4, 1944. The Brooklyn Museum

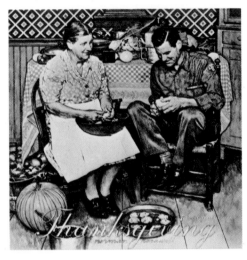

246. *The War Hero. Post* cover,
October 13, 1945

247. *Home for Thanksgiving. Post* cover,
November 24, 1945

on furlough, fast asleep beneath a gaudy patchwork quilt (Fig. 251). Shortly after this we find Willie at a USO party, bearing up under the ministrations of two attractive volunteer workers (Fig. 252). Willie Gillis may be a "somewhat ineffective" soldier, but if we are to judge by the glimpses of his career that Rockwell gives us, he is remarkably effective in his dealings with the fair sex. June, 1942, finds him confronted with the problem of "What to do in a blackout" (Fig. 254). The young lady whose elegantly gloved hands rest on his shoulders offers an immediate solution which, it is quite evident, Willie is not about to ignore. July of the same year, however (Fig. 255), finds him sitting soberly in church. Earlier that year we had been shown Willie on KP—distracted by the arrival of *The Home Town News* (Fig. 253).

As we have remarked, Robert Buck's enlistment presented the artist with something of a problem, since the Willie Gillis covers had proved to be very popular with *Post* readers. Rockwell resolved this predicament by painting pictures in which Willie himself did not appear but in which his likeness, in the form of photographs, did. The first of these covers (Fig. 256) shows a moment of conflict involving two young ladies who have both received letters from the ever-attractive Willie. Rockwell has remarked that painting pretty girls has never been his forte, but Willie could feel agreeably flattered to have these sweet young things fighting over him. Another cover (Fig. 258) shows one of the young ladies fast asleep with photos of Willie hung near her bed. A third cover showed Willie's photograph juxtaposed with pictures of some of his illustrious military ancestors (Fig. 259). The photograph rests on a row of books—books with titles such as *A History of the United States and the Gillis Family* and *Gillis at Gettysburg.* (Dozens of Gillises wrote to Rockwell asking where they could purchase these volumes. Needless to say, they were the products of the artist's imagination.)

In June, 1943, Rockwell fitted in another Willie Gillis cover showing Willie in the mysterious East, amazing a fakir with a demonstration of Western magic—cat's cradle, to

248. *An Imperfect Fit. Post* cover,
December 15, 1945

be exact (Fig. 257). The final Willie Gillis cover appeared in October, 1946, and showed Willie—out of the service now—attending college. War souvenirs surround his window seat, but the peaceful scene outside his room, his books, and his casual clothes attest to a significant change of mood (Fig. 260).

In retrospect, the Willie Gillis covers seem more sympathetic—more modern even—than, for example, *The Four Freedoms,* which certainly served their purpose at the time. As Thomas Buechner has said, "For many Americans World War II made sense because of the goals depicted in the Four Freedoms." Millions of copies were printed and distributed; the Treasury Department circulated the originals to sixteen cities, where they were seen by 1,222,000 people and were instrumental in the sale of $132,999,537 worth of war bonds. *The Four Freedoms,* however, tend to seem dated in a way that the Willie Gillis covers do not. Willie Gillis is an early prototype of the American antihero who has appeared so frequently in postwar literature and movies. It is indicative of the enormous respect the American public has for Rockwell that he could bring off this characterization. Taken in its context, it becomes a very audacious move. Given the privilege of our perspective on the period, it makes perfect sense. We must remind ourselves that Rockwell painted these covers at a time when every citizen was expected to subjugate his individuality and make his contribution to the common cause. Willie Gillis contributes to the common cause but remains very much an individual. The essential humanism of Rockwell's position is revealed in this series as much as in anything that he has ever done.

World War II played a very strange role in Rockwell's career. Rockwell is very far from being a warlike person; he is, on the contrary, a gentleman in the literal sense of the word. Yet the war brought out the best in him and turned him toward the naturalistic portrait of home-town America which he put to good use in the decades that followed. His immediate contribution to the war effort on the home front was quite considerable. What is most important about this period, in relation to his career as an illustrator, is the fact that he was given an opportunity to prove to himself and to others that he was capable of dealing with serious subjects without abandoning the human touch which had always been his trademark.

249. *On Leave. Post* cover, September 15, 1945

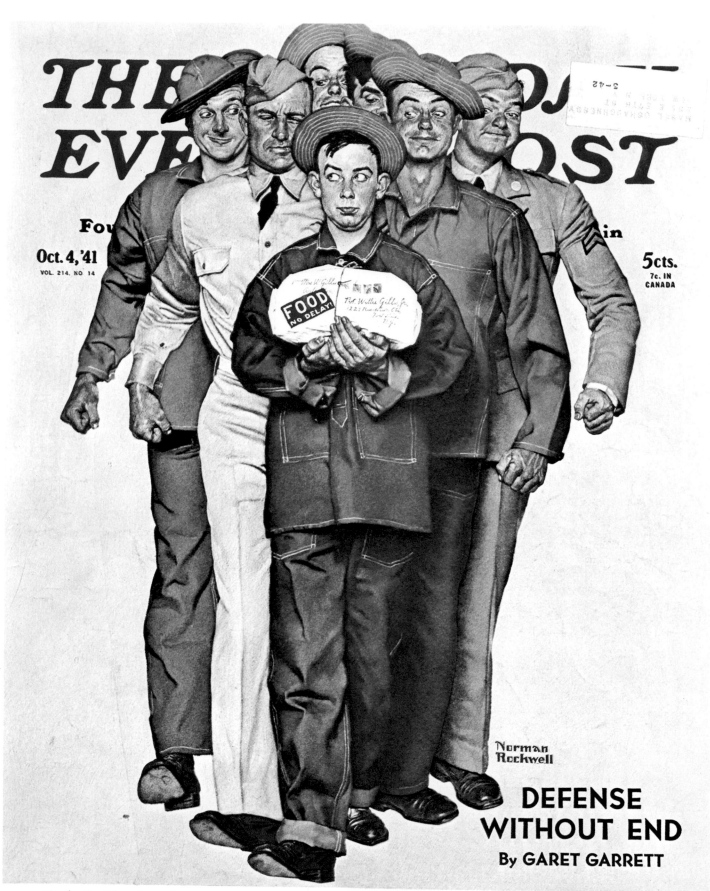

250. *Package from Home. Post* cover, October 4, 1941

November 29, 1941

February 7, 1942

April 11, 1942

June 27, 1942

July 25, 1942

September 5, 1942

June 26, 1943

January 1, 1944

September 16, 1944

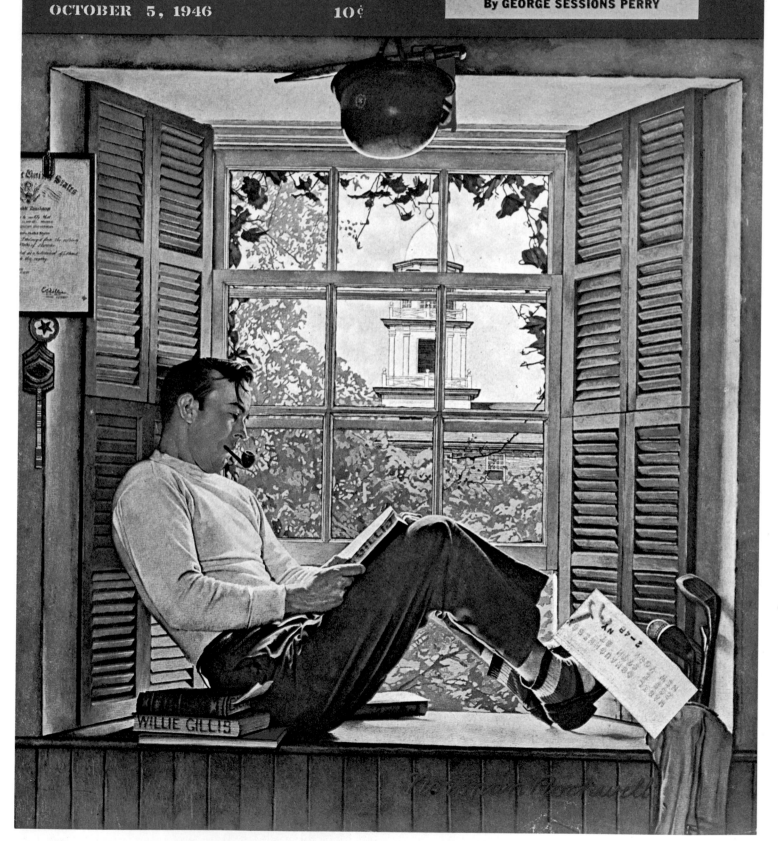

THE SATURDAY EVENING

POST

OCTOBER 5, 1946 10¢

260. *Willie Gillis in College. Post* cover, October 5, 1946

Americans at Work

261. Advertisement for Massachusetts Mutual Life Insurance Company, Springfield

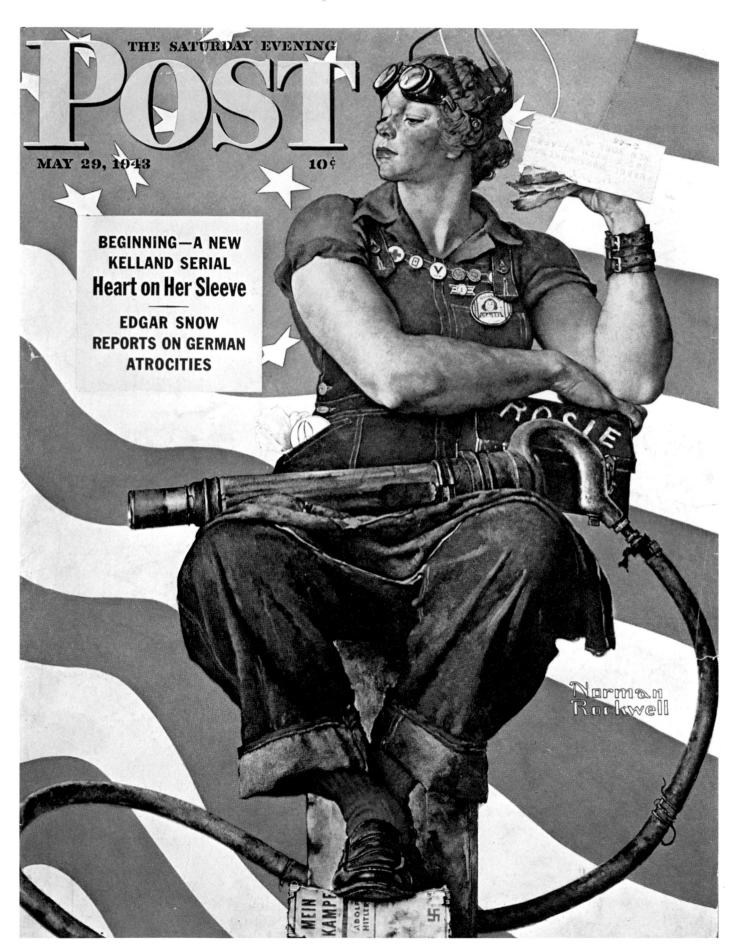

THE SATURDAY EVENING

POST

MAY 29, 1943 10¢

BEGINNING—A NEW
KELLAND SERIAL
Heart on Her Sleeve
—
EDGAR SNOW
REPORTS ON GERMAN
ATROCITIES

Norman
Rockwell

262. *Rosie the Riveter. Post* cover, May 29, 1943

263. *The Haircut. Post* cover, August 10, 1918

Before we leave World War II there is one more *Post* cover that must be mentioned. The war produced the unprecedented phenomenon of millions of American women doing work of which only men had previously been thought capable. Rockwell celebrated this fact in his portrait of a girl named Rosie (Fig. 262). Superbly muscular, she sits on a crate—striking a pose that is borrowed from Michelangelo's Prophet Isaiah on the Sistine ceiling (it is interesting to recall, in the context of this cover, that Michelangelo's women often had a very masculine appearance). Goggles at her brow, a halo above her head, Rosie has an imperious and dignified expression. A heavy riveting machine rests across her knees and a sandwich is poised in one hand. Her practically shod feet are planted firmly upon the hated *Mein Kampf* while, in contrast, the Stars and Stripes fly proudly behind her. This is, I believe, a splendid cover—humorous and heroic at the same time. Rockwell has often shown Americans at work, but this is one of his finest efforts.

In Rockwell's earlier idiom, people are shown at work from time to time but generally as an incidental component of some idea—humorous or otherwise. A 1918 cover, for example, shows a hairdresser, but he is not the chief focus of attention (Fig. 263). A 1923 cover (Fig. 264) focuses on a farmer, a scythe clutched beneath his arm. But the interest resides more in the fact that he is rescuing a bird than in the nature of his work. In a cover from the following year we see a clerk sitting dismally at his desk—ostensibly adding up columns of figures, but in fact dreaming of adventure (Fig. 265). The concept in this instance is almost Dickensian. A 1928 cover shows a workman gilding the eagle that tops a flagpole (Fig. 266). This time the worker's role is more explicitly presented, but the emphasis seems to fall on the eagle, with all its patriotic overtones.

264. *Farmer and Bird. Post* cover, August 18, 1923

265. *Daydreamer. Post* cover, June 7, 1924

A 1925 *Post* cover gave us a portrait of a worker, but it cannot be said that he is actually "at work" (Fig. 267). This image of the sleeping porter is brought to life by the simple device of showing a "rush" label pasted to the trunk on which he has established himself. Ten years later Rockwell gives us an amusing picture of a billboard artist who is indeed pursuing his calling. The image he is painting has been outlined; above the word "kiss," a female head has been drawn. One eye and one eyebrow have been filled in and the artist is at work on the second eyebrow. The billboard itself shares a common plane with the *Post* cover, and the artist, perched on his frail-looking rig, seems to be suspended in front of both. In 1937 Rockwell painted a bored ticket clerk (Fig. 269). It has sometimes been suggested that Rockwell chose to ignore the Depression, but this is not quite true. Certainly he did not paint breadlines, but in compositions such as this one, he did sometimes approach the subject indirectly. The ticket clerk is bored because no one can afford to travel anymore. The enticements of the posters which surround his booth are being steadfastly ignored; the call of the Orient remains unheeded. Here again we have a man at work but not working. This time it is through no fault of his own.

The druggist in the 1939 cover (Fig. 268) is certainly hard at work, and the small boy who holds a handkerchief to his nose is anticipating the results of this labor with ill-concealed nervousness. This is an essentially humorous treatment, as is another cover from the same year (Fig. 271) showing a sheriff guarding a cell, somewhat overcome by

208

266. *Man Painting Flagpole. Post* cover, May 26, 1928

267. *Asleep on the Job. Post* cover, August 29, 1925

268. *The Druggist. Post* cover, March 18, 1939

the melancholy tunes which his prisoner is wringing from his harmonica. The 1940 illustration of competing blacksmiths (Fig. 270) has an altogether different atmosphere. Its style is more reminiscent of some of Rockwell's historical compositions displaying a blend of heroic naturalism and near-caricature.

In 1944 the *Post* commissioned Rockwell to paint a ration board—then very much a feature of the national scene. *Norman Rockwell Visits a Ration Board* became the prototype for a series of documentary spreads that was to include *Norman Rockwell Visits a Country*

Editor, Norman Rockwell Visits a Country School (Fig. 278), *Norman Rockwell Visits His Country Doctor* (Fig. 145), and *County Agricultural Agent* (Fig. 276). The paintings and drawings that resulted from this group of commissions show Rockwell at his very best—observing Americana with a friendly but objective eye and setting it down faithfully in line and color.

For the first of these documentary paintings Rockwell visited a ration board at Manchester, Vermont. On a rainy day, a petitioner is presenting his case to the committee, which is comprised of six men and one woman. Another petitioner—Rockwell himself—is shown waiting his turn. The mood is serious. The members of the board seem to be making a common effort not only to analyze the petitioner's case, but also to size up the sincerity of his presentation.

For his visit to a country editor, Rockwell did his research in the offices of the *Monroe County Appeal.* Monroe County, Missouri, is on the edge of Huck Finn country (Hannibal is situated in adjacent Marion County). Mark Twain was actually born within Monroe County and another distinguished American, General Omar Bradley, was raised there. The scene that Rockwell gives us is warm and businesslike. The furniture is old but looks comfortable and functional. The office equipment is basic. The brown walls are dotted with photographs and memorabilia. Single light bulbs have been screwed into brackets designed to take two. Locals are placing advertisements at the reception desk, and Rockwell shows himself entering the door, like an aspiring illustrator, with a folio of sketches under his arm.

For his visit to a country school, Rockwell made a trip to hill country—Carroll County, Georgia. On the first day of his visit, the children, knowing that he would be there, appeared in their Sunday best, as if for a class photograph. Rockwell explained that this was not exactly the image that he wanted; the next day they appeared in their everyday clothes and work began in earnest. When it came to painting a country doctor, Rockwell decided to remain in New England and use as his model his own doctor—George Russell—who had been serving his patients in the Arlington, Vermont, area for almost half a century. The picture that Rockwell gives us of the doctor's life is one that has virtually vanished from the American scene during the last two decades. The comfortable office, with its hunting rifle and stag's head, and the house calls—all this is rapidly vanishing into the past. Rockwell's doctor has an essential reassuring friendliness. The same can be said of his agricultural agent. The respect with which the farmer and his family regard him is quite evident.

The importance of these documentary pictures for Rockwell's later development should not be underestimated. We have seen how during the war he began to look at the American scene in a new and more objective way. The documentary paintings helped to focus this emerging interest. He found himself painting real people in real situations. This was to set the pattern for the finest of his later *Post* covers. The prewar work, as we have already suggested, tended to be slightly idealized. What we were shown were American myths represented in terms of archetypes (there were, of course, exceptions to this, but it was a general tendency). Now, in the later work, the myths become subordi-

269. *Ticket Agent. Post* cover, April 24, 1937

270. *The Horseshoe Forging Contest.* Painted for "Blacksmith's Boy—Heel and Toe" by Edward W. O'Brien, *Post,* November 2, 1940. Collection Norman Rockwell

271. *Sheriff and Prisoner. Post* cover, November 4, 1939

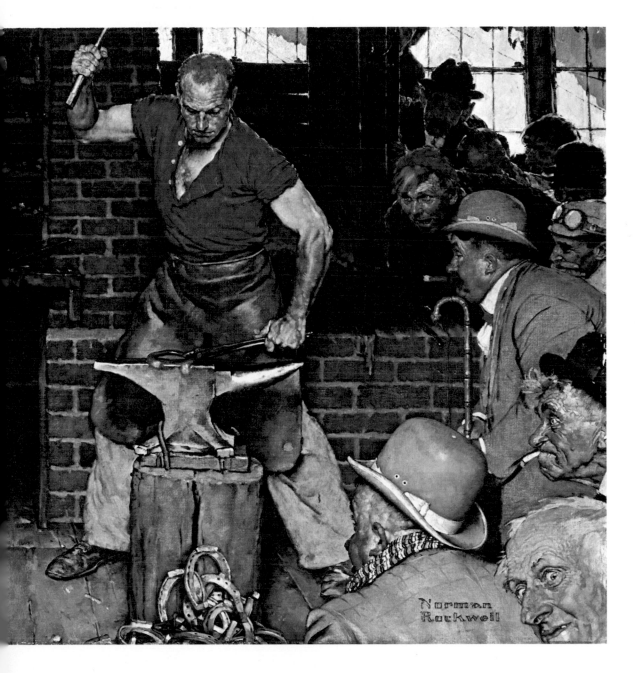

272

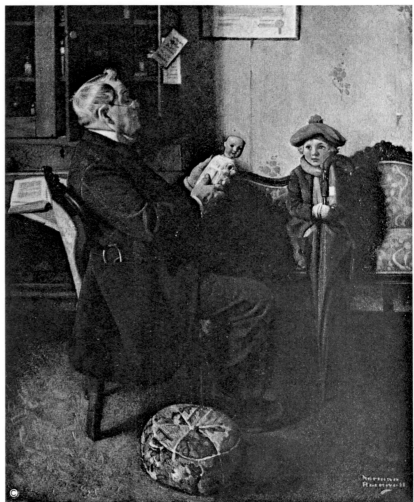

273

274

275

276. *County Agricultural Agent. Post,* July 24, 1948. University of Nebraska Art Galleries, Lincoln

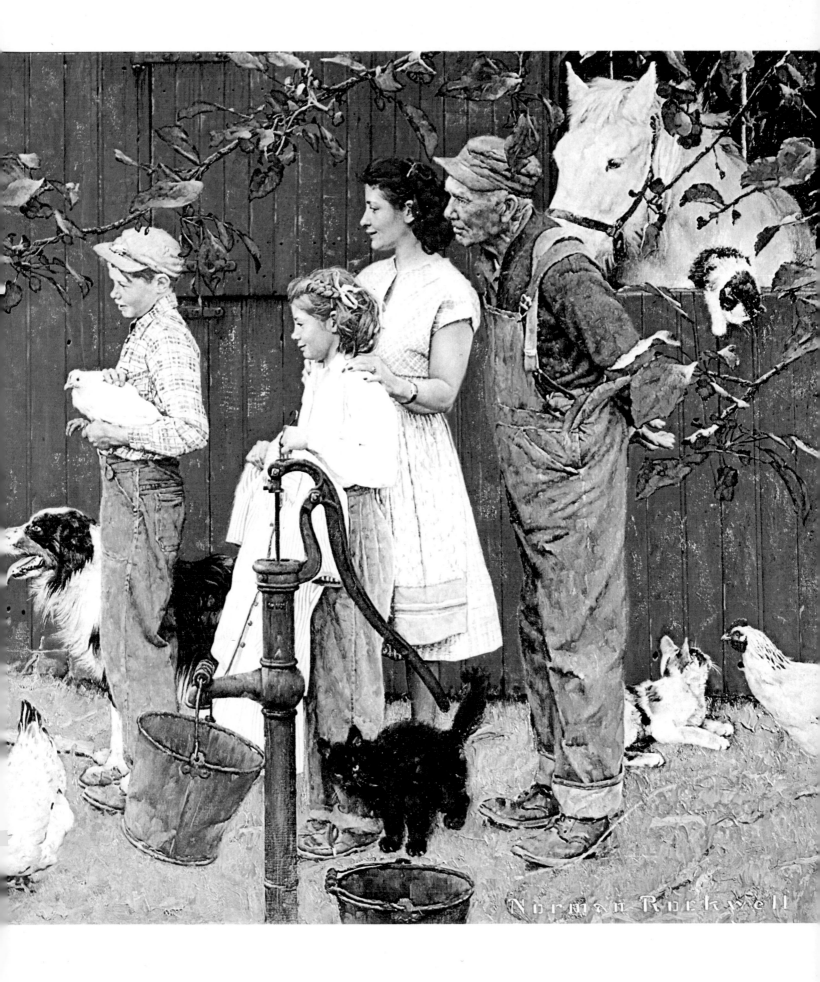

Norman Rockwell

278. Illustration for "Norman Rockwell Visits a Country School," *Post*, November 2, 1946

277. *The Spelling Bee.*
Illustration for
"Norman Rockwell Visits
a Country School,"
Post, November 2, 1946

279. Advertisement for
Massachusetts Mutual
Life Insurance Company,
Springfield

280. *Construction Crew. Post* cover, August 21, 1954

281. *Just Married. Post* cover,
June 29, 1957

282. *Balancing the Account. Post* cover,
November 30, 1957

283. *The Plumbers. Post* cover,
June 2, 1951

nated to a highly detailed naturalism. This is not to say that the mythology is abandoned; rather, it is absorbed and transformed by naturalism. It continues to act upon the imagination but in a fresh and more palatable way.

A good example of the new naturalism is to be found in the *Post* cover which shows an old man about to adjust the hands of a giant clock (Fig. 287). Apart from the central image, we are given a fascinating glimpse of a city street. The sense of scale is put to great use in this painting. The same is true of a 1946 cover (Fig. 286) showing men at work on the torch of the Statue of Liberty. The fact that Rockwell had turned toward explicit naturalism did not mean, of course, that he had lost his old sense of humor—as is quite evident from the 1951 cover (Fig. 283) that shows two plumbers in a lady's boudoir. Humor, combined with pathos, is very much in evidence in a slightly later cover which shows a bunch of kids pleading with the operators of a steam shovel who have been given the unenviable task of clearing the local lot—home plate and all. The two chambermaids clearing the bridal suite (Fig. 281) is a good example of the kind of low-keyed humor at which Rockwell had become so adept. Here there is no staged "joke." The humor derives directly from an apparently "real life" incident. Another cover shows a plump salesman laboring over his expense account as the plane wings him back from his business trip (Fig. 282). Here much of the humor lies in guessing at the activities which led to the outlay that he is now trying to justify. One gets the impression that his calculations may be impeded somewhat by a hangover.

A totally different image of the American workingman is to be seen in Rockwell's painting of a telephone lineman (Fig. 284). This is a simple, dignified portrayal of somebody carrying out a physically demanding task. The *Post* artist at his drawing board is concerned with demands of another kind. It illustrates the genesis of a change (a

285. *The Full Treatment. Post* cover, May 18, 1940

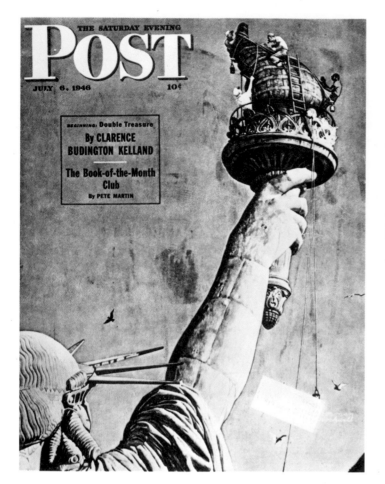

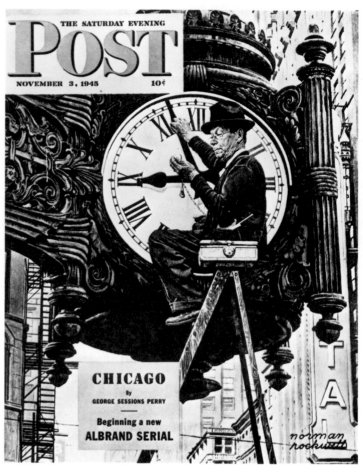

286. *The Statue of Liberty. Post* cover, July 6, 1946

287. *Clock Repairman. Post* cover, November 3, 1945

short-lived change, as things turned out) in the *Post*'s masthead. Attached to the drawing board are samples of *Post* covers dating back to Benjamin Franklin's day.

Rockwell gives us a rather varied picture of Americans at work. He shows us people working with their hands and people working with their heads and he accords them all equal dignity. At the same time he does not give us a puritan view of the inviolable sanctity of labor. Work, he seems to suggest, is something that is as apt to produce amusing moments as anything else (in Rockwell's America, something funny is liable to occur at any moment, however unlikely).

The Sporting Life

288. Advertisement for Massachusetts Mutual
Life Insurance Company, Springfield

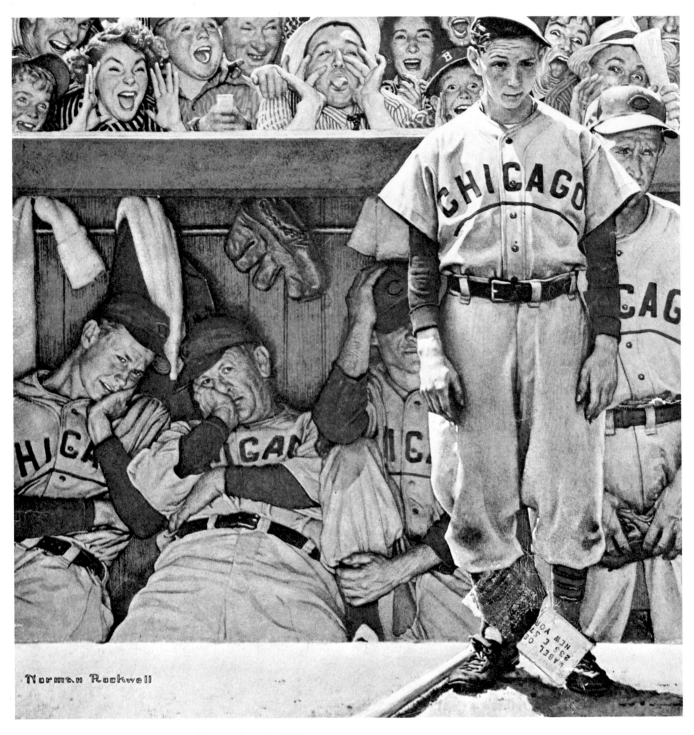

289. *The Dugout. Post* cover, September 4, 1948

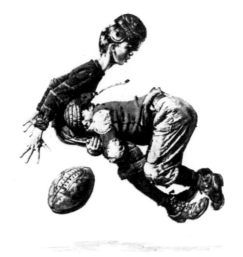

290. *Tackled. Post* cover,
November 21, 1925

291. *Croquet. Post* cover, September 5, 1931

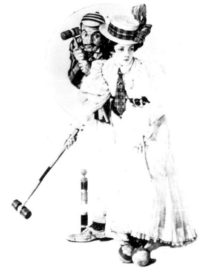

1948

was a vintage year for masochism among Chicago baseball fans. Both Charlie Grimm's Cubs and the White Sox, piloted by Ted Lyons, contrived to finish the season in the cellars of their respective leagues. The Cubs—spurred on by stalwarts such as the veteran Phil Cavarretta (then in his fifteenth of twenty seasons with the club) and Handy Andy Pafko—managed to win 64 games against 90 losses. Things might have been much worse had not Johnny "Bear Tracks" Schmitz had the best season of his pitching career, winning eighteen games with an ERA of 2.64. For the most part, the bleacher bums at Wrigley Field had to satisfy themselves with betting nickles on balls and strikes; for White Sox fans, things were even worse. Their ball club ended the year with a record of 51 wins and 101 losses. They did not have a single winning pitcher on the team, and only Luke Appling, then nearing the end of his playing career, batted over 300. The solitary high spot of the season was provided by outfielder Pat Seerey, who hit four home runs in a single, eleven-inning game. Toward the end of the campaign, Norman Rockwell's own record of this dismal chapter in Chicago sporting history appeared as a *Post* cover (Fig. 289). He shows us the dugout and the jeering fans. Some peculiarly embarrassing incident has evidently occurred on the playing field. The whole story is summed up by the expressions of disbelief worn by the players and the bat boy.

Sport—organized or otherwise—has long been a favorite subject of Rockwell's. In the earlier part of his career he illustrated everything from fishing (Fig. 293) to croquet (Fig. 291). A typical early work is the 1925 cover showing a sure tackle in a game of sandlot football (Fig. 290). The outcome of the resultant fumble can only be guessed at. The ball

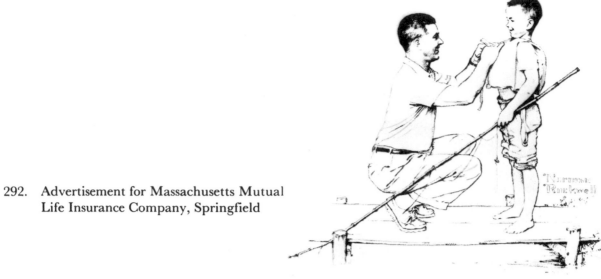

292. Advertisement for Massachusetts Mutual
Life Insurance Company, Springfield

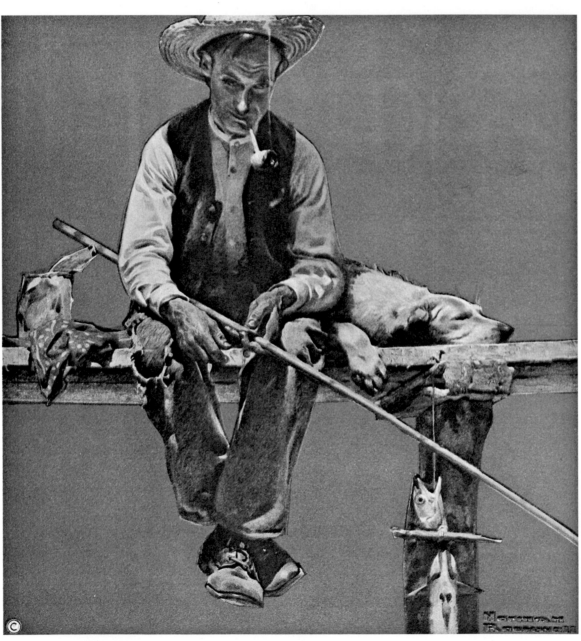

293. *Gone Fishing. Literary Digest* cover, July 30, 1921

itself is an interesting period piece. Not even John Unitas could throw a perfect spiral with that.

One of Rockwell's more somber celebrations of the outdoor life was painted for a 1939 cover which shows a fisherman in the rain (Fig. 294). Like so much of Rockwell's work, this scene is a straightforward evocation of a situation with which it is very easy to identify. That same year he painted a cover to mark the centennial of baseball (Fig. 295: the original is now in the Baseball Museum at Cooperstown, N.Y.). This is a rather curious composition. Why is the umpire crouching immediately behind the pitcher? Probably the reason lies in the realm of aesthetics, but I prefer to believe that Casey is at the plate and the umpire has decided to take precautionary measures.

Quite a different kind of painting is the illustration which Rockwell did for D. D. Beauchamp's story "Strictly a Sharpshooter," which appeared in the *American Magazine* in June, 1941 (Fig. 304). To research the atmosphere of the fight game, Rockwell spent some time at a sports club situated on Columbus Circle. There he studied "the effect of the smoke-filled room and the types of people who frequent such places. . . ." For models, however, he used neighbors and acquaintances, as is his habit. The belligerent lady, for example, was modeled by the wife of his friend and fellow *Post* artist, Mead Schaeffer (Rockwell gallantly insists that this picture shows Elizabeth Schaeffer very much out of character). Rockwell's photographer, Gene Pelham, posed for the cigar-smoking aficionado at the far left of the painting and also for the second behind the seated fighter. The battered pugilist leaning through the ropes was modeled by Clarence Decker, whom Rockwell describes as "Master of the West Arlington Grange." The overall impact is undeniably authentic. This painting belongs to the period when Rockwell was developing the essentially naturalistic idiom which has been the hallmark of his later work.

Another baseball subject appeared as a *Post* cover in April, 1949 (Fig. 305). It shows umpires about to call a game as rain begins to fall from threatening skies. The original painting for this cover, like that for the centennial of baseball, is now in the Cooperstown Museum. A 1950 cover shows the toss prior to a high-school football game (Fig. 296). It is interesting to compare this with the 1925 cover showing sandlot ball. The uniforms have changed over the years and Rockwell now gives the incident a detailed, naturalistic setting; but the players themselves, although representative of different generations, have a casualness of manner and a frailty of physique that seems to belie their enthusiasm. The same can be said of the group of boys whose sporting activities supplied Rockwell with his theme for a 1951 calendar (Figs. 305-08).

Two humorous versions of cheerleaders have provided Rockwell with *Post* covers. The first of these (Fig. 301), which appeared in 1952, shows the despondency of a trio of girls in a high-school gym—their basketball squad having tasted the agony of defeat by the narrowest of margins. The sense of anticlimax is complete. The game has gone right down to the wire, but the partisan cheers of the home crowd have not proven to be quite enough to spur their team to victory. The second of these covers (Fig. 302) was painted in 1961 and makes use of a kind of cartoon-strip technique in which the reactions of a

294. *Sport. Post* cover, April 29, 1939

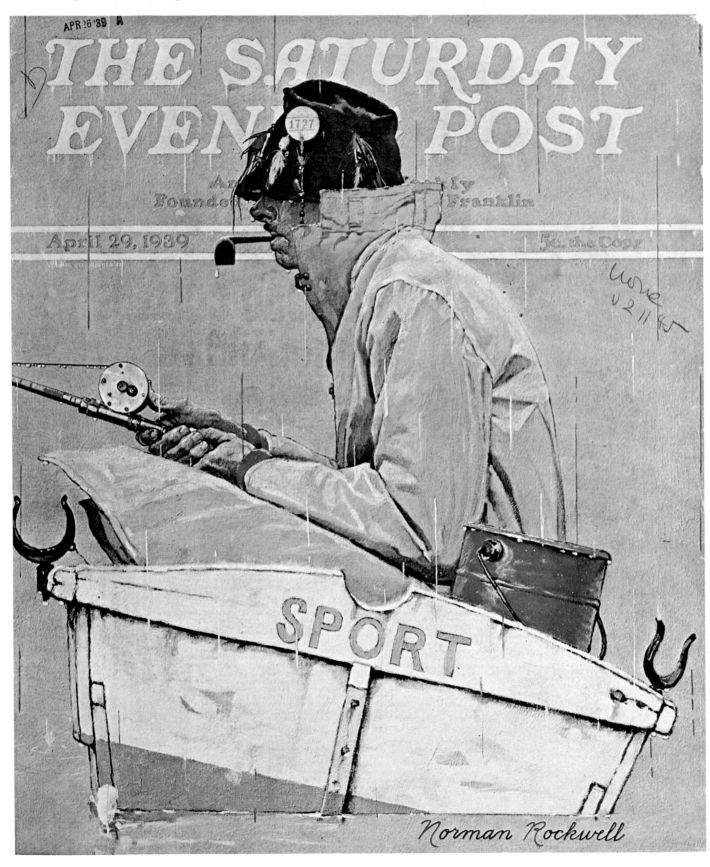

cheerleader are superimposed upon various phases of the action on the field. We can almost read her mind as she moves from enthusiasm to despair, to disgust, and finally to ecstasy as some home-team star breaks for the end-zone, leaving a wake of unsuccessful blockers and would-be tacklers. In neither of these covers do we get an image of the cheerleader as some kind of glamorous being. Rockwell shows her, rather, as an awkward, if athletic, tomboy. The poses that he chooses for them are scarcely ladylike—even in the case of the 1952 cover, which shows the three girls in repose.

In 1957 Rockwell returned to the subject of baseball in order to take a look at spring training. He shows us the locker room of the Boston Red Sox camp. This cover

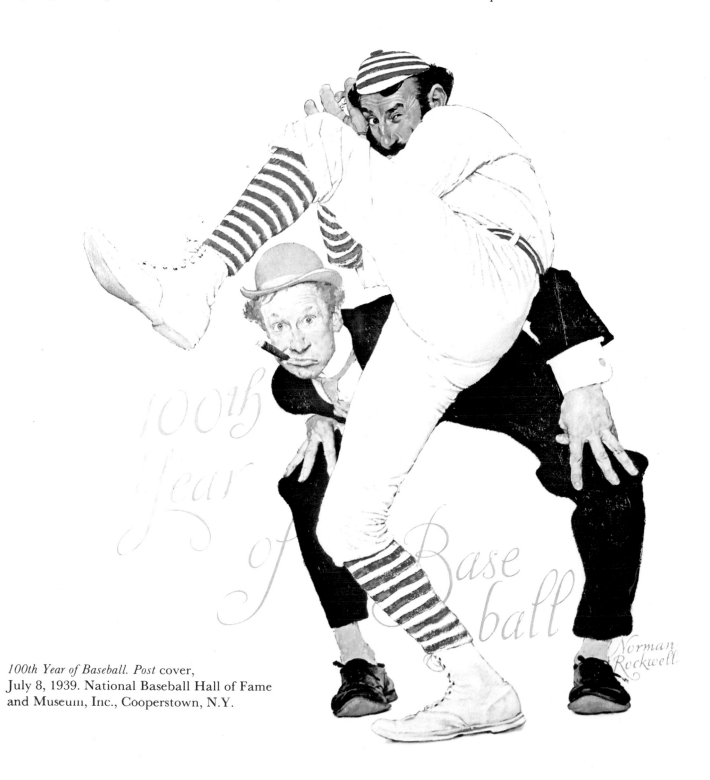

295. *100th Year of Baseball. Post* cover, July 8, 1939. National Baseball Hall of Fame and Museum, Inc., Cooperstown, N.Y.

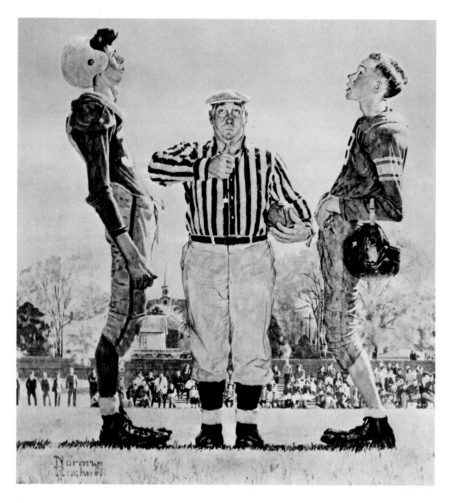

296. *The Toss. Post* cover, October 21, 1950

(Fig. 300) is painted in Rockwell's documentary style and includes, of course, portraits of Red Sox personnel—notably the "Splendid Splinter" himself, Ted Williams (Williams was to have another spectacular season, hitting thirty-eight home runs and winning his fifth American League batting title with a .388 average). One can decipher other names on the lockers, including those of pitcher Frank Sullivan and right-fielder Jackie Jensen. Typically, in this painting Rockwell takes us behind the scenes. Except when he is showing us youngsters, he seldom gives us a glimpse of the action on the playing field. In the Chicago dugout cover we can guess at the action on the field from the expressions of the watching players and fans, but it remains in the realm of speculation. Similarly, in this spring-training cover we can only speculate upon the coming season. These two paintings represent unseen but implied action in the present or in the future.

Another *Post* cover (Fig. 299), showing a jockey weighing in, implied unseen action in the immediate past. The model for this painting was Eddie Arcaro. The concept is simple and effective. Much is made of the scale differential between Arcaro and the steward. The pair is set against a plain, neutral background which emphasizes this scale factor and the color of the jockey's silks. Such a neutral background is unusual in

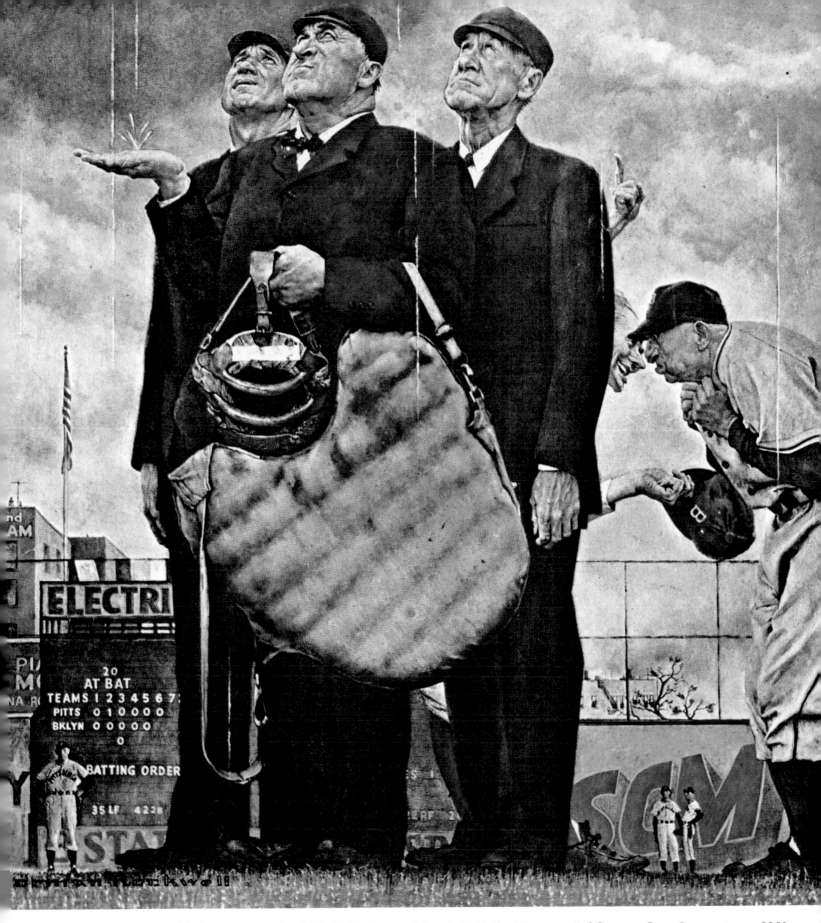

297. *Game Called Because of Rain. Post* cover, April 23, 1949. National Baseball Hall of Fame and Museum, Inc., Cooperstown, N.Y.

298. Advertisement for Massachusetts Mutual Life Insurance Company, Springfield

Rockwell's work of this period, but it seems totally suitable to the subject. It isolates the all-important incident from its surroundings and helps us to focus on the concentration of the two protagonists. All the details essential to the telling of the story are included—note, for example, the spattering of mud on Arcaro's riding britches.

A picture which can be described as "part-documentary" is *The Recruit*, painted for *Look* in 1966 (Fig. 309). It shows a college football player talking with his coach and trainer. It is a documentary study in that it contains portraits of real people. The player is Dennis Kelly—6'3", 218 lbs.—of Williams College. The coach is Williams' Frank Navarro and the trainer Joseph Altott. At the same time, this is not a documentary. To give the picture a heroic quality, Rockwell directed Kelly to strike a very formal pose based on Michelangelo's sculpture of Giuliano de' Medici. Again we are given a situation in which the real action on the playing field has yet to occur.

Most people are as fascinated by the atmosphere that surrounds sports as by the events that happen on the field. Babe Ruth's appetite is as important to his legend as the 714 home runs. Rockwell realizes this and has given us a vision of the sports world based not upon heroic achievements and statistics but, rather, upon the passages of ritual that are merely interrupted by the touchdowns, the homers, and the photo finishes.

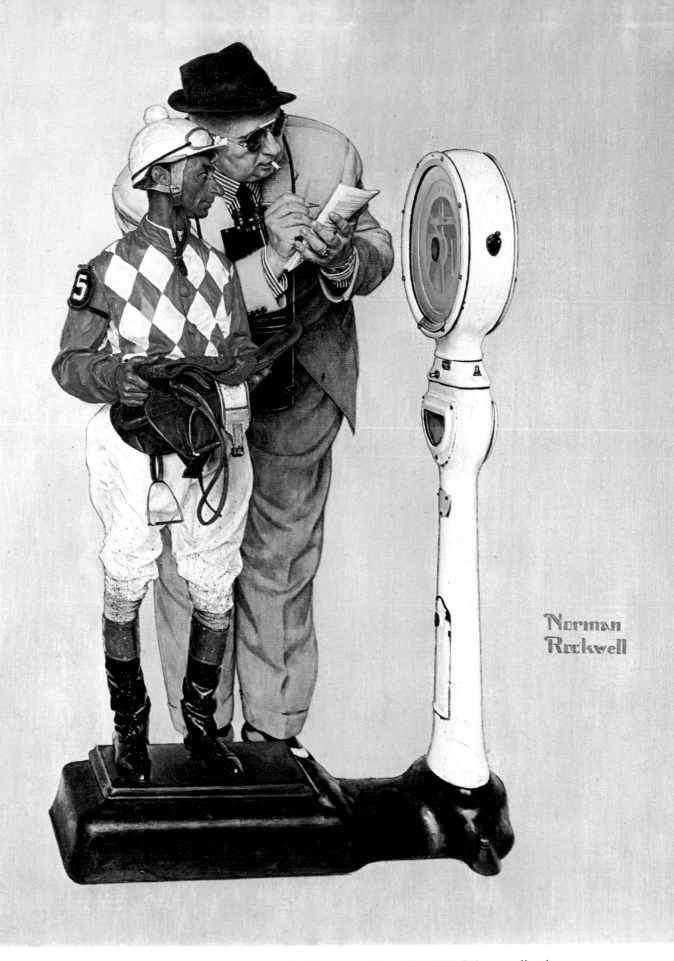

299. *Jockey Weighing In.* Original oil painting for *Post* cover, June 28, 1958. Private collection

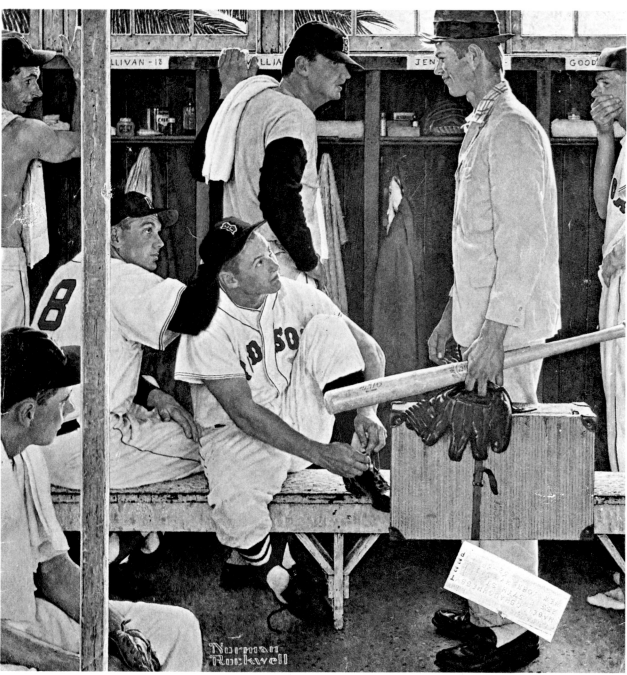

300

301

302

300. *The Locker Room. Post* cover,
March 2, 1957

301. *Losing the Game. Post* cover,
February 16, 1952

302. *The Cheerleader. Post* cover,
November 25, 1961

303. *Gone on Important Business. Post* cover, September 20, 1919

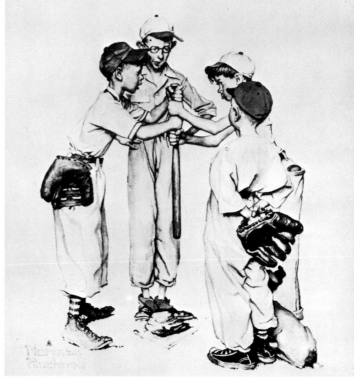

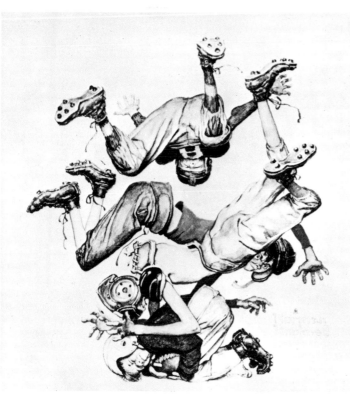

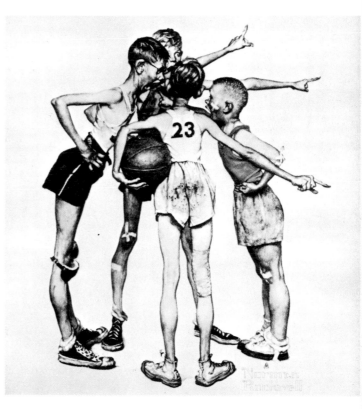

305-08.　Four Seasons calendar: *Four Boys.* 1951.
　　　　© Brown and Bigelow, a division of Standard Packaging Corporation

◀ 304.　*Strictly a Sharpshooter.* Original oil painting for "Strictly a Sharpshooter"
　　　by D. D. Beauchamp, *American Magazine,* June, 1941. Collection Robert C. Benedict,
　　　Arlington, Vt.

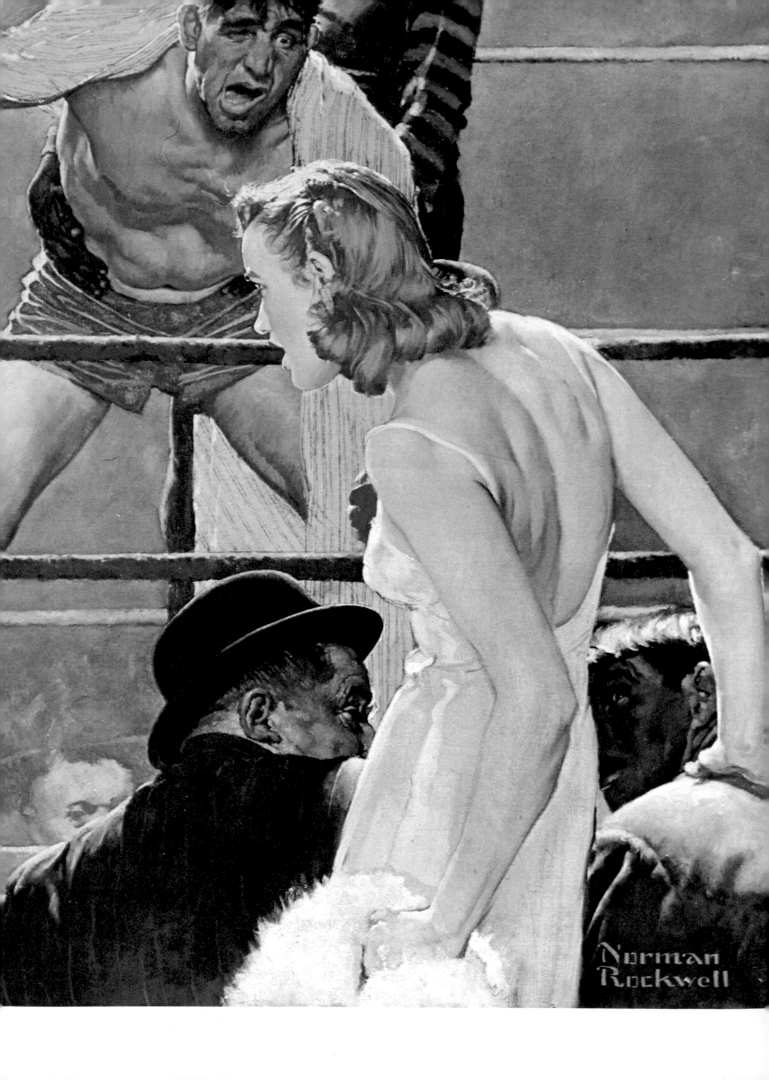

309. *The Recruit. Look,* September 20, 1966. © Cowles Communications, Inc.

An American Portrait Gallery

310. *Rockwell and His Wife Molly.* 1967. Charcoal.
Collection Norman Rockwell

311. *John Wayne.* National Cowboy Hall of Fame and Western Heritage Center, Oklahoma City

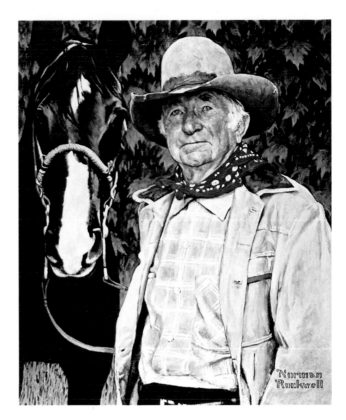

312. *Walter Brennan.* National Cowboy Hall of Fame and Western Heritage Center, Oklahoma City

Since Norman Rockwell has always worked from live models, his picture of America is peppered with portraits of real Americans. His friends and neighbors, playing any number of roles, have appeared over and over again in his work. Rockwell has sometimes included celebrities in his documentary compositions (for example, and as we have already seen, sports figures such as Ted Williams and Eddie Arcaro). Then there have also been individual portraits of various celebrities. The politicians have been mentioned in an earlier chapter. Another important group is made up of entertainers, and in this category we find Bing Crosby, Bob Hope, Jack Benny, and Johnny Carson, among others. And finally there have been individual portraits of persons who are not public figures. What follows is a representative selection of Rockwell portraits.

All portraits are by definition character studies, but Rockwell's portraits tend to be character studies in a fairly specific sense. The classic portrait in the Western tradition—and this applies to examples by artists as disparate as Rembrandt and Ingres—concentrates upon the sitter as a physical presence. The entire character of the sitter is frozen into the moment which has been caught by the artist and this moment has been isolated from the sequence of moments that go to make up the sitter's life. Rockwell's approach to the portrait is somewhat different. His career has been concerned with storytelling; when he paints someone he generally seems to be looking at the sitter as a possible—if not actual—character in some story. His portraits do not have the concentrated nobility

314. *Ann-Margret.* Illustration based on the film "Stagecoach," 1966.
Twentieth Century Fox Film Corporation and Martin Rackin
Productions. All rights reserved

of the great portraits of the past, but the point is that we should not judge them by those standards. What Rockwell catches in his portraits are the possibilities for expression that are to be found in any given sitter's face. He seems to be not so much concerned with what his sitters have done—that is to say, with the face as a record of experience—as with speculating upon how his sitters would react to various situations. Rockwell's treatment of Ted Williams' head, for example, does not lead us to speculate upon Williams' boyhood in San Diego, on his experiences as a night-fighter pilot during two tours of duty, or even upon his approach to the science of batting. What Rockwell gives us, rather, is a hint of how Williams is likely to react to an overconfident rookie or the Boston press corps. All of which can be summed up by saying that Rockwell's portraits have the bias of the illustrator—which is exactly what we should expect to find.

◄ 313. *Gary Cooper.* c. 1940s. Oil painting. Collection Ira Resnick, New York

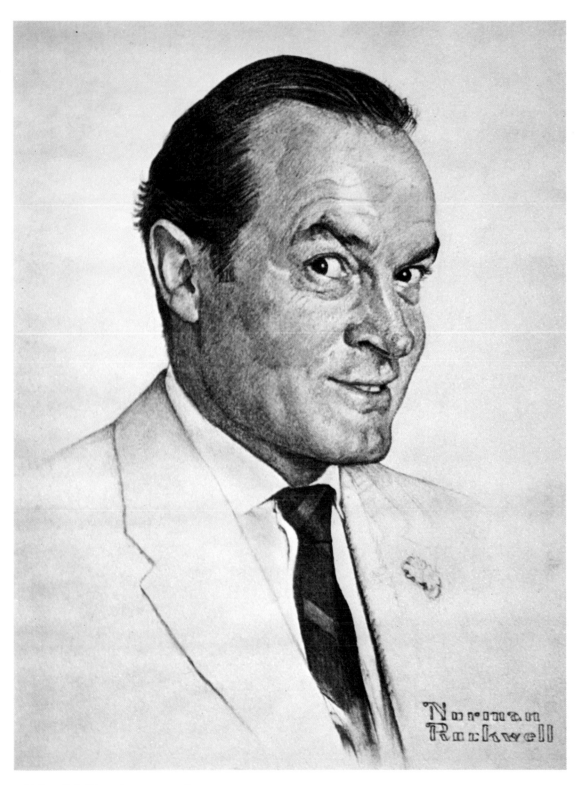

316. *Bob Hope. Post* cover, February 13, 1954

◀ 315. *Bing Crosby.* Illustration based on the film "Stagecoach," 1966. Twentieth Century Fox
Film Corporation and Martin Rackin Productions. All rights reserved

317. *Jack Benny. Post* cover,
March 2, 1963

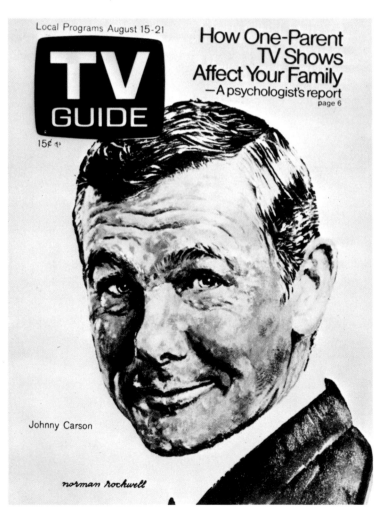

318. *Johnny Carson. TV Guide,* August 15–21, 1970.
© 1970 by Triangle Publications, Inc.

319. Norman Rockwell with his painting of Frank Sinatra. Courtesy Louis Lamone, Lenox, Mass. ▶

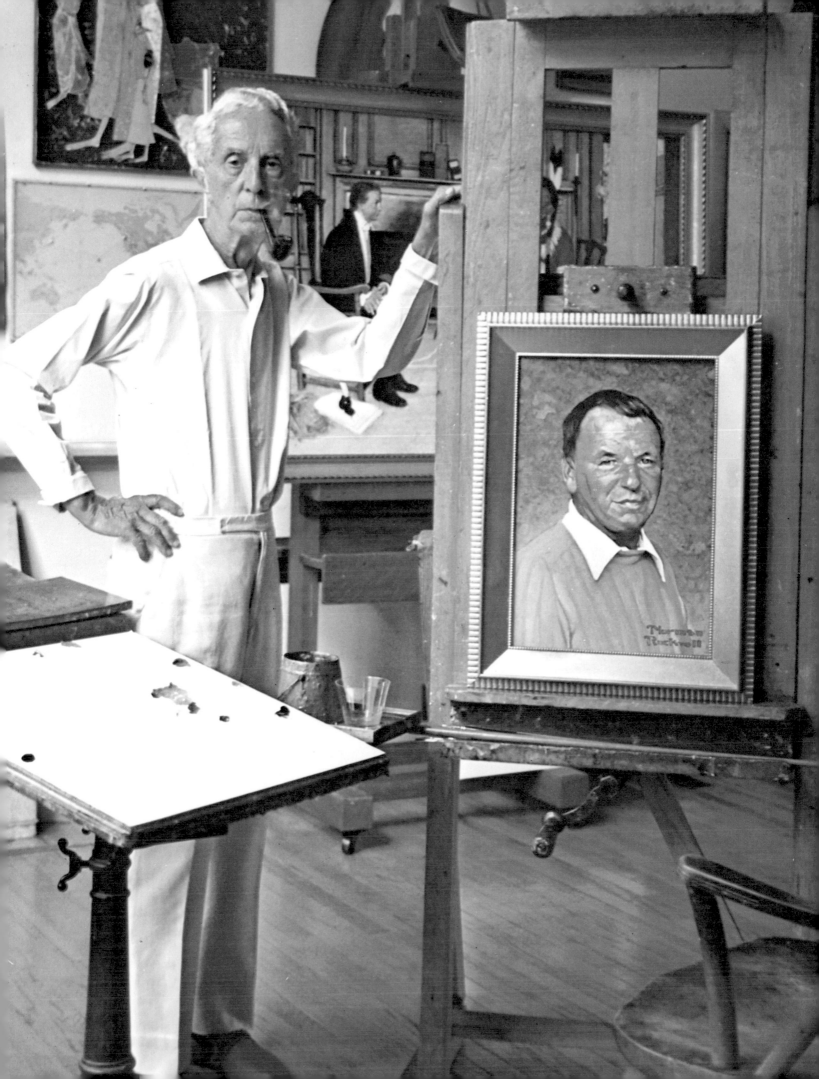

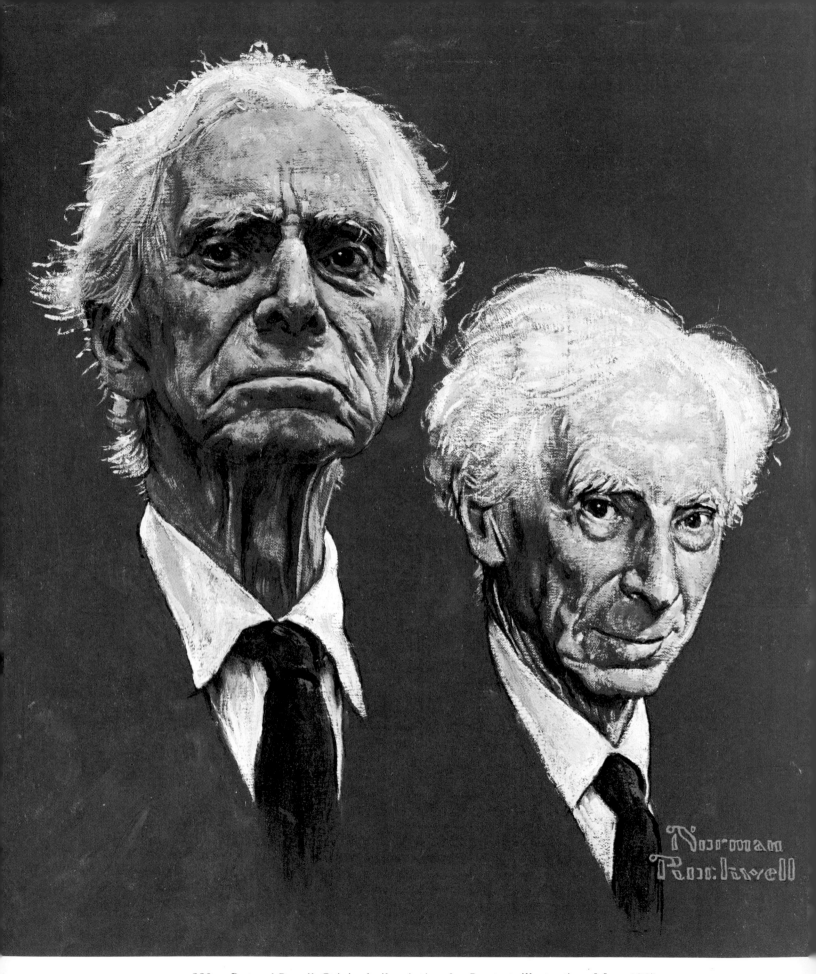

320. *Bertrand Russell.* Original oil painting for *Ramparts* illustration, May, 1967

321. *Rockwell at the Barber's. Look,*
October 20, 1964. © Cowles Communications, Inc.

322. *Ted Williams* (detail of fig. 305)

323. *Arnold Palmer*

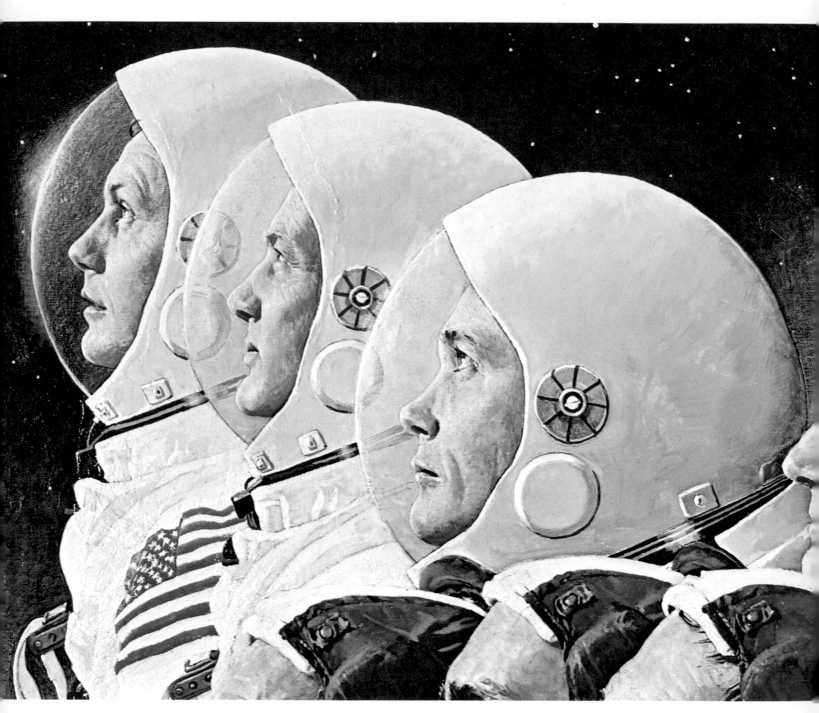

324. *Apollo 11 Space Team* (detail). Original oil painting for *Look* illustration, July 15, 1969.
© Cowles Communications, Inc. National Air and Space Museum,
Smithsonian Institution, Washington, D.C.

Christmas

325. *Boy with Candle.* Courtesy Hallmark Cards, Inc.

326. *News Kiosk in the Snow. Post* cover, December 20, 1941

327. *Playing Santa. Post* cover, December 9, 1916

Norman Rockwell has painted so many Christmas covers for the *Post* and other magazines that for many people they represent an institution within a tradition. Rockwell himself celebrated this fact in 1941 (Fig. 326). His Christmas cover that year showed a newsstand which has been transformed into a fortress to withstand the siege of cold and snow. The owner sits comfortably inside the warmth and light. The only reminder that Pearl Harbor had been attacked two weeks previously is provided by the Red Cross and defense-bond stickers that have joined the Christmas decorations (the painting would, of course, have been made some weeks before Pearl Harbor, to allow for publishing deadlines). The most notable feature of this cover, however, is the fact that the newsstand is festooned with copies of the *Saturday Evening Post* on the cover of which we discover the exact same scene we are looking at. This is an extremely reassuring cover and must have seemed very appropriate to the mood of that particular Christmas season, when reassurance was at a premium.

Rockwell's earliest Christmas covers are essentially lighthearted. We see, for example, a grandfather trying on a Santa Claus beard (Fig. 327), another grandfather confronted by his own effigy in snow (Fig. 328), Santa poring over his account sheet (Fig. 329), and elves coming to the assistance of an exhausted toymaker (Fig. 330). Other covers showed children playing in winter landscapes (Fig. 331). All these examples date from a period covering the years 1916 to 1922. In the later twenties and early thirties, Rockwell did a number of Christmas covers with historical themes. At least one of these is vaguely medieval, but most are Dickensian in spirit.

Rockwell's 1933 Christmas cover reintroduced Grandfather to the picture—this time

328. *Gramps Encounters—Gramps? Post* cover,
December 20, 1919

329. *Santa. Post* cover, December 4, 1920

sharing Junior's rocking horse (Fig. 334). 1935 finds Santa reading his mail (Fig. 337). The 1937 cover, showing Grandfather and his gifts half submerged in a snow drift, is surely one of the most banal that Rockwell has ever painted. It is symptomatic, perhaps, of the fact that he had exhausted the conventional Christmas themes and was looking around for a new way of handling the subject. The 1938 cover was Dickensian and the 1939 cover (Fig. 335) took a traditional theme—showing Santa in front of a map. With the 1940 cover, however, we find ourselves in the middle of a totally different vision of Christmas. The breakthrough has occurred. The image we see is that of a small boy on the subway staring in amazement at an off-duty Santa whose mind seems to be occupied not so much with sacks full of toys for good girls and boys as with the painful fact that his feet are cold from standing out in the snow all day ringing a bell (Fig. 338).

Rockwell's 1944 Christmas cover is perhaps the most untypical, but at the same time one of the most interesting. When he painted it, he was perhaps under the influence of John Falter, another *Post* artist who specialized in detailed representations of real pieces of America (New York's Gramercy Park, for instance). This influence cannot be underestimated in the light of Rockwell's later development. As with all his influences, Rockwell soon digested it and blended it with his own particular idiom; at the time of this 1944 cover, however, Falter's influence appears to be very strong. Rockwell decided to show a station at Christmastime (Fig. 336) and selected Chicago's North

330. *Christmas: Santa with Elves. Post* cover,
December 2, 1922

331. *Christmas. Country Gentleman* cover, December 18, 1920

332

334

333

332. *Christmas. Post* cover,
 December 6, 1930

333. *"Merrie Christmas." Post* cover,
 December 10, 1932

334. *Gramps Joins in the Fun. Post* cover,
 December 16, 1933

335. *Extra Good Boys and Girls. Post* cover, ▶
 December 16, 1939

337. *Santa. Post* cover,
 December 21, 1935

339. OVERLEAF: ▶
Christmas in Bethlehem. Look,
December 29, 1970.
© Cowles Communications, Inc.

338. *Santa on Train. Post* cover,
 December 28, 1940

336. *Union Station, Chicago, at Christmas.*
 Post cover, December 23, 1944

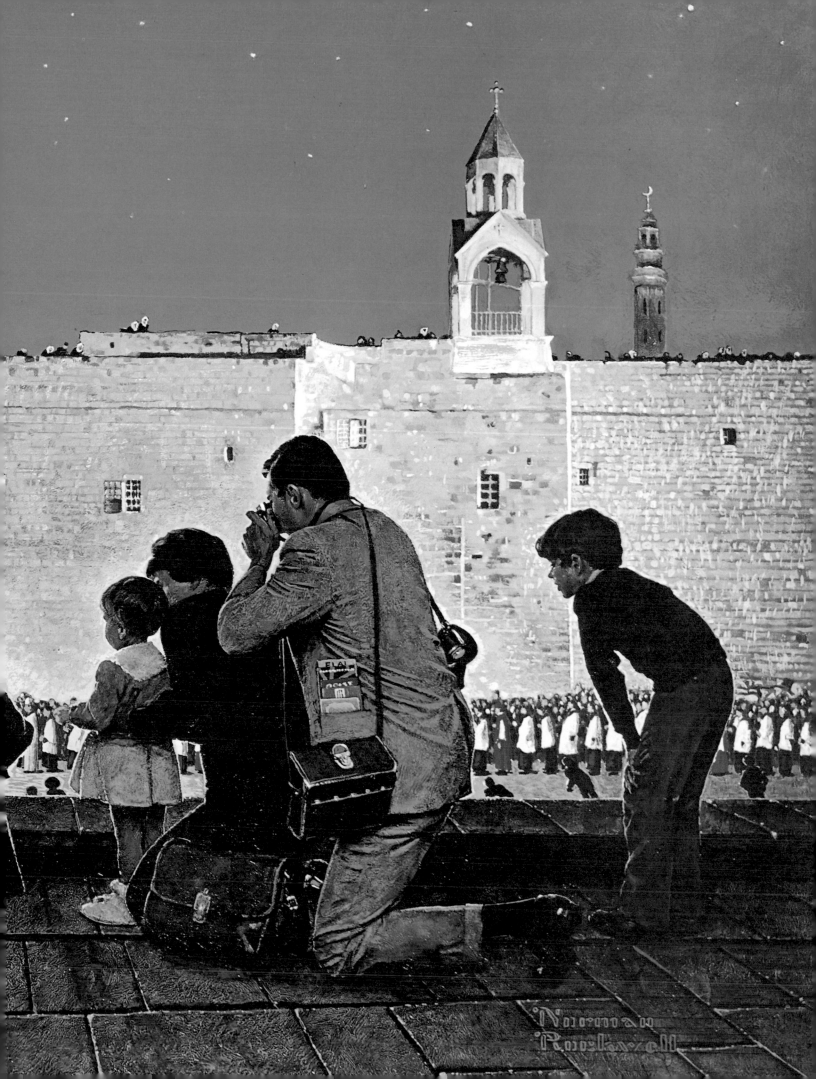

Western Railroad Station. Setting up a platform, he directed his photographer to take pictures of hundreds of servicemen at the moment of reunion with their friends and families. The result was an excellent documentary painting, very suitable for the mood of a wartime Christmas.

Perhaps the most telling of Rockwell's postwar Christmas covers is the one painted in 1956, which shows the shocked disillusionment of a small boy who has discovered a mothballed Santa suit in his father's chest of drawers. The only mitigating circumstance is that this cover did not appear until December 29, so that we may presume that the child's rude awakening did not occur until after the main festivities were over.

Quite a different mood is to be found in the Hallmark Christmas cards that Rockwell has designed (see Fig. 325). These tend to sustain a very traditional Christmas mood. My own particular favorite is the 1949 card which shows a girl being driven from a country station in a horse-drawn sleigh while, in the background, the train on which she has arrived moves through the night against the snow-covered hills. This, it seems to me, sums up the essential spirit of Christmas without lapsing into the more tiresome clichés.

Post Covers*

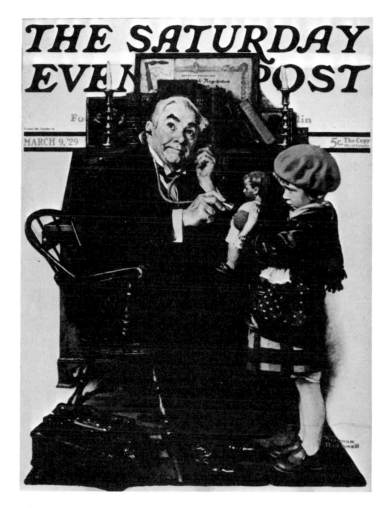

THE EMPIRE BUILDERS—By Mary Roberts Rinehart

May 20, 1916

FRANCE AND THE NEW AGE—By Will Irwin

June 3, 1916

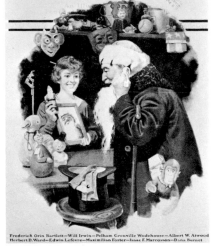

In This Number: Harry Leon Wilson—Samuel G. Blythe—George Lee Burton

August 5, 1916

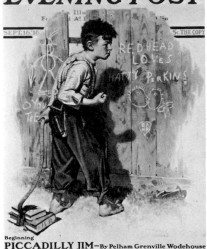

Beginning
PICCADILLY JIM—By Pelham Grenville Wodehouse

September 16, 1916

his Number

October 14, 1916

Frederick Orin Bartlett—Will Irwin—Pelham Grenville Wodehouse—Albert W. Atwood
Herbert D. Ward—Edwin Lefevre—Maximilian Foster—Isaac F. Marcosson—Dana Burnet

December 9, 1916

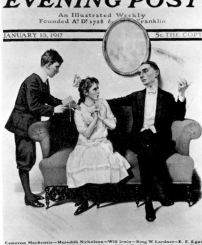

Cameron Mackenzie—Meredith Nicholson—Will Irwin—Ring W. Lardner—E. F. Egan
Elizabeth Frazer—Mary Brecht Pulver—Edward Mott Woolley—Arthur Somers Roche

January 13, 1917

WHAT OF THE EAST—By SAMUEL G. BLYTHE

May 12, 1917

In This Number: Carl W. Ackerman—Maximilian Foster—Will Irwin—Basil King
Charles E. Van Loan—Elizabeth Jordan—Nalbro Bartley—Eleanor Franklin Egan

June 16, 1917

Again and again, in any consideration of Norman Rockwell's career, we are bound to return to his relationship with the *Saturday Evening Post*. Rockwell's *Post* covers give us his entire development. We have already discussed the effect that the *Post*'s editors had upon Rockwell's choice of subject matter. We have described how the change in the *Post*'s cover design allowed him to adopt a more flexible approach. One thing we have not looked into is a possible relationship between Rockwell's covers and the contents of the magazine.

From 1916—the year of Rockwell's first cover—until the great stock-market crash of October, 1929, we find such articles as "France and the New Age," "The Little Hen of the Republic," "Following the Red Cross," "England After the War," "All American," "The Big Four of the Peace Conference," "The Reminiscences of a Stock Operator," and "The Personal Memoirs of Benito Mussolini." To find the real strength of the *Post* during this period we must turn to the list of contributors: this includes such names as Ring Lardner, P. G. Wodehouse, Booth Tarkington, Sinclair Lewis, Edith Wharton, F. Scott Fitzgerald, Alfred Noyes, Don Marquis, J. P. Marquand, Octavus Roy Cohen, Arnold Bennett, Stephen Leacock, Will Rogers, Amos Alonzo Stagg, E. Phillips Oppenheim, C. E. Scoggins, and Julian Street. This was, of course, the Silver Age of the American short story and the serialized novel. Authors such as Fitzgerald were publishing some of their best work in the *Post*. Are Rockwell's covers of that period in the same category? I'm afraid the answer to this question is no. His earlier covers were very competent, sometimes witty, and seen in perspective, packed tight with nostalgia, but they do not compare in quality with much of the other material that the magazine contained. It seems a little curious, in retrospect, that such sophisticated material should have been packaged in such folksy covers.

In the years covering the period from the Wall Street Crash to Pearl Harbor, many of the already named contributors returned and were joined by others such as Agatha Christie, Paul Gallico, Stephen Vincent Benét, and C. S. Forester, as well as by personalities such as Henry Ford, Red Grange, and Eddie Cantor. We find during this period the life stories of Marie, Queen of Romania, Paderewski, and Helen Hayes—but we also find "The Dangers of Inflation," "The $47,000,000,000 Blight," "The Crisis in Christianity," "Communist Wreckers in American Labor," "Jewish Pawns in Power Politics," "New Deal's J. P. Morgan," "Will Europe Hunger This Winter?" and "The Facts About Lindbergh." The quality of the fiction became lighter and the facts of the Depression could not be ignored. Something was wrong in the State of the Union. Rockwell's covers of this period fluctuated between matching the lightness of much of the fiction and making tentative gestures toward a new naturalism.

During the war years, well-known authors became less and less important and the

emphasis was placed upon stories such as "Last Man off Wake Island," "We Skip-Bomb the Japs," "Help Us Hold Australia," "Billion Dollar Plane Builder," "Our Two Months on Corregidor," "The Nazis Fail in Denmark," and "Sniper Ship." True, we will also find "Woes of an Army Cook," "Katharine Hepburn's Story," and "So It's the House-wife's Fault, Is It?"—not to mention, more seriously, "Wendell Willkie's Case for the Minorities"—but the war was the main business at hand. We have already seen that Rockwell handled this situation by adopting a particularly humanistic viewpoint and developing a naturalistic idiom to accommodate this.

After World War II we find a few new authors: Irving Wallace, Luke Short, Art Linkletter, John O'Hara, William Saroyan, and Taylor Caldwell, among others. We also find celebrity contributions from Bob Hope, Casey Stengel, Omar Bradley, and Boris Karloff. For the most part, however, journalism took over the spotlight from storytelling. There was a return to the kind of scare stories that had begun to appear during the Depression. Now, of course, they were geared to the Cold War: "Russia Builds a Base in Japan," "Case History of College Communism," "Stalin's Plans for the U.S.A.," and "What I Saw Inside Red China." More cheerfully we found "How Our Seamen Bounced the Commies," "Is the Marshall Plan Dead?" and "Germany Faces the Facts." We were told that "G.I. Deviltry Costs Us Plenty" and introduced to "The Drug That Makes Criminals Talk." This is not to say that the eternal truths were neglected, as can be judged by titles such as "Headaches of a Little League Umpire." There was "The Strange Case of Milton Berle" and Helen Hayes tried Hollywood again; "We Bar-rymores!" was a popular feature story and many other show-business personalities were interviewed. Toward the end of Rockwell's period with the *Post,* the Kennedy legend began to take shape in the pages of the magazine. Meanwhile—throughout the forties and fifties and into the sixties—Rockwell produced the finest of his *Post* covers. It was during this period that his art reached its peak. Some of the covers were light, but others—such as *Breaking Home Ties* and *Marriage License*—are richly conceived, fully round-ed works that take illustration to its limits and cross over into the realm of art.

In the beginning Rockwell's work had been something that merely decorated the cover of the magazine and, hopefully, attracted the sympathy of the casual buyer. In these later years, however, Rockwell's covers were often the most impressive things about the magazine. At times one is almost tempted to think that his covers were the sole justification for the magazine. In the forties and fifties, Rockwell's covers took on the confidence and sophistication which, in the twenties, had been the province of the writers.

Throughout this book we have used many of Rockwell's *Post* covers as illustrations. In this chapter we are reproducing all of these covers in chronological order. The progress of these covers over the years is a story in itself. Rockwell started out with an idiom that capitalized upon cliché and generalization; he evolved a new idiom which transformed the general into the particular and which took apart the components of cliché, only to reconstruct them in a fresh and original way. This has been a remarkable evolution and one which is, so far as I am aware, unique in twentieth-century illustration.

270

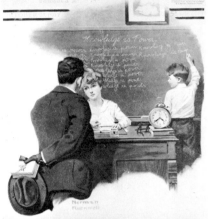

FOLLOWING THE RED CROSS—By Elizabeth Frazer

October 27, 1917

Captain Schlotterwerz—By Booth Tarkington. England After the War—By Isaac F. Marcosson

January 26, 1918

All American—By Irvin S. Cobb

May 18, 1918

Gerald Stanley Lee — Edward N. Hurley — Wallace Irwin — Arthur Train
Sinclair Lewis — Neville Taylor Gherardi — Frederick Orin Bartlett

August 10, 1918

THE ZERO HOUR—By GEORGE PATTULLO

September 21, 1918

Edith Wharton—Octavus Roy Cohen—Peter Clark Macfarlane
Isaac F. Marcosson—Basil King—Albert W. Atwood—Rob Wagner

January 18, 1919

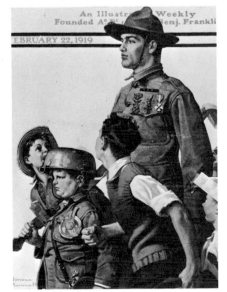

February 22, 1919

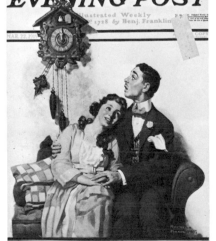

George Randolph Chester — Samuel G. Blythe — May Edginton — Gerald Stanley Lee

March 22, 1919

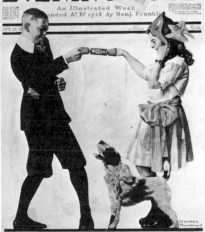

MORE THAN TWO MILLION A WEEK

April 26, 1919

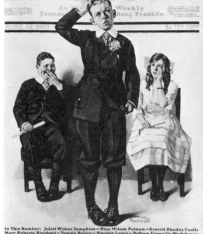

June 14, 1919

June 28, 1919

August 9, 1919

September 6, 1919

September 20, 1919

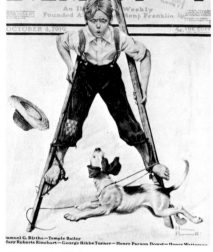

October 4, 1919

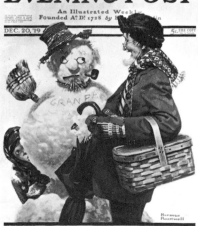

December 20, 1919

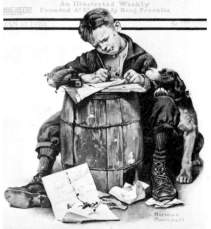

January 17, 1920

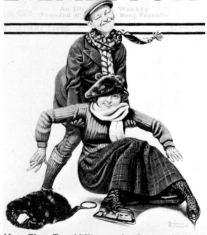

February 7, 1920

March 27, 1920

May 1, 1920

May 15, 1920

June 19, 1920

July 31, 1920

August 28, 1920

October 9, 1920

October 23, 1920

December 4, 1920

January 29, 1921

March 12, 1921

June 4, 1921

July 9, 1921

August 13, 1921

October 1, 1921

December 3, 1921

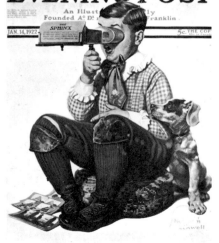

January 14, 1922

February 18, 1922

April 8, 1922

April 29, 1922

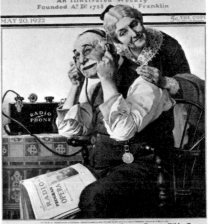

May 20, 1922

June 10, 1922

August 19, 1922

September 9, 1922

November 4, 1922

December 2, 1922

February 3, 1923

March 10, 1923

April 28, 1923

May 26, 1923

June 23, 1923

August 18, 1923

September 8, 1923

November 10, 1923

December 8, 1923

March 1, 1924

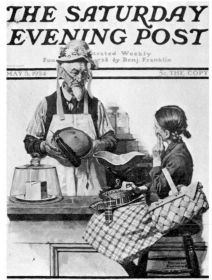

April 5, 1924

May 3, 1924

June 7, 1924

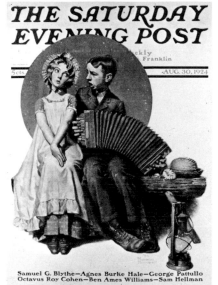

June 14, 1924

July 19, 1924

August 30, 1924

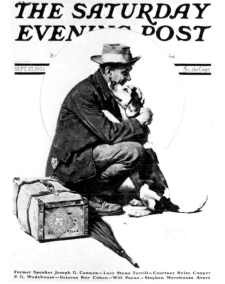

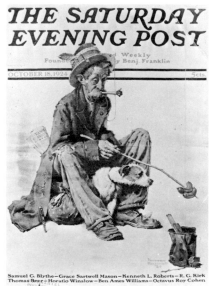

September 27, 1924

October 18, 1924

November 8, 1924

December 6, 1924

January 31, 1925

April 18, 1925

May 16, 1925

June 27, 1925

July 11, 1925

August 29, 1925

September 19, 1925

November 21, 1925

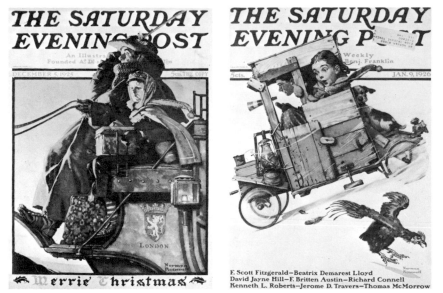

December 5, 1925

January 9, 1926

February 6, 1926

March 27, 1926

April 24, 1926

May 29, 1926

June 26, 1926

August 14, 1926

August 28, 1926

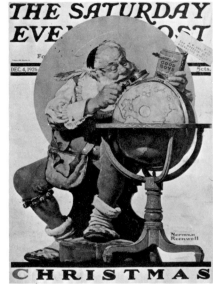

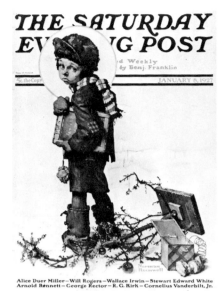

October 2, 1926

December 4, 1926

January 8, 1927

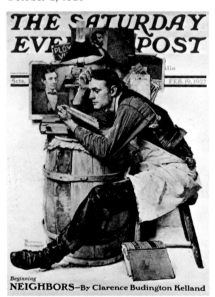

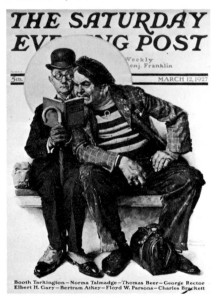

February 19, 1927

March 12, 1927

April 16, 1927

June 4, 1927

July 23, 1927

August 13, 1927

September 24, 1927

October 22, 1927

December 3, 1927

January 21, 1928

April 14, 1928

May 5, 1928

May 26, 1928

June 23, 1928

July 21, 1928

August 18, 1928

September 22, 1928

December 8, 1928

January 12, 1929

February 16, 1929

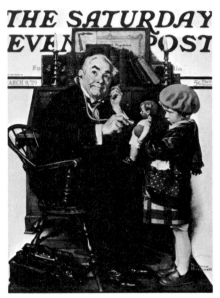

March 9, 1929

April 20, 1929

May 4, 1929

June 15, 1929

July 13, 1929

August 3, 1929

September 28, 1929

November 2, 1929

December 7, 1929

January 18, 1930

March 22, 1930

April 12, 1930

May 24, 1930

July 19, 1930

August 23, 1930

September 13, 1930

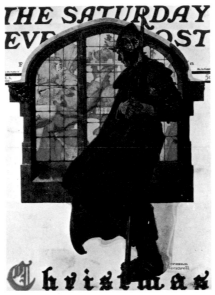

November 8, 1930

December 6, 1930

January 31, 1931

March 28, 1931

April 18, 1931

June 13, 1931

July 25, 1931

September 5, 1931

November 7, 1931

December 12, 1931

January 30, 1932

October 22, 1932

December 10, 1932

April 8, 1933

June 17, 1933

BEN AMES WILLIAMS · JAMES WARNER BELLAH

August 5, 1933

J. P. McEVOY · ALICE DUER MILLER · PAUL GALLICO

October 21, 1933

THE DANGERS OF INFLATION—By BERNARD M. BARUCH

November 25, 1933

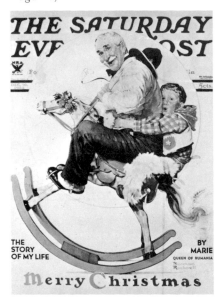

THE STORY OF MY LIFE · BY MARIE, QUEEN OF RUMANIA

December 16, 1933

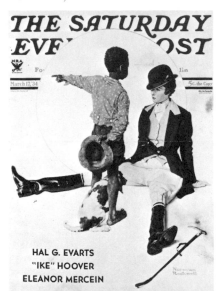

HAL G. EVARTS · "IKE" HOOVER · ELEANOR MERCEIN

March 17, 1934

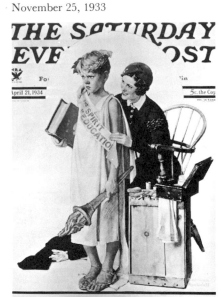

BOOTH TARKINGTON · COREY FORD · JOHN T. FOOT

April 21, 1934

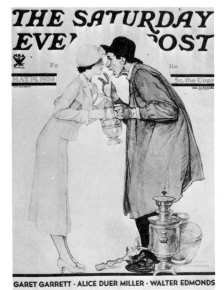

GARET GARRETT · ALICE DUER MILLER · WALTER EDMONDS

May 19, 1934

IN THIS NUMBER GENERAL HUGH S. JOHNSON

June 30, 1934

BEGINNING IN THIS ISSUE PITCAIRN'S ISLAND

By JAMES NORMAN HALL AND CHARLES NORDHOFF

September 22, 1934

MAURICE WALSH · BOOTH TARKINGTON · RED GRANGE

October 20, 1934

December 15, 1934

February 9, 1935

AGATHA CHRISTIE · JIM COLLINS · GENERAL JOHNSON

MANUEL KOMROFF · GILBERT SELDES · J. ROY STOCKTON

March 9, 1935

SPRINGTIME

JOHN TAINTOR FOOTE · GUY GILPATRIC · JOSEPH HERGESHEIMER

April 27, 1935

BEGINNING IN THIS ISSUE

PAMPA JOE
By C. E. SCOGGINS
· · ·
SINCLAIR LEWIS
J. P. MARQUAND
F. SCOTT FITZGERALD

July 13, 1935

CHRISTIAN GAUSS · CONRAD RICHTER · GEORGE S. BROOKS

September 14, 1935

EVALYN WALSH McLEAN · JOHN TAINTOR FOOTE

November 16, 1935

Christmas

WILLIAM HAZLETT UPSON · FRANK H. SIMONDS

December 21, 1935

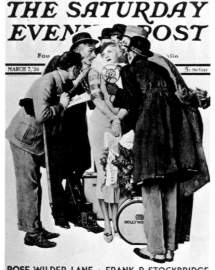

CONRAD RICHTER · ROBERT MOSES · J. P. McEVOY

January 25, 1936

ROSE WILDER LANE · FRANK P. STOCKBRIDGE

March 7, 1936

VINCENT SHEEAN · J. P. McEVOY · EDDIE CANTOR

April 25, 1936

ALVA JOHNSTON · PAUL GALLICO · BOOTH TARKINGTON

May 30, 1936

BOOTH TARKINGTON · COREY FORD · PERCY MADEIRA

July 11, 1936

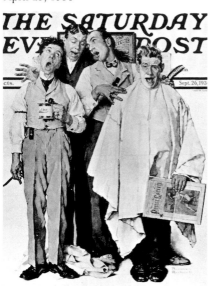

OLLYWOOD ON THE THAMES—BY HENRY F. PRINGLE

September 26, 1936

THE DEVIL
AND DANIEL WEBSTER—BY STEPHEN VINCENT BENÉT

October 24, 1936

FOOTBALL
WIFE
BY VIRGINIA BLACK

LIFER—BY CHARLES FRANCIS COE

November 21, 1936

SWING BUSINESS · HENRY ANTON STEIG

TISH GOES TO JAIL · MARY ROBERTS RINEHART

December 19, 1936

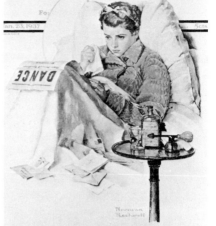

BEGINNING **PADEREWSKI'S LIFE STORY**

January 23, 1937

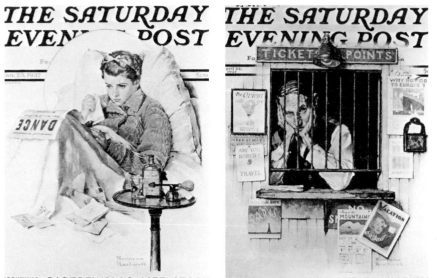

HE $47,000,000,000 BLIGHT—By SENATOR VANDENBERG

April 24, 1937

JESSE H. JONES · MARY ROBERTS RINEHART

June 12, 1937

WHITE-HOUSE TOMMY—By ALVA JOHNSTON

July 31, 1937

Beginning **AND ONE WAS BEAUTIFUL** By ALICE DUER MILLER

October 2, 1937

MORE THAN 3,000,000 AVERAGE NET PAID CIRCULATION IN 1937

December 25, 1937

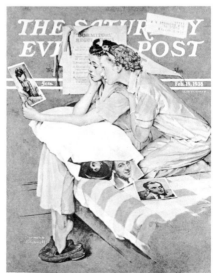

BEGINNING **A STORY BY WALTER D. EDMONDS**

February 19, 1938

BEGINNING
LITTLE DOC—THE STORY OF DR. DAFOE

April 23, 1938

ELEANOR MERCEIN
WILL DURANT · STANLEY WALKER

June 4, 1938

MISSOURI DARK MULE—By JACK ALEXANDER

October 8, 1938

BEGINNING EASY TO KILL—By AGATHA CHRISTIE

November 19, 1938

Merrie Christmas

MRS. WOODROW WILSON'S STORY

December 17, 1938

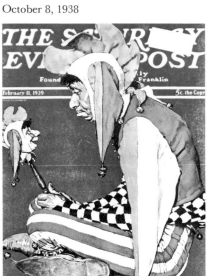

NOT SO FREE AIR—BY STANLEY HIGH

February 11, 1939

JEWISH PAWNS IN POWER POLITICS

BEGINNING FALSE TO ANY MAN By LESLIE FORD

March 18, 1939

BEGINNING TWENTY-FIRST CROSSING WEST

April 29, 1939

BEGINNING
ESCAPE
A NOVEL OF TODAY'S REIGN OF TERROR

July 8, 1939

THE CRISIS IN CHRISTIANITY By WILL DURANT

August 5, 1939

COMMUNIST WRECKERS IN AMERICAN LABOR

September 2, 1939

BEGINNING
THE STORY OF HELEN HAYES

November 4, 1939

BEGINNING A SERIAL By CLARENCE BUDINGTON KELLAN

December 16, 1939

THE GREAT MONOPOLY MYSTERY By RAYMOND MOLEY

March 30, 1940

BEGINNING
**REAP THE
WILD WIND**
By
THELMA STRABEL

April 27, 1940

DOROTHY THOMPSON By JACK ALEXANDER

May 18, 1940

YOUNG AMES RETURNS By WALTER D. EDMONDS

July 13, 1940

BEGINNING **SAILOR TAKE WARNING** By RICHARD SALE

August 24, 1940

NEW DEAL'S
J. P. MORGAN
By Samuel Lubell

**WILL EUROPE
HUNGER THIS WINTER**
By PETER F. DRUCKER

November 30, 1940

**THE FACTS
ABOUT
LINDBERGH**

BEGINNING **WHEREVER THE GRASS GROWS** By ALLAN R. BOSWORTH

December 28, 1940

March 1, 1941

May 3, 1941

July 26, 1941

October 4, 1941

November 29, 1941

December 20, 1941

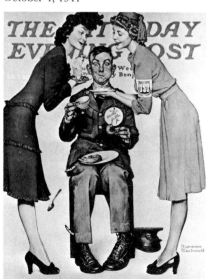

February 7, 1942

March 21, 1942

April 11, 1942

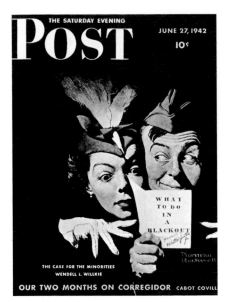

June 27, 1942

July 25, 1942

September 5, 1942

November 28, 1942

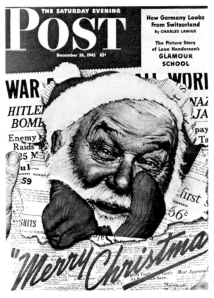

December 26, 1942

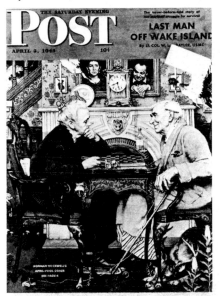

April 3, 1943

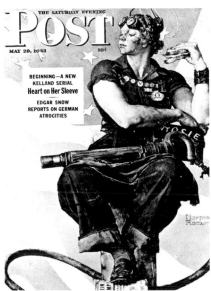

May 29, 1943

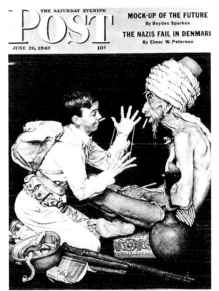

June 26, 1943

September 4, 1943

November 27, 1943

January 1, 1944

March 4, 1944

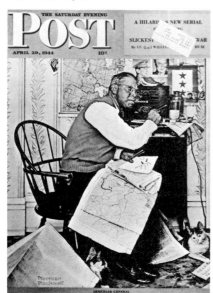

April 29, 1944

May 27, 1944

July 1, 1944

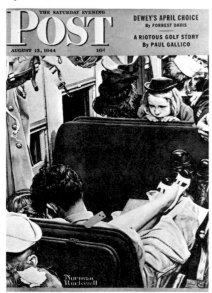

August 12, 1944

September 16, 1944

November 4, 1944

December 23, 1944

March 17, 1945

March 31, 1945

May 26, 1945

August 11, 1945

September 15, 1945

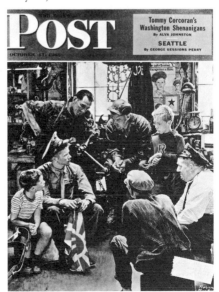

October 13, 1945

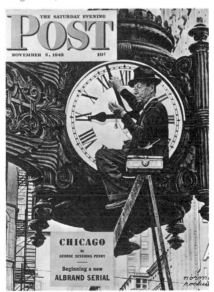

November 3, 1945

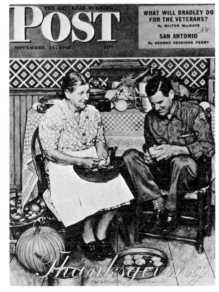

November 24, 1945

December 15, 1945

December 29, 1945

March 2, 1946

April 6, 1946

July 6, 1946

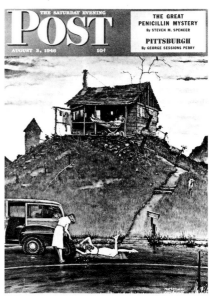

August 3, 1946

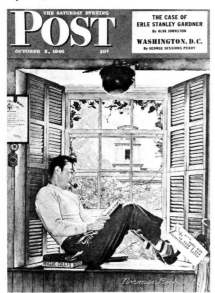

October 5, 1946

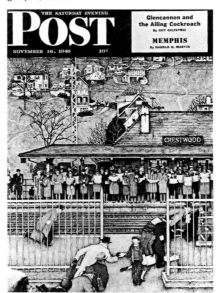

November 16, 1946

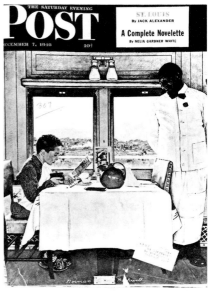

December 7, 1946

January 11, 1947

March 22, 1947

May 3, 1947

August 16, 1947

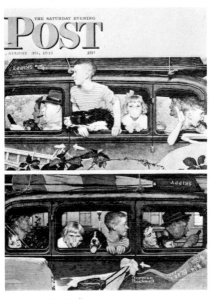

August 30, 1947

November 8, 1947

December 27, 1947

January 24, 1948

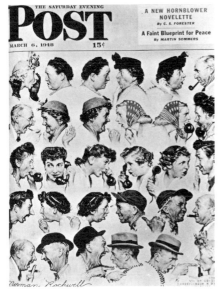

March 6, 1948

April 3, 1948

May 15, 1948

September 4, 1948

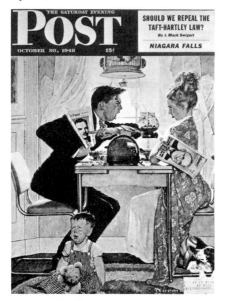

October 30, 1948

December 25, 1948

March 19, 1949

April 23, 1949

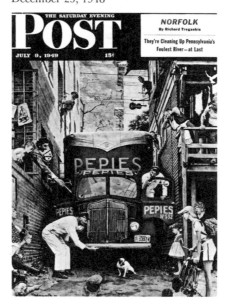

July 9, 1949

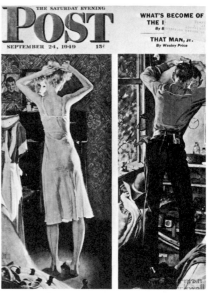

September 24, 1949

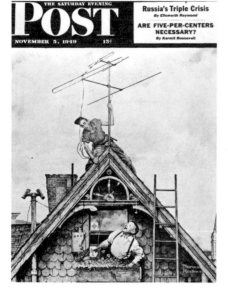

November 5, 1949

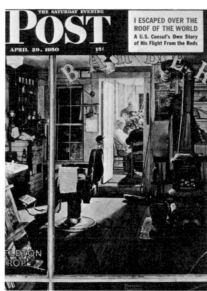

April 29, 1950

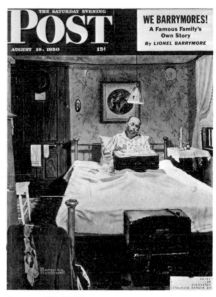

August 19, 1950

October 21, 1950

November 18, 1950

June 2, 1951

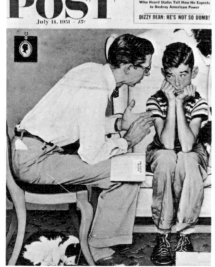

July 14, 1951

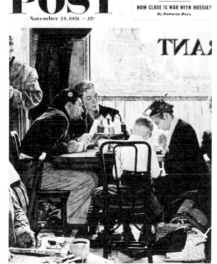

November 24, 1951

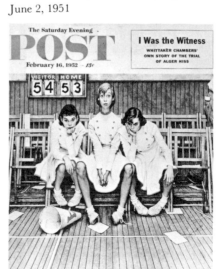

February 16, 1952

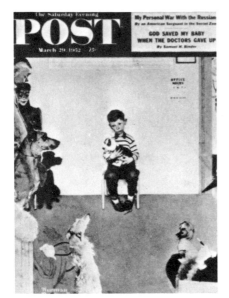

March 29, 1952

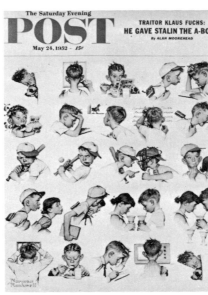

May 24, 1952

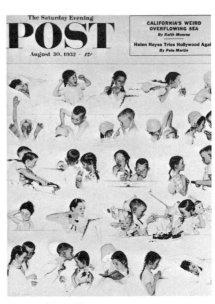

August 30, 1952

October 11, 1952

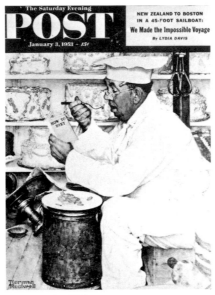

January 3, 1953

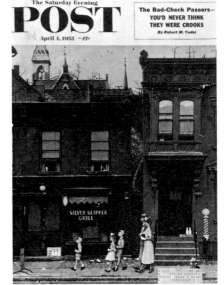

April 4, 1953

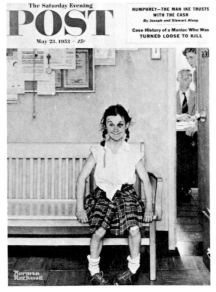

May 23, 1953

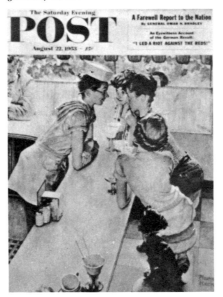

August 22, 1953

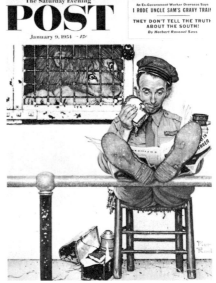

January 9, 1954

February 13, 1954

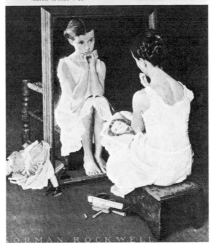

March 6, 1954

April 17, 1954

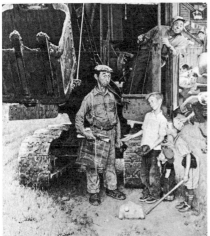

August 21, 1954

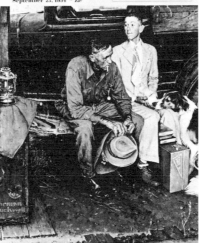

September 25, 1954

April 16, 1955

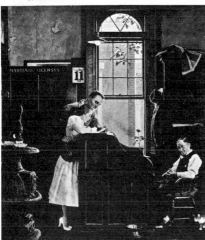

June 11, 1955

August 20, 1955

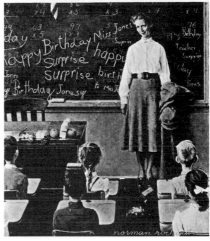

March 17, 1956

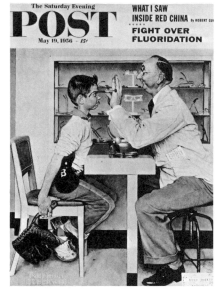

May 19, 1956

October 6, 1956

December 29, 1956

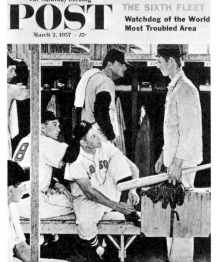

March 2, 1957

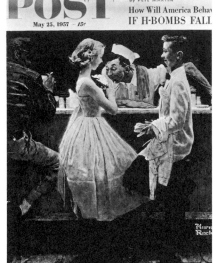

May 25, 1957

June 29, 1957

September 7, 1957

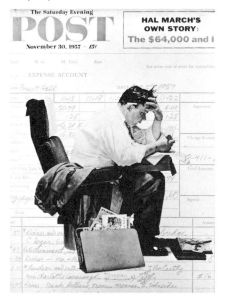

November 30, 1957

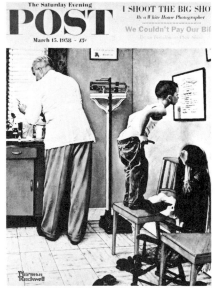

March 15, 1958

June 28, 1958

August 30, 1958

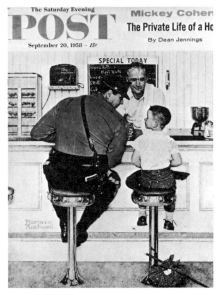

September 20, 1958

November 8, 1958

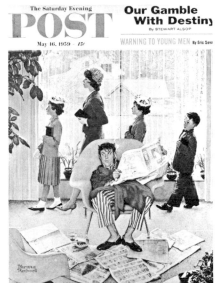

February 14, 1959

May 16, 1959

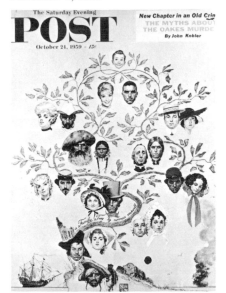

October 24, 1959

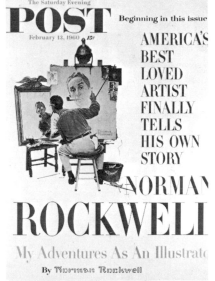

February 13, 1960

April 16, 1960

August 27, 1960

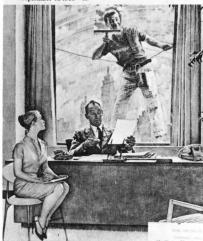

September 17, 1960

October 29, 1960

November 5, 1960

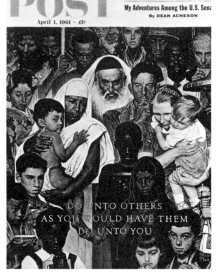

April 1, 1961

September 16, 1961

November 25, 1961

January 13, 1962

November 3, 1962

January 19, 1963

March 2, 1963

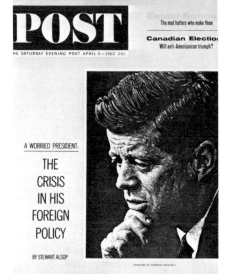

April 6, 1963

May 25, 1963

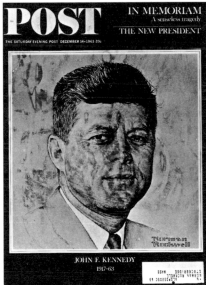

December 14, 1963

Biographical Outline

1894 Norman Percevel Rockwell born in New York City, the eldest son of Jarvis Waring Rockwell and Nancy Hill Rockwell.

1903 The Rockwell family moved to Mamaroneck in Westchester County.

1909 Rockwell, age fifteen, enrolled at the National Academy School in New York City.

1910 Transferred to Art Students League. That same year he received his first commission (four Christmas cards).

1911 Illustrated *Tell Me Why Stories.*

1912 The Rockwell family returned to live in New York City. Rockwell was by now receiving enough commissions to become a full-time illustrator and rented his first studio.

1913 Became the art editor of *Boys' Life.* At about this time he began to contribute to other youth-oriented periodicals such as *St. Nicholas, Youth's Companion, Everyland,* and *American Boy.*

1915 The Rockwell family moved again, this time to New Rochelle. Rockwell followed, setting up a studio there.

1916 Rockwell's first cover for the *Saturday Evening Post.* This marked the beginning of a professional relationship that was to last almost half a century. Married Irene O'Connor.

1917–18 During service with the Navy, Rockwell was stationed in Charleston, South Carolina, but continued to supply his regular clients with covers and illustrations. Along with the *Post,* these now included *Collier's, Life, Country Gentleman, Literary Digest,* and *Popular Science.*

1919 Back in New Rochelle, Rockwell found himself a highly respected member of an artistic community that included such eminent figures as Coles Phillips, Clare Briggs, Charles Dana Gibson, and the Leyendecker brothers.

1923 On a visit to Paris, Rockwell flirted briefly with modern art. This trip was one of many that he made during the twenties—trips that took him to South America and North Africa as well as Europe. He was working more for the *Post* now and less for other publications. His first wife divorced him.

1930 While on a visit to Los Angeles, Rockwell met Mary Barstow and married her.

1932 Dissatisfied with his work, Rockwell took his wife and baby son to Paris. Only three Rockwell *Post* covers appeared that year.

1935 Rockwell's work took a sharp turn for the better. Symbolic of this were the illustrations that he executed for *Tom Sawyer* and *Huckleberry Finn.* These were executed after careful research in Mark Twain's home town—Hannibal, Missouri—and enjoyed wide popularity.

1939 Rockwell's family, which now included three sons—Jerry, Tommy, and Peter—moved to Arlington, Vermont. At this time, Rockwell's work was becoming increasingly naturalistic.

1942–45 The war years inspired Rockwell to produce some of his strongest works, including the famous *Four Freedoms.* Detailed backgrounds, unusual in his earlier covers and illustrations, now became commonplace. In 1943 a major fire in his studio destroyed many of his props and older paintings.

1946–48 During this period, Rockwell executed a number of highly detailed documentary paintings for the *Post*—illustrating visits to places such as a country school and the editorial office of a country newspaper.

1951 Rockwell painted *Saying Grace,* his most popular *Post* cover. His *Post* covers during the fifties display a consistently high level of invention, ranging in subject matter from broad humor to political portraiture.

1953 Another move, this time to Stockbridge, Massachusetts.

1959 Mary Rockwell died.

1961 Molly Punderson became Rockwell's third wife.

1963 Rockwell's last *Post* cover.

The termination of Rockwell's link with the *Post* has not diminished the energy that he puts into both life and work. During the past decade he has traveled to places as diverse as the Soviet Union and Ethiopia. After six decades as a professional artist Norman Rockwell remains as active as ever.

Index to Illustrations

Illustrations have been indexed by category — alphabetically and chronologically within each category. Numbers on the left refer to plates; asterisks* indicate colorplates. In addition to the following listing, all of Rockwell's *Saturday Evening Post* covers are reproduced in chronological order in the last chapter of the book.

*111. May 8, 1920
*113. February 26, 1921
*293. July 30, 1921
*159. December 24, 1921
*169. February 25, 1922
*158. March 25, 1922
*149. April 15, 1922
*154. May 27, 1922
*153. June 24, 1922
*273. January 13, 1923

Look
*202. "A Time for Greatness," original oil painting for *Look* cover, July 14, 1964

Post
*3. May 20, 1916
51. August 5
68. September 16
327. December 9

87. January 13, 1917
88. October 27

243. January 8, 1918
60. January 26
263. August 10

89. March 22, 1919
69. June 28
303. September 20
328. December 20

77. January 17, 1920
94. May 1
201. October 9
329. December 4

*42. "No Swimming," original oil painting for *Post* cover, June 4, 1921
95. October 1

58. January 14, 1922
*57. June 10
152. May 20
163. August 19
330. December 2

264. August 18, 1923
155. September 8

265. June 7, 1924
92. August 30
156. October 18

165. January 31, 1925
168. May 16
*267. August 29
*93. September 19
290. November 21

37. January 9, 1926
73. June 26

72. January 8, 1927
203. February 19
10. August 13
167. October 22

*266. May 26, 1928

*164. January 12, 1929
*1. "Doctor and Doll," original oil painting for *Post* cover, March 9, 1929
***50.** June 15

*11. May 24, 1930
*151. July 19
115. August 23
*120. September 13
102. November 8
332. December 6

74. June 13, 1931
98. July 25
291. September 5

333. December 10, 1932

117. October 21, 1933
116. November 25
334. December 16

70. April 21, 1934
*13. May 19

91. March 9, 1935
12. September 14
337. December 21

97. July 11, 1936
96. November 21

269. April 24, 1937

101. February 19, 1938
*166. June 4
*5. October 8
*103. November 19

268. March 18, 1939
294. April 29
*295. July 8
36. September 2
271. November 4
334. December 16

*127. March 30, 1940
285. May 18
338. December 28

*15. July 26, 1941
*250. October 4
251. November 29
*326. December 20

252. February 7, 1942
253. April 11
254. June 27
255. July 25
256. September 5

*262. May 29, 1943
257. June 26
*16. November 27

258. January 1, 1944
*245. "The Tattooist," original oil paint-
 ing for Post cover, March 4, 1944
106. August 12
259. September 16
212. November 4
*336. December 23

*244. "Homecoming GI," original oil
 painting for Post cover, May 26, 1945
*174. August 11
*249. September 15
246. October 13
287. November 3
247. November 24
*248. December 15

286. July 6, 1946
*26. August 3

*260. October 5
*25. November 16
*71. December 7

*129. August 30, 1947

19. March 6, 1948
*289. September 4
130. October 30

*30. March 19, 1949
*297. April 23
*32. July 9
104, 105. September 24
*27. November 5

*29. "Shuffleton's Barber Shop," original
 oil painting for Post cover, April 29,
 1950
*31. August 19,
296. October 21

283. June 2, 1951
76. July 14
*33. "Saying Grace," original oil painting
 for Post cover, November 24, 1951

301. February 16, 1952
*78. March 29
52. May 24
53. August 30

20. January 3, 1953
*28. "Walking to Church," original oil
 painting for Post cover, April 4, 1953

21. January 9, 1954
*316. February 13
35. "Girl at the Mirror," original oil paint-
 ing for Post cover, March 6, 1954
*280. August 21
*63. "Breaking Home Ties," original oil
 painting for Post cover, September 25,
 1954

*85. "Marriage License," original oil
 painting for Post cover, June 11, 1955

75. March 17, 1956
22. May 19
231. October 6
*232. October 13

Woman's Home Companion
187, 189, 198–99. "Louisa May Alcott: Most Beloved American Writer," December, 1937—March, 1938

MURALS AND POSTERS

*204–7. "Four Freedoms" posters
*181. "Yankee Doodle" mural (Nassau Tavern, Princeton, N.J.)

MISCELLANEOUS

162. "The Argument," painting
* 236. "Robert F. Kennedy," painting
* 238. "Eugene McCarthy," painting
*323. "Arnold Palmer," painting
*184. "Becky Sharp," unfinished sketch
*157. "Family Saying Grace," painting

325. Hallmark card
*185, *186. "Ichabod Crane," paintings (never published)
*311. "John Wayne," painting
*183. "Matthew Brady Photographing Lincoln," painting
4. Photograph, Rockwell in his studio, 1934
8. Photograph, Rockwell in his studio, 1961
6. Photograph, Rockwell in his studio, 1970
310. "Rockwell and His wife Molly," 1967
*319. Rockwell with his painting of Frank Sinatra
312. "John Wayne," painting
313. "Walter Brennan," painting
*314. "Gary Cooper," painting